FREDERIC REMINGTON

FREDERIC REMINGTON

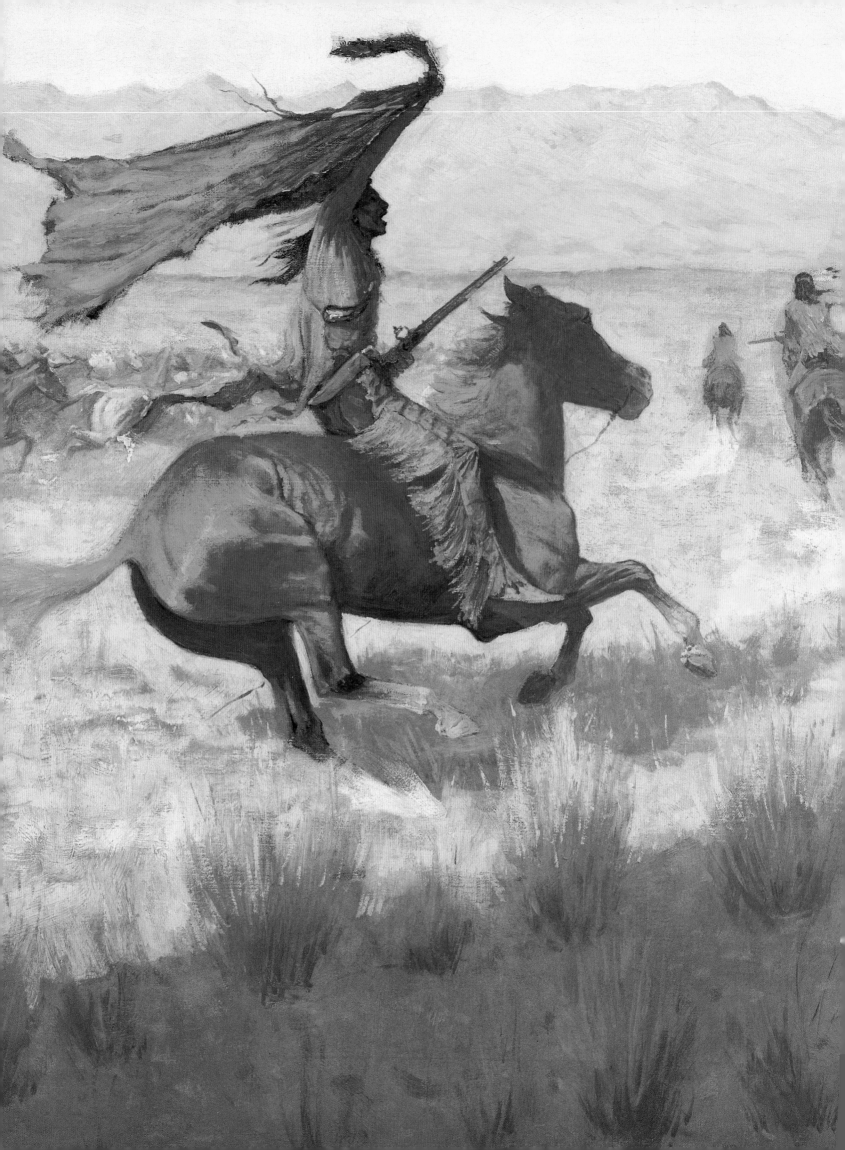

FREDERIC REMINGTON

The Hogg Brothers Collection

of the Museum of Fine Arts, Houston

EMILY BALLEW NEFF

with WYNNE H. PHELAN

PRINCETON UNIVERSITY PRESS

IN ASSOCIATION WITH THE MUSEUM OF FINE ARTS, HOUSTON

Published by Princeton University Press, 41 William Street,
Princeton, New Jersey 08540
In the United Kingdom: Princeton University Press,
Chichester, West Sussex
The Museum of Fine Arts, Houston, P.O. Box 6826,
Houston, Texas 77265-6826

Photography by Thomas R. DuBrock with Jud Haggard, Department of
Photographic Services, The Museum of Fine Arts, Houston
Infrared reflectogram montages created by John Twilley
Unless noted, all photographs © The Museum of Fine Arts, Houston
Certain other illustrations are covered by claims to copyright,
which are listed in the photographic captions.

Jacket/cover illustration: *Fight for the Water Hole,* 1903 (cat. no. 15, detail)
Frontispiece: *Change of Ownership,* 1903 (cat. no. 16, detail)
Pages 38–39: *The Parley,* 1903 (cat. no. 17, detail)
Pages 108–9: *Episode of the Buffalo Gun,* 1909 (cat. no. 22, detail)

Designed by Carol S. Cates
Typeset in Adobe Garamond by Jo Yandle
Printed by South China Printing, Hong Kong

Printed in Hong Kong

10 9 8 7 6 5 4 3 2 1

LIBRARY OF CONGRESS CATALOGING-IN-PUBLICATION DATA
Neff, Emily Ballew.
Frederic Remington : the Hogg Brothers Collection of the Museum of Fine Arts,
Houston / Emily Ballew Neff with Wynne H. Phelan.
p. cm.
Includes bibliographical references and index.
ISBN 0-691-04928-9 (cloth : alk. paper).
—ISBN 0-89090-092-2 (pbk. : alk. paper)
1. Remington, Frederic, 1861–1909 Catalogs. 2. West (U.S.)—In art Catalogs.
3. Hogg Family—Art collections Catalogs. 4. Painting—Private collections—Texas—
Houston Catalogs. 5. Museum of Fine Arts, Houston Catalogs.
I. Remington, Frederic, 1861–1909. II. Title.
ND237.R36 2000
709'.2—dc21 99-39063
 CIP

With grateful thanks to

THE JAMES W. GLANVILLE FAMILY FOUNDATION

Contents

Foreword

The Museum of Fine Arts, Houston, founded in 1900, was born in an era of intense social and political reform. President Woodrow Wilson, in *The New Freedom* (1913), noted, "This is nothing short of a new social age, a new era of human relationships, a new stage-setting for the drama of life." As Dr. Emily Ballew Neff explains in this book, Will Hogg and his family were civic and cultural leaders in Houston who helped lay the foundation for the museum. On a broader scale, they were social and educational reformers who hoped to recapture the values of the American past. They embraced the art of Frederic Remington in much the same way that the conservative wing of the Progressive Party favored an earlier time in American history, looking to turn the clock back to an era before trusts and big business. However, the Hogg family also looked to the future, foreseeing the possibilities in what President Theodore Roosevelt called the "inevitable-ness of combinations in business."

The pull of the past and the push into the future create the dramatic story that Dr. Neff has researched so thoroughly. At first glance, the Hogg family ideal, to lead Texas forward by collecting the art of the past—whether through paintings by Remington or furniture by the eighteenth-century craftsmen of Rhode Island—may seem contradictory. However, within the whirligig of American life during the mercurial early decades of the twentieth century, this systematic and inspired collecting represented a search for a heroic "American" identity. What did it mean to be an American? The past, the Hoggs believed, would help Americans determine their collective identity and use that awareness to navigate the unknown future.

In addition to writing about Will Hogg and his quest to foster Texas's evolution into a "progressive" state, Dr. Neff helps us see Frederic Remington as a "progressive" in his own right: an artist who continued to experiment and change throughout his productive career. Remington's genius as an illustrator places him, in rank, alongside Winslow Homer and Norman Rockwell. Yet, beyond this assessment, one must also appreciate the complexity of his sculptures and the enormous range of his paintings. From his monochromatic paintings in subtle yet effective shades of gray to the works that boast color explosions with brilliant effects of atmosphere and light, this "Western" or "cowboy" artist was proficient in grisaille and Impressionism and a host of styles in between.

The Hogg Brothers Collection of Remingtons in the Museum of Fine Arts, Houston, is one of the most important in the world. The paintings are powerful even when they stand alone, without explanation. Our hope is that this book will bring an even greater appreciation of their importance—both as works of art and as objects imbued with the purpose of a visionary collector, dedicated to building a stronger, more progressive community.

In closing, I would like to dedicate this catalogue to the memory of William C., Ima, and Michael Hogg.

Peter C. Marzio
Director
The Museum of Fine Arts, Houston

Acknowledgments

Biographer Garry Wills once called Hollywood star John Wayne a symbol of "Manifest Destiny on the hoof." Wayne powerfully inhabited the role—invented in largest part by the nineteenth-century American artist Frederic S. Remington—of a scrappy, no-nonsense cowboy whose swagger helped convey America's confidence in expanding its dominion west to the Pacific Ocean. As late-twentieth-century viewers of the art of Remington, we cannot help but see the artist filtered through the silver screen of the Hollywood Western movies that have captivated audiences throughout the century and dominated the popular view of the frontier past. Remington's art gives authority to these movies; his art, in fact, inspired them, and in turn, they reify our image of the West as a heroic battleground for America's sovereign destiny.

We are, of course, now aware of the cultural biases built into the West of Remington and Hollywood and recognize that Remington's enduring role as a popularizer of the West both enriches and obscures our understanding of the artist and his specifically urban East Coast milieu at the turn of the century. We also know that the personality of Remington belies his popular image as a "cowboy artist." Remington was, in fact, a Yale football player; a journalist personally interested in United States military affairs; a New York City clubman; a phenomenally successful illustrator, ambitious and eager to win approval as an artist of the first rank; an advocate of the strenuous life as a North Woods outdoorsman; and a political conservative troubled by the profound social change of his time, who used the trope of the vanishing West to eulogize a perceived heroic past. In this, he was not unlike the American artist Thomas Cole, who, earlier in the century, used nostalgia about a bygone America as a vehicle to convey his concerns about the present.

The Hogg Brothers Collection of the Museum of Fine Arts, Houston, comprising twenty-nine oil paintings, ten works on paper, and one bronze, is one of the most distinguished public collections of works by Remington in the country. With their varied subject matter and range of dates and media, they present a broad survey of the artist's career and provide an opportunity to spotlight the multifaceted issues and concerns that pulse throughout

Remington's career. It has been a special privilege to study this collection and to explore the motivations that impelled Will Hogg to make Remington one among many of his civic crusades. This catalogue should be understood, then, as a study in the patronage of Western American art as well as a study of Remington's career and technique as seen through this remarkable collection.

In preparing this catalogue, I am indebted to the many scholars who have peeled away the layers surrounding the American cultural icon that Remington has become, namely: Peter H. Hassrick, Melissa J. Webster, Alexander Nemerov, James K. Ballinger, Brian W. Dippie, Rick Stewart, Estelle Jussim, Ben Merchant Vorpahl, Michael Edward Shapiro, David McCullough, Doreen Bolger, and John Seelye. The work of Allen P. and Marilyn D. Splete, Peggy and Harold Samuels, and the late Harold McCracken has also expanded our knowledge about the artist. Richard H. Saunders, through his excellent work on the patronage of Western American art, also deserves special mention.

At the Frederic Remington Art Museum in Ogdensburg, New York, Lowell McAllister and Laura Foster, director and curator, respectively, made the extraordinary Remington archives available and generously gave of their time, answering numerous queries and providing gracious North Country hospitality. At the Center for American History, the University of Texas at Austin, director Don Carleton and his staff were unfailingly helpful and supportive of my research. At the Amon Carter Museum, Fort Worth, Texas, Ruth Carter Stevenson, president of the board, graciously granted access to the papers of her father, Amon G. Carter, Sr., and special thanks go to Amon Carter staff members for their friendly cooperation, including Milan R. Hughston, Paula Stewart, Ben Huseman, Sam Duncan, Courtney DeAngelis, and Karin Stroebech. At the Art Institute of Chicago, Judith A. Barter, Field-McCormick Curator of American Arts, and Andrew Walker, assistant curator of American painting and sculpture, offered the best kind of advice and research assistance; to them I am especially grateful. On matters of Houston history and architecture, Stephen Fox responded to my requests for help with patience, generosity, and good humor. I am also indebted to William C. Howze for his

work on the relationship between Western American painting and the films of John Ford. William Prior, Jane Zivley, Lucie Wray Todd, Emily Todd, and Nancy Cravens Chamberlain graciously shared memories, stories, and provided leads about the Hogg and Cullinan families. Other individuals and institutions also provided support, including Carrie Rebora Barratt, the Metropolitan Museum of Art, New York; Jack Cowart and Marisa Keller, the Corcoran Museum of Art, Washington, D.C.; Sarah Boehme, Nathan Bender, and Frances Clymer, the Buffalo Bill Historical Center, Cody, Wyoming; Sue Ellen Jeffers, the Jack S. Blanton Museum of Art, Austin; Louis Marchiafava, Steven Strom, and Joel Draut, the Houston Metropolitan Research Center; Gerianne Schaad, Woodson Research Center, Fondren Library, Rice University, Houston; Wallace Dailey, the Theodore Roosevelt Collection, Houghton Library at Harvard College, Cambridge, Massachusetts; Sam D. Ratcliffe, Hamon Arts Library, Southern Methodist University, Dallas; Jeff Hutchinson, Varner-Hogg Plantation State Historical Park, West Columbia, Texas; James Hoobler, Tennessee State Museum, Nashville; Michael Winey, United States Military Institute, Carlisle, Pennsylvania; and Judy Throm, Archives of American Art, Smithsonian Institution, Washington, D.C. The staffs of the Will Rogers Memorial, Claremore, Oklahoma; the Denver Public Library; the Avery Library at Columbia University, New York; and the New York Public Library, also provided assistance.

As always, I owe the greatest thanks to the people with whom I am privileged to work every day. First and foremost, Peter C. Marzio, director, and the Board of Trustees of the Museum of Fine Arts, Houston, enthusiastically supported this research project from its inception. Wynne H. Phelan, head of the conservation department, guided the Remington conservation project with grace, determination, and humor. Her thoroughly researched essay on Remington's technique will help Remington scholars and conservators alike for years to come. For the conservation phase of this project, Andrea di Bagno, Maite Leal, Bert Samples, Jill Whitten, Robert Proctor, John Twilley, Chris Shelton, Steve Pine, and Debby Breckeen deserve a special salute. Curatorial colleagues Michael K. Brown and Alison de Lima Greene offered encouragement and helped refine the ideas presented here with patience and unparalleled wit. Special thanks also go to Gwendolyn H. Goffe, associate director, finance and administration; Margaret C. Skidmore, associate director, development; Lorraine Stuart, archivist; Charles J. Carroll and Linda Wilhelm in the registrar's department; Celia Cullen Martin and G. Clifford Edwards in the curatorial department; Jacqui Allen,

Jeannette Dixon, Jon Evans, Margaret Ford, and Lea Whittington in the museum's Hirsch Library; Marcia K. Stein, image librarian; Thomas R. DuBrock, photographer; Kathleen Crain and the preparations department; Beth Schneider, education director; Frances Carter Stephens, public relations director; and George Zombakis, Celine Reno, and Alice Ross in the rights and reproductions office.

Former staff member Edward Mayo, the museum's registrar for over thirty years, enthusiastically supported the project and offered helpful advice, and other former staff members, including Britt Chemla, Melina Kervandjian, Georgia McAlpin, Misty Moye, and former intern Elizabeth Callicott, made significant contributions to the preparation of the catalogue. As always, we owe a debt of gratitude to the museum's and Bayou Bend's docents, whose research on the permanent collection has been an invaluable resource: specifically, to Sarah Shaw and to Marjorie Thompson, whose illustrated pamphlet of the Hogg Brothers Collection was the museum's only published resource for many years.

Diane P. Lovejoy, publications director, and Hillery Hugg, assistant editor, took a sprawling manuscript and herded it into a more concise form. Their professionalism and commitment to the project are especially appreciated. We are fortunate to copublish this catalogue with Princeton University Press. Patricia Fidler, art editor, deserves special thanks for her constant support of the project. Curtis Scott, production editor, guided the book smoothly through all stages of production. Lory Frankel copyedited the manuscript with sensitivity, grace, and as always, razor-sharp skill. Carol S. Cates created a design that handsomely complements its subject, and Ken Wong, production manager, worked diligently to ensure the highest quality printing and reproductions.

Finally, and most important, I am greatly indebted to Nancy Hart Glanville, Tom Glanville, and the James W. Glanville Family Foundation, for their generosity and steadfast support of this project; Dr. Mavis P. and the late Mary Wilson Kelsey, whose collection of Remington graphics at the museum continues to be an invaluable resource; to Christie's, which provided additional funds to publish this handsome catalogue; and, not least, Alice C. Simkins, for bringing the Hogg family legacy into the twenty-first century.

Emily Ballew Neff
Curator
American Painting and Sculpture
The Museum of Fine Arts, Houston

FREDERIC REMINGTON

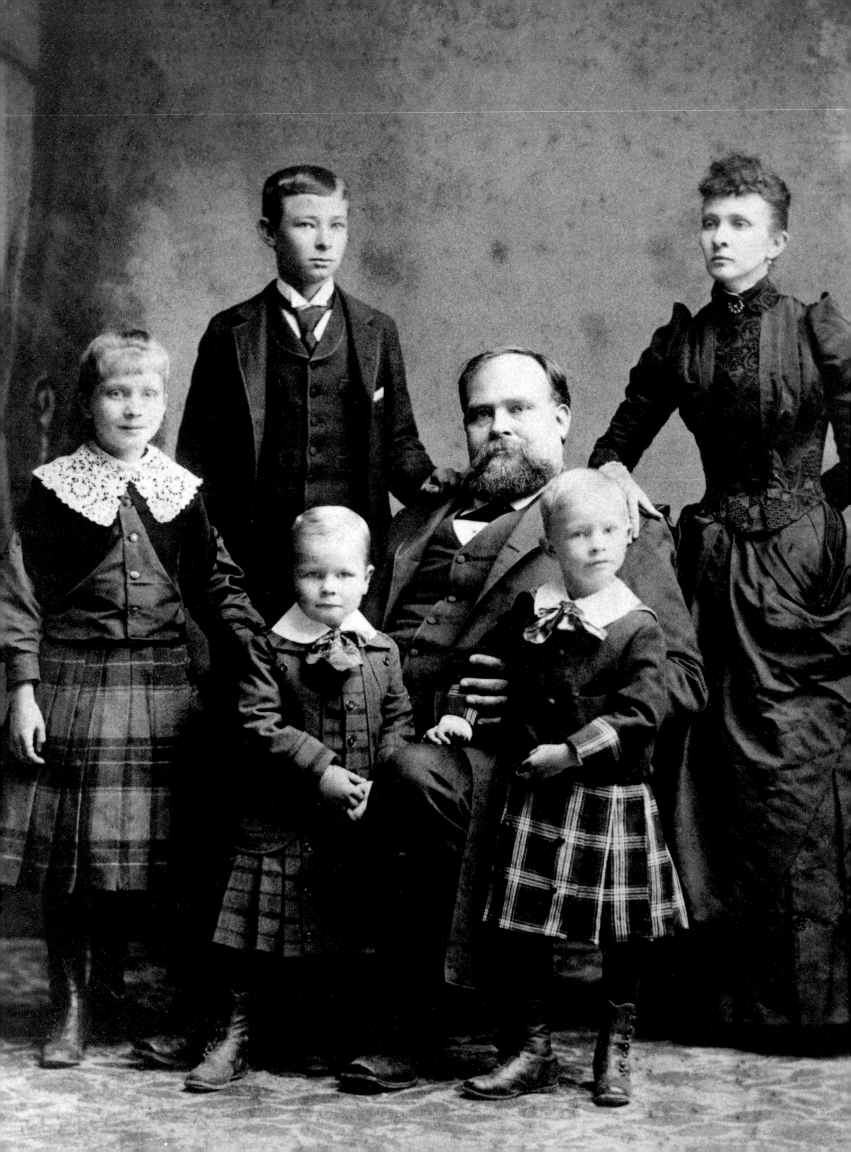

Will Hogg: Building Heritage in Texas

Emily Ballew Neff

WILL HOGG'S CRUSADE to acquire the works of Frederic S. Remington underscores the personality trait that defined him best: he thought "big." His collection of works by Remington was the largest of its kind in the 1920s outside the Frederic Remington Art Museum in Ogdensburg, located near the artist's birthplace in Canton, New York.[1] Hogg built his collection primarily in New York City and led the migration westward of Remington's artworks to the Southwest in the early decades of the twentieth century. Hogg's pursuit of the work of this quintessential artist of the American West was a major factor in the surge of national appreciation for Remington and the subsequent institutional acquisition of his work. His example encouraged other prominent collectors in later decades, including Amon Carter, Thomas Gilcrease, Lutcher Stark, C. R. Smith, Sid Richardson, and R. W. Norton, to acquire the work of Remington and other artists who depicted the American West and to give these works to a public museum or use them as a core collection for the building of their own museums in the Southwest.

While the Remingtons that Will Hogg acquired beginning in September 1920 were not presented to the Museum of Fine Arts in Houston until 1943 by his sister, Ima, the collection was immediately identified with the city where he maintained his primary residence and with its newly established museum. Hogg made it clear in his will that the collection would eventually go to the museum when Ima and their brother Michael (Mike) so desired.[2] When the Museum of Fine Arts, Houston, first opened its doors in 1924, Will Hogg loaned ten works from the collection, and the following year he loaned his entire collection for the first Remington memorial exhibition.[3] In 1936, in honor of the Texas centennial, the museum included several Remingtons from the Hogg Brothers Collection in its exhibition celebrating frontier life in the Southwest. From 1939 to 1941, the collection was exhibited annually before it was donated to the museum in 1943, even though Miss Hogg and Mike Hogg's widow, Alice Nicholson Hogg Hanszen, reserved the right to display their favorite paintings, *Fight for the Water Hole* (cat. no. 15), *The Herd Boy* (cat. no. 20), and *The Mule Pack* (cat. no. 13), in their homes. The institution was so firmly linked with Remington that the museum's first director, James Chillman, Jr., provided the introduction to the first scholarly publication on the artist, Harold McCracken's *Frederic Remington: Artist of the Old West* (1947).

Although Hogg acquired his Remingtons with his own money, he had, from the very beginning, the intention to hang them all in the Hogg Brothers offices in downtown Houston. The works formed, in effect, the first corporate art collection in Houston. Well-connected visitors to Houston in the 1920s sought out the Hogg Brothers Collection; while attending the 1928 Democratic National Convention in Houston, the humorist Will Rogers and Fort Worth's Amon Carter came by to see them. Carter, in fact, visited several times and, beginning in the mid-1930s, formed his own collection of works by Remington and Charles M. Russell. After 1943, visitors to Houston made a special point of seeing the collection at the museum (fig. 1), from the film director John Ford, who claimed Remington as the artistic muse of his famous Western movies, to John Wayne, the charismatic actor who starred in them. During their terms in office, two politicians who emphasized their ties to Texas—President Lyndon Johnson and Vice President George Bush—even borrowed a few Remingtons from the Hogg Brothers Collection to hang in the White House and vice president's home, respectively, finding Remington's dramatic image of the Western frontier an appropriately heroic background for performing public duties. The Hogg Brothers Collection of Remingtons continues to be among the most popular and enduring highlights of the museum today.

Despite the collection's popularity and the importance of Will Hogg, a man described in his *New York Times* obituary as Houston's "first citizen," the publication of this

The Hogg family, c. 1890. *Left to right:* Ima, William Clifford, Thomas Elisha, Governor James Stephen, Michael, and Sarah Stinson Hogg. Prints and Photographs Collection, the Center for American History, the University of Texas at Austin (CN0347)

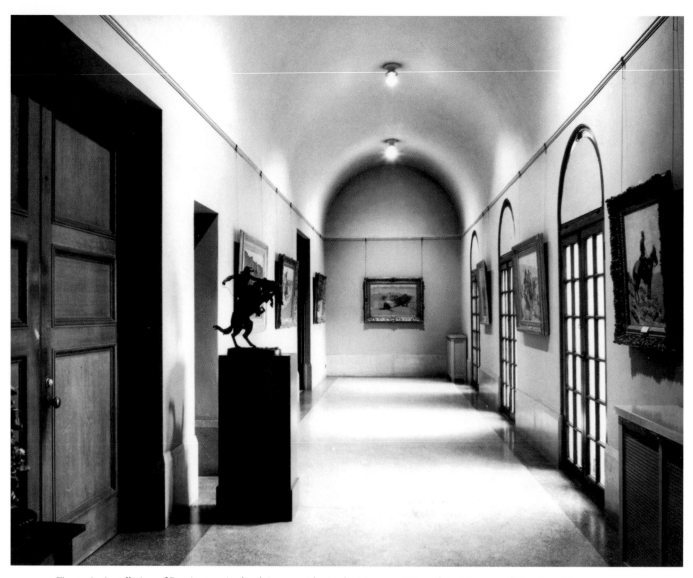

Fig. 1 An installation of Remingtons in the cloister corridor in the Montrose Wing of the Museum of Fine Arts, Houston, c. 1943

volume is the first on the subject of Will Hogg and the Hogg Brothers Collection of Remingtons.[4] The story of Will's development as the foremost collector of Remington in the early decades of the twentieth century cannot be told, however, without taking into consideration the Hogg family's important role in the evolution of cultural philanthropy in Houston, as well as the relationship between Will and Ima as they evolved into serious collectors of Americana: their activity as collectors was inextricably bound to their acute sense of responsibility to the community in which they lived. Both Will and Ima Hogg played key roles—many would argue *the* key role—in the development of cultural leadership in Houston, today the fourth-largest city in the country and, in the Hoggs' lifetime, a booming metropolis eager to match its economic success with an enlightened civic consciousness.

Will dominated the social and civic scene of Houston in the early decades of this century with a life so intensely lived it was documented with detail in the press—both locally and nationally. Dividing his time between his Park Avenue apartment in New York City and the home he shared with Ima and their brother Mike in Houston, he took frequent trips to Europe in between. He died a bachelor in 1930 at the age of fifty-five. Ima lived to the age of ninety-three. Her life has been recently documented and her memory still looms large.[5] Her achievements as the undisputed leader of Houston's philanthropic scene for many decades and her distinguished national reputation as a collector of American decorative arts and paintings virtually eclipse her brother's political and civic activities in today's popular memory.[6] Will, among his other personae, was a collector in his own right and an involved partner in Ima's collecting. It is likely, in fact, that he was the instigator of what would amount to the Hoggs' lifelong interest in preserving objects of early American material culture—a passion that would result in a major collection that, from its inception, was meant to be given to a Texas institution for future generations to learn from and enjoy. True to their plan, the Hoggs' former Houston home—a twenty-eight-room residence on Buffalo Bayou nestled in lush gardens

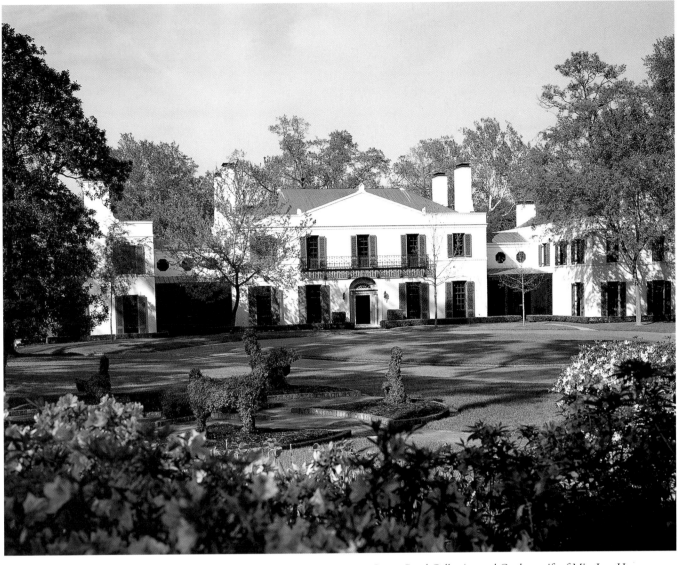

Fig. 2　South facade of Bayou Bend. The Museum of Fine Arts, Houston, Bayou Bend Collection and Gardens, gift of Miss Ima Hogg

and approached by winding roads—is now Bayou Bend Collection and Gardens, the early American decorative arts and paintings wing of the Museum of Fine Arts, Houston, and one of the nation's cultural treasures (figs. 2–4).

Beginning in 1920, Ima and her brother Will, along with a handful of important collectors and museums (all, except the Hoggs, located in the East or in the Midwest), dedicated themselves to the relatively new proposition that early American decorative arts and painting constituted important records of American culture and significant works of art in their own right. The Hoggs were a singular light in the final decades of what is termed the colonial revival, a cultural phenomenon dominating the period between the late 1870s and 1930s in which Americans took a keen interest in relics of the past as part of a broad effort to create and define national identity. In Will and Ima Hogg, the Progressive politics of their upbringing merged with colonial revival patriotism, and both traits were distilled into a utopian vision of community and kinship. They believed, and it was an idea shared by many, that

Americans could find solidarity and unity through an understanding of a collective past, a past animated by objects—furniture, silver, ceramics, textiles, paintings, sculpture, and prints. Bayou Bend is testimony to the Hoggs' belief that these objects could speak a kind of language, one that could create community, forge identity, and act as a bridge to the past. Although Will and Ima's collecting interests embraced modern European paintings, Native American objects from the Southwest, and paintings by the American landscape painter George Inness, it was Ima's dedication to American decorative arts and Will's to Remington that constituted their greatest achievements as collectors. In addition, the way in which the Hogg siblings intertwined the regional and the national represents their unique contribution to the colonial revival in American culture.

Miss Hogg summarized the Hogg family's philosophy of collecting in 1966 at the dedication ceremony for Bayou Bend Collection and Gardens: "Texas, an empire in itself, geographically and historically seems to be regarded as remote or alien to the rest of the nation. I hope in a modest

Fig. 3 Queen Anne Sitting Room, Bayou Bend

way that Bayou Bend may serve as a bridge to bring us closer to the heart of an American heritage which unites us."[7] Changed and expanded since that time, the definition of "American heritage" for the Hoggs meant, in large part, high-style furniture from the Eastern seaboard. By referring to Bayou Bend as a bridge builder to national unity, Miss Hogg signaled her understanding that the collection seemed strangely out of place in a state that had none or little of the eighteenth-century Anglo heritage represented by Newport desk and bookcases, Boston bureau tables, and Philadelphia sofas. Miss Hogg also specifically mentioned Texas and what she considered its "remote" or "alien" image nationally, a perception of which she would have been acutely aware as the daughter of one of the most celebrated governors in Texas history. Bayou Bend, she believed, would serve a unique role ("in a modest way") not only as a bridge builder between Texas and a colonial past, but literally between Texas and the rest of the nation. No matter its geographical, and what she regarded as its cultural, distance, Texas was but one piece of a larger American quilt. Both the interior of Bayou Bend—which included a room filled with Texas (and Southern) objects (fig. 4), a tribute to Texas and the Texas history of which her family was an integral part—and its

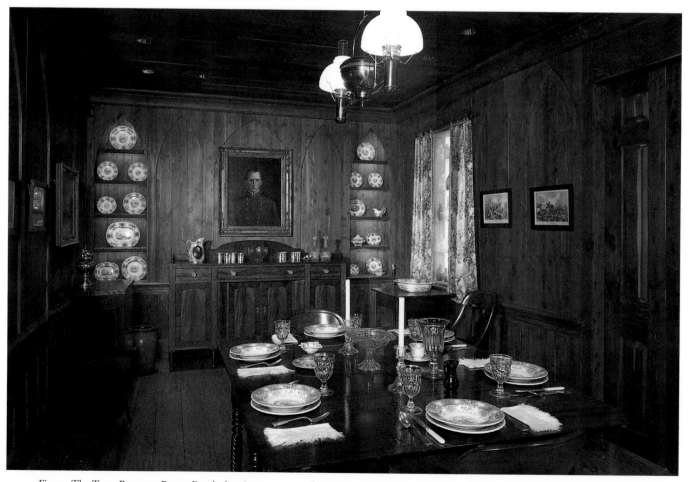

Fig. 4 The Texas Room at Bayou Bend, showing a portrait of Brig. Gen. Joseph Lewis Hogg by William Huddel (photo: Rick Gardner)

exterior, which fused "Latin" embellishments and colonial form, integrated Texas in a larger drama and provided a pedigree for a local entity.[8]

This impulse guided the underlying philosophy of an earlier Hogg display that served as Bayou Bend's model—Will's collection of Remingtons in the family offices in downtown Houston in the 1920s (figs. 18, 19, 22). Here, Will showed his growing collection of Americana—Windsor chairs, hooked rugs, clocks, looking glasses, and American glass—with artworks by Remington that inter-preted the American West as the center of a heroic national story of courage, independence, and stamina. With this thoughtfully conceived environment, Will Hogg provided himself, his family, and his employees with a powerful identity founded on local lore and traditions that were believed also to represent national characteristics. This ten-sion between regional pride and the desire to homogenize culture into something that could be called "American" is a trait Will and Ima Hogg nurtured into a lifelong commit-ment to bring Texas to the national cultural table.

His interest in art assured the success of this building. His vision was made manifest

in many beautifications of Houston. His civic consciousness has become a proud

heritage of Texas. His many virtues endeared him to its people.

LIKE HIS FATHER, JAMES STEPHEN HOGG (known as Jim), the colorful reform governor of Texas from 1891 to 1895, Will had a larger-than-life personality. He had thor-oughly absorbed his father's Progressive values, which were manifested in the governor's support of the lower and middle classes, small business, the oppressed, education, tolerance, and spreading social and cultural goods. His was also a personality filled with contradictions. He so valued his privacy that the Museum of Fine Arts, Houston, waited until three years after his death to put up a memorial

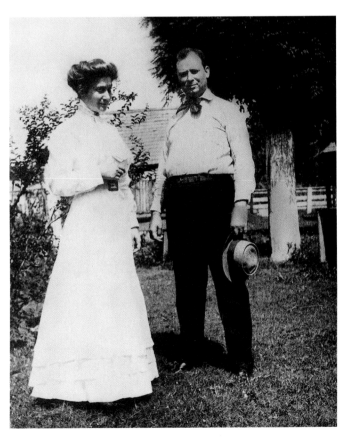

Fig. 5 Will and Ima Hogg at Varner Plantation, c. 1906

tablet in his honor: "His civic consciousness has become a proud heritage of Texas." Hogg was characterized by *Houston Post* columnist George Fuermann as one of two of the "most vital figures to the history of this city. . . . one widely known and the other, thanks to his shyness and a yearning for privacy, hardly thought of any more as a shaper of Houston. The men were Jesse H. Jones and Will C. Hogg. Will Hogg, who died in 1930, spent his 55 years covering his tracks. . . . He was a doer, a man, immense in size and incomparable in spirit."[9] Yet when called before a grand jury to testify about a neighbor of his, a widowed woman receiving "gentleman callers," he responded to the district attorney, "I don't know why she has gentlemen callers, I don't know how often they drop in, and I don't give a damn. . . . why don't you pick on somebody your size?" He then went on to give the address of his mistress and those of other prominent Houston businessmen, say-ing "go after us and leave that little widow woman alone."[10] Folklorist John Lomax, Hogg's friend and biographer, decided not to publish this story. In a letter to his editor at the *Atlantic Monthly,* however, he noted that the anec-dote "epitomized the man whom I cannot even faintly hope to describe."

When Hogg's friends and associates tried to describe him, they used adjectives and phrases that run the gamut from mercurial, blustery, and quixotic to tenderhearted and generous. Hogg was an unlikely combination of a zealous crusader battling foes with colorful language and a cosmopolite of sardonic wit and expensive taste. Photo-graphs of him also suggest his various personae: a simple, plain-speaking farmer (fig. 5) and a Lost Generation aes-thete sunbathing in chic resorts (fig. 6). He was enough of a character that two of his friends, the humorists Odd

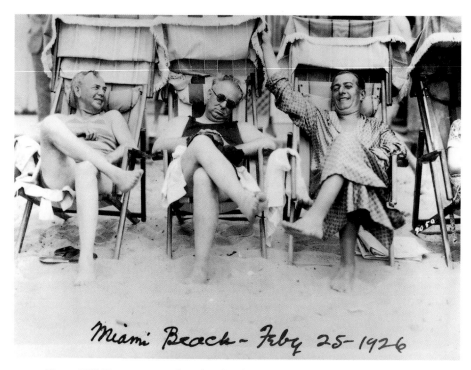

Miami Beach - Feby 25-1926

Fig. 6 Will Hogg, *center,* and unidentified friends lounging in Miami Beach, Florida, February 25, 1926. William Clifford Hogg Papers, the Center for American History, the University of Texas at Austin (CN10148)

McIntyre and Irvin Cobb, wrote about him in their nationally syndicated columns, McIntyre claiming that people "loved Bill Hogg chiefly because he was different."[11]

Hogg left incomplete records of his numerous philanthropies and talked little about his private life. As journalist Roscoe Wright wrote, using the patois of a Texas tall tale and thus reinforcing the idea that Will Hogg was a legendary as well as quintessentially Texas figure, "It's not likely anybody'll ever be knowin' the whole story of Will Hogg. It'll have to be a sort o' legend. He wasn't a man to tell things. You get a little from one man, an' a little from another, but he was such an active man you never finish gettin.'"[12] In the two published biographies of Hogg, in a series of vignettes by Lomax, and in Wright's tall tale, the authors use language and literary forms that merely hint at a larger whole, as if the largeness of Hogg's personality could only be glimpsed rather than fully comprehended. Certain patterns of behavior emerge, however, that can be attributed, in part, to his father's firebrand personality and to Will's Progressive upbringing. The spirit of progressivism inspired Hogg's political activities in the ways he identified and attacked political foes with a combative spirit and rapier wit, all the while fanning the flames with media publicity. His infamous temper even earned him the nickname William "C. for Combustible" Hogg.[13] In an early draft of the biography written for *The Handbook of Texas,* Hogg friend and historian Arthur Lefevre explained that "any sign of lack of understanding or appreciation of

a sense of ordinary obligation aroused Will's unfaultering [*sic*] and often explosive scorn. Future Texans may often be puzzled by many anecdotes about his apparent impetuosity if they fail to comprehend this truth. His innate feeling of obligation as a moral imperative intensely sustained his devoted friendships, made him ever a trusted business associate, and profoundly quickened his civic consciousness."[14]

Contemporaries characterized Hogg as a statesman of disinterested leadership and powerful oratory, saying his political speeches and letters "ranked with Cicero and Chesterfield's."[15] When Hogg felt that the state of Texas was threatened by a corrupt politician, he printed circulars at his own expense and delivered stump speeches throughout the state, calling his foe a "dirt-dauber of discord . . . the very promoter of a shameful system of public administration for private profit."[16] On another occasion Hogg wrote a letter to a governor who was about to endorse a candidate for president whom Hogg believed had questionable business practices. In this letter, Hogg claimed that the offender made a series of "monthly peculations . . . a consistent and calculating career of mendacity which would belittle even Jesse James, who was romantic enough to ride a horse."[17] Hogg's leadership in political matters caused widespread speculation, recorded in papers throughout the state, that Hogg himself was poised for the governorship in 1913 and again in 1917. Responding to the reports with characteristic Progressive bravado, Will stated, "I'm not running for office and I never will. I won't wear a ball and

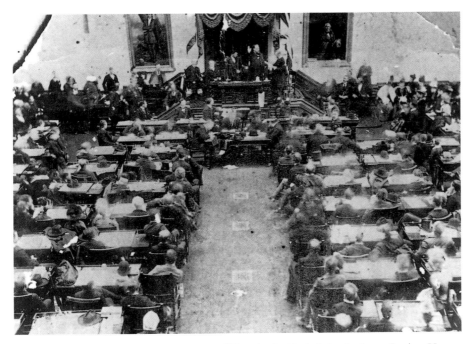

Fig. 7 Jim Hogg's swearing-in as governor of Texas in the Capitol, Austin. James Stephen Hogg
Papers, the Center for American History, the University of Texas at Austin (CN04122)

chain on my leg while I am fighting those coyotes who are
befouling the name of the State of Texas. I'd rather be a
rock-throwing private soldier with a free voice than be the
mouthpiece of an organization that would tell me when to
talk and what to say."[18] Hogg's critics portrayed him as a
disruptive "savage," noting that "when he swears a vendetta
he paints the skull and cross bones on his shield, smears
blood on the moon, and goes out head-hunting. And noth-
ing but the real trophies will do."[19]

Will Hogg was no stranger to the tough talk and inflated
rhetoric of Texas politics. His grandfather, Joseph Lewis
Hogg, a planter-lawyer from Georgia by way of Alabama
who had moved to East Texas in 1839 with his wife, served
as state senator after Texas was annexed to the United
States.[20] Will's father, Jim Hogg, served as county attorney
in 1878, district attorney in 1880, and attorney general of
Texas in 1887. In 1891, Jim Hogg began the first of two
terms as governor of Texas, serving until 1895. His rise to
political power had been swift, decisive, and shaped by his
early years of hardship. In 1862, when he was eleven years
old, his father, Joseph Hogg, then a brigadier general in
the Confederate Army, died of dysentery, and his mother
died one year later. His experiences during the crippling
aftermath of the Civil War and the difficult reconstruction
of the South determined his future course of action. Jim
Hogg first embarked on a career in newspaper publishing,
which provided him with an excellent political education
as well as an awareness of the power of the media to dis-
seminate views widely and to reach a consensus on issues,
a handy lesson for this future governor, and one that later

would not be lost on his eldest son, Will.[21] Concurrent
with his journalism career, Jim Hogg studied law, passed
the bar, and, in 1873, was elected justice of the peace in
Quitman, beginning a career in public service that would
last more than twenty years. With a stable and promising
career ahead of him, Hogg successfully courted Sarah
Ann (Sallie) Stinson, the daughter of a wealthy mill
owner in Mineola, and one year later, William Clifford
Hogg (1875–1930) was born, followed by Ima (1882–1975),
Michael (1885–1941) and Thomas Elisha (1887–1949) (see p. 2).

Jim Hogg proved an able statesman at a time when
Texas—and, indeed, the entire South—was making the
painful transition from a rural to an urban culture. Texas
had a one-crop economy—cotton—and that fact, com-
bined with the lingering effects of Reconstruction, created
a peasantry in which the freehold farmer was impover-
ished and disenfranchised.[22] Enter Hogg, a native Texan,
a champion of commoners, small merchants, ranchers,
and farmers, and a politician who soared to victory by
painting big business and corporations as the enemy. The
wave of anti–big business sentiment in which Governor
Hogg participated existed nationwide, but its effect on
a state rendered especially vulnerable by its economic
conditions put Texas in the forefront of the Progressive
movement, with Jim Hogg as its leading promoter. Whether
celebrated as a representative of the "plain people" or
vilified as a demagogue, Hogg was certainly among Texas's
most influential governors, a political leader who deter-
mined the course of Texas politics at a critical time in its
history (fig. 7).

Under Hogg's Progressive reform leadership as attorney general, Texas became the second state to pass a usable antitrust statute. As governor, he created an effective railroad commission to regulate what had been a thoroughly corrupt industry and also initiated other sweeping reforms.[23] A large man, both in stature and in personality, flamboyant, earthy in his humor, Jim Hogg has been characterized as a "stump man." As if to describe a gladiator fighting in a bloodthirsty coliseum, not for sport but for political power, Texas historian T. R. Ferenbach noted that Hogg "could hold a crowd of Texas farmers for hours, blasting railroads, bloated capitalists, insurance companies, gold; he extolled the simple life and the virtues of the men who tilled the soil. He threw off his coat and worked up sweats; he dropped his suspenders and splashed water over his brow, got his second wind, and went on to new heights amid cheers."[24] In this portrait of words, Hogg represents the many facets of the Progressive movement—an essentially conservative turn-of-the-century crusade to correct the uglier side effects of industrialization, urbanization, and ethnic anxieties.[25]

Hogg demonstrated courage and political savvy in his various crusades. Like other Progressive politicians, he recognized the symbolic, but no less real, importance of grand gestures, even going so far as to launch a campaign to extradite Standard Oil founder John D. Rockefeller to Texas to stand trial for violating the state's antitrust act.[26] Of the many legacies Hogg left to his son Will, one was his crusading spirit—the courage and determination to bring down the oppressor in whatever cause or value he championed. Hogg demonstrated to his children the importance of teaching by example, of making a politically astute beau geste with decisiveness and flourish. Nowhere is this attitude more apparent than in Jim Hogg's instructions for his burial. In 1906, on the night before he died, he asked for a simple tribute rather than a stone monument: "Let my children plant at the head of my grave a pecan tree and at my feet an old-fashioned walnut tree. And when these trees shall bear, let the pecans and the walnuts be given out to the plain people so that they may plant them and make Texas a land of trees."[27]

After a lifetime of large acts, this final one was quintessential Hogg, as nuanced as Miss Hogg's modest dedicatory statement for Bayou Bend. Hogg's burial instructions reflected his lifelong commitment to representing the "plain people," the lower- and middle-class farmers and small businessmen who feared the incorporation of America and who had put their faith in him to preserve their way of life. Hogg's democratic request also had biblical overtones: to distribute the fruits to the citizens of the state for

replanting, an ethos that eschewed hoarding and instead encouraged the virtues of transplanting as promoted by the biblical parable of the talents. Hogg's instructions also embraced the art of horticulture, which he developed to its greatest extent at the family country home, Varner Plantation, in West Columbia, approximately thirty miles south of Houston.[28] In Jim Hogg's instructions lay the keys to his life: his children (who would plant the trees), the people he represented (who would, in turn, plant the seeds of the trees), and Texas (which would thrive and improve through husbandry). Folksy and perhaps contrived to modern eyes, Jim Hogg nonetheless made in one stroke a life-defining gesture. The act itself, as well as its meaning, provided his children with a blueprint for life. In Houston, Ima and Will exercised his legacy in the cultural and civic realm, stepping up their activities when they became "oil rich" in the late 1910s. Among the very few major cultural philanthropists in Houston backed by a combination of new wealth and a strong background in politics, Will and Ima Hogg initiated sweeping changes, employing motives and methods characteristic of their father, that altered the cultural and civic landscape of their community.[29]

While Will Hogg's developed sense of moral obligation and responsibility were inspired by his father's example, they were also rooted in his early home life. Seven years separated Will from Ima, the second child, and twelve from Tom, the youngest. This wide gap in ages likely prompted Will's lifelong role of part sibling and part father figure to the other Hogg children and, after the deaths of their parents, of paterfamilias. Will portrayed himself in early family letters as a studious young man plagued by feelings of loneliness that could only have been exacerbated by the firsthand experience of his mother's declining health.

Only months before she died, Sallie Hogg wrote her father that "Willie and Ima are well and sweet to Mama. Willie shows me the tenderest care."[30] In a letter Will wrote to his mother after she left Austin to rest at her parents' home in East Texas, his sensitive nature, his sadness and despair as he watched his mother die of tuberculosis is painfully clear: "Dear Mother, You are gone—so has the larger part of myself. . . . Be calm and content; everything else will seem so. The color of the lens [sic]—the imagination—is a powerful engine of force in our lives. Try and be light-hearted. . . . Don't use smoked-glass or a prism, but look at the world with a piece of window pane. Should I not get to work, intensest lonliness woud [sic] steal my soul; melancholy and dyspepsia cross my disposition."[31] The letter, written when Will was twenty years old, reveals a considerable depth of character, particularly at such a

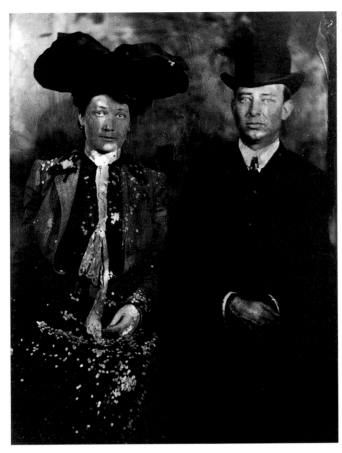

Fig. 8 Will and Ima Hogg at Coney Island, New York, 1902.
Ima Hogg Papers, the Center for American History,
the University of Texas at Austin (CN09844)

young age. His remarks may be construed as a letter of advice more to himself perhaps than to his mother: to face squarely the reality of his mother's dying condition and to fight his despair by absorbing himself in his studies. But the letter reveals larger secrets; the ethics of frankness and honesty concerning all aspects of life, work as a means of staving off melancholy, and an imaginative vision as a machine for progress recur thematically throughout Will's adult life.

Sallie Hogg died in September 1895 when Will was twenty and Ima only thirteen. Until his death, Jim Hogg made it his business to provide stability—financial and otherwise—for his children.[32] Hogg soon tried to reconstruct the happy home life of their recent past, buying in 1896 a two-and-a-half-story house at Nineteenth Street and Rio Grande, enlivening it with the usual flurry of pets, including the family ostriches, Jack and Jill. He established the law firm Hogg and Robertson. Will studied law at the University of Texas while Ima and the boys continued life under the supervision of Jim's older sister Martha (called Aunt Fannie). When Aunt Fannie left a couple of years later, Ima found herself, at the age of sixteen, bearing the responsibility of running the house, helping to supervise Mike and Tom, and attending political events as her father's companion and helpmate.[33]

If Ima balked at her new responsibilities, there is no evidence to support it; in fact, she appears to have risen to the occasion and relished her new role. Neither did she tire of the constant letters of advice from family, all of whom, in their own way, expressed their concern for a young, unmarried, and motherless woman. According to prevailing Victorian conventions about the prescribed role of women in the home, Will advised Ima to "cultivate your good qualities of mind and heart that you may be fitter for life. And above all—do not forget your duty to father and the boys. You are the bond that ties the family together in a home—they look to you for sunshine and love of the softening kind—so you must give freely of your heart to them."[34] Ima accommodated these prejudices about her sex as she clung to her own aspirations. In an era of rising attempts at independence by women, and because she was a modern woman of more than average talent and means, she also determined to pursue her studies as a concert pianist. After attending the University of Texas from 1899 to 1901, Ima departed for the National Conservatory of Music in New York City, followed by a three-year stint studying in Berlin beginning in 1907 (fig. 8).

While the younger boys attended a military boarding school, Will, having received his law degree, moved to San Antonio in 1897 to establish a law practice. Initially hopeful of his prospects, Will boasted to Ima, "A painter is nearly finishing a sign on a certain bay window of an office in San Antonio and that sign spells: 'Law Office, Will C. Hogg.' Neat, simple, plain and unassuming it bespeaks the qualities looked for and wished-for in everything and everybody and above all in himself, by the owner thereof."[35] Will, however, was unhappy in San Antonio, feeling lonely and at loose ends without his family. He soon returned to Austin to join his father's firm, now styled Hogg, Robertson, and Hogg. He yearned for the days when the family had been together, and wrote to Ima, then studying music in New York City, "I am now a resident of Austin, and, candidly, not enthusiastically inclined in any direction. With father [constantly traveling on business], yourself and the boys away, I feel more of a homeless vagrant than I did in San Antonio."[36] In his domineering way, he made his intentions clear to Ima when he remarked on her student tenure in New York: "At the end of that time you will be a full-grown woman and amply fitted to return here to make a home for him (father) (and me too . . .)."[37] Will wrote more plaintively about the importance of the home than the other Hogg children, but the value appears to have been shared. It seems there was no doubt among them that the Hogg family would be living under the same roof again, not in Austin but, permanently, at Varner and in Houston.

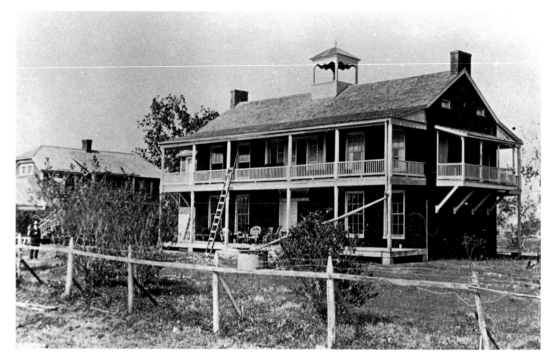

Fig. 9 Varner Plantation before the 1919 refurbishment (photo: courtesy of Varner-Hogg Plantation State Historical Park)

The discovery of vast oil reserves in East Texas prompted the Hogg family to move away from Austin. As a lawyer in the private sector, Jim Hogg redirected his interests when Spindletop, near Beaumont, erupted in 1901 and began producing 75,000 barrels of oil a day. Spindletop was a magnet for oil speculators, and around 1901, Hogg and his friend James Swayne of Fort Worth formed the Hogg-Swayne Syndicate, a group of aggressive lawyers who bought and sold drilling leases near the edge of the mound.[38] After unsuccessful efforts to capitalize their business, they invited Joseph S. Cullinan, formerly of Standard Oil (and, more recently, a successful oil producer in Corsicana), and Walter B. Sharp, an industrialist, to move their interests from Corsicana to the Spindletop mound and manage their operations. In 1902, they merged to form the Texas Company, known as Texaco after 1906.[39] Hogg also speculated in other Texas real estate for the purpose of drilling. In 1899, he and his law partner, Judge James H. Robertson, purchased the Gaines Plantation in West Columbia, and in 1901, Hogg expanded the property through the purchase of the Patton Place, 4,100 acres of the Martin Varner and Josiah H. Bell Leagues, contiguous to the Gaines Plantation, and later renamed Varner Plantation (fig. 9). Hogg hoped to attract drillers to the West Columbia property but had little luck. It was more than a decade after his death before the land made the Hogg children "oil rich."

Although Varner did not produce oil during the governor's lifetime, it did not lie dormant. Varner represented to the former governor a lifelong dream to "have a great, big, *Country home*. . . . Then we'll all have a happy time in

family circles."[40] After a political career of championing the "plain people," Jim Hogg had decided to become one, transforming the large sugar plantation Varner once had been into a model of Progressive farming marked by efficiency and agricultural improvements.[41] Jim wanted to live closer to Varner but not too far from the center of the oil industry, so he chose Houston, a city rapidly transforming into the petroleum capital of Texas. Will wrote to Mike, "While I do not like the climate here, Houston *is* the *growing* city of Texas and father should do well here."[42] In late 1904, Jim Hogg dissolved his Austin law practice and formed another partnership in Houston. After he was severely injured in a train collision on one of his many trips between Houston and West Columbia, Jim spent his remaining days at Varner with Ima and Will. There he shared with Will his hopes for the future, including the idea of starting a forum for promoting higher education in Texas. Will commented later, "Until that six months I spent talking with my father, I had really never known him, I had just taken him for granted. Then, for the first time, I understood why he had always espoused the cause of the common people, the need of battling for the weak against the strong, the necessity of free education for all, if a democracy is to survive. So I came to love more deeply this plantation, this farmhouse, and my father. Whatever little good I may do, whatever ideas may be found behind any action of mine, whatever has given my life any worth or dignity, all are due to him."[43]

The six months Will spent with his father at Varner kindled Will Hogg's civic-mindedness, specifically, a life-

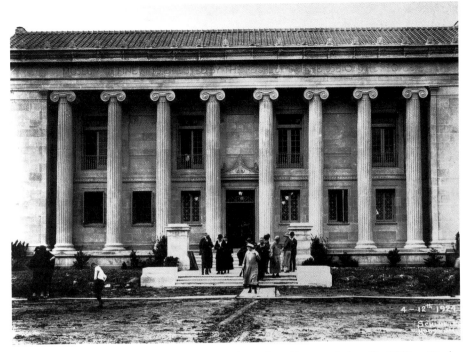

Fig. 10 The original building of the Museum of Fine Arts, Houston, designed by William Ward
Watkin with Ralph Adams Cram, consulting architect, on opening day, April 12, 1924
(photo: Frank J. Schleuter, courtesy of the Woodson Research Center, Rice University)

long commitment to higher education; in fact, Will Hogg's civic contributions began and ended with that one issue, especially but not exclusively as it related to the University of Texas. Taking a tip from his father, he founded in 1911 the Organization Looking to Enlargement and Extension by the State of the University Plan of Higher Education in Texas (renamed, mercifully, the Hogg Organization and run by colorful Texas folklorist Roy Bedichek), a consciousness-raising organization that argued that higher education for all was in the state's best interest.[44] Later, when Hogg's financial resources grew exponentially, he made personal financial commitments as well, covering the University of Texas tuition bill for one hundred World War I veterans and instructing Bedichek to take care of the expense for any student in need and bill him directly. He added only one stipulation: "if they ever know where the money comes from, I'll never send you another blankety-blank cent."[45] One may measure his commitment to education by the fact that Hogg left the bulk of his more than three-million-dollar estate to educational institutions in Texas, including the University of Texas, Rice University, and Prairie View A&M University.[46]

After education, Will Hogg's greatest passion was urban planning; he loved cities. Hogg, in fact, played Cities, an urban-planning game he and his friends devised during long business trips by train in which each would itemize the finer and the lesser points of various cities, such as their architecture and their cultural, educational, and social institutions.[47] When he reluctantly moved to Houston with

his father in 1904, little did he know that he would become a major player in a real Cities "game." Philanthropic organizations identified with Will included the Emma Newsboys Home, the YMCA and YWCA, the Girl Scouts and Boy Scouts, and the Community Chest. Of Hogg's civic crusades involving Houston's cultural life, the most important included raising funds, in just a few weeks in 1924, to complete the first building for the Museum of Fine Arts, Houston (fig. 10). Hogg recognized the important role that cultural institutions played in the prosperity and growth of the city—and, clearly, the Houston museum needed his brand of help: after the founding of the museum in 1900, it took more than twenty years to build a structure for it. When Will Hogg, who was not a museum trustee, voluntarily "stepped into the breach" in 1924, as James Chillman, Jr., phrased it, he was fighting what looked like a losing battle: to build for Houston its first art museum and, indeed, the first building specifically designated a museum in the state of Texas.[48]

The museum originally began in 1900 under the auspices of the Houston Public School Art League, founded by a group of five women who, guided by Progressive movement ideals about education, believed art should serve a fundamental role in the education of children.[49] From this volunteer effort to place copies of art in the public schools, the organization grew and evolved into the Houston Art League in 1913, which became the guiding force behind the movement to build a museum. At the time, Houston's art activities, significant as they were, lagged far behind those

offered in Dallas and Fort Worth, the latter well on its way toward establishing a center for high-quality art collections. Houston's lack of exhibition space hindered its efforts, as Houston Art League member Fannie Volck remarked in a letter to Elizabeth Scheuber, one of the stalwarts of the Fort Worth Art Association: "You know we are handicapped in not having a home. Every year . . . there is a despairing search for temporary quarters."[50] Artworks, by default, were displayed in the city offices, in the offices of its league members (such as in the Scanlan Building, offered by league member Kate Scanlan), or in the University Club.

In 1919, the museum received its first major gift, the large collection of paintings bequeathed by George M. Dickson.[51] Yet it still lacked a permanent home. After years of negotiations, and with the help of Joseph S. Cullinan, the estate of George Hermann donated a site, dedicated in 1917, but included a stipulation that the league had ten years to build a museum building costing at least $20,000 or the gift would be revoked.[52] The discouraged Julia Ideson, Houston's most distinguished librarian, wrote to Scheuber in 1919, "The Houston Museum can hardly be said to exist, nevertheless I suppose it might as well be left in the directory [American Association of Museums]."[53] Ironically, once the Houston museum had a building, the tables would turn. After New York's Grand Central Art Galleries held a successful exhibition at the museum (a show celebrating the completion of the museum's wings in 1926), the organizer wrote Mrs. Scheuber, "Why can't we approximate this [Houston's success] in Fort Worth?"[54]

Part of the reason may be that artistic development in Fort Worth in its early years rested almost wholly on the extraordinary efforts of one woman, Mrs. Scheuber, while in Houston it derived from a team whose influence reached different groups of people. Perhaps more important, the Houston museum's close relationship with Rice Institute (now Rice University) ensured that the growth of the museum would be both tempered and shaped by the academic influence of Rice, offering a type of relationship no other museum in the state could claim. Rice was so integral to the museum's struggling identity that when Will Hogg decided to raise funds for the museum, many of his appeals for funds were made on the basis of a donor's affiliation with Rice. The university itself, ably led by its first president, Edgar Odell Lovett, served as an institutional model of high standards: its Byzantine-influenced Mediterranean architecture, designed by the Boston architect Ralph Adams Cram, provided a model for graceful and harmonious urban planning; its head of the art history department, James Chillman, Jr., also served as the museum's first director, while other university professors lent their support by lead-

ing or serving on the board; the dean of the architecture school, William Ward Watkin, served as the museum's first architect; and William Marsh Rice himself provided the museum with an extraordinary model of philanthropy— he had bequeathed his entire fortune to found the college. The participation of those affiliated with Rice was joined with a large network of individuals who were already involved: businessmen in banking, law, timber, oil, paint and hardware, department stores, residential development; doctors; civic-minded women, including artists such as Emma Richardson Cherry and suffragettes such as Annette Finnegan; and religious leaders such as Henry Barnston, the cultured rabbi of Congregation Beth Israel who came to Houston in 1900 and helped found the Houston Public School Art League, as well as the Houston Symphony, with his friend Ima Hogg.

When William Ward Watkin submitted plans for the first phase of the museum building—the severe Greek neoclassical central structure and part of the flanking wings—the sum of $200,000 was budgeted and a fund drive was initiated in the spring of 1922. Because only $80,000 was secured (including funds from Will, Ima, and Mike) in this campaign, the following fall Watkin modified his plans to focus on the central block alone, reducing the budget to $115,000. Construction and fund-raising simultaneously lurched forward. By the winter of 1923–24, however, less than $100,000 had been raised, and it appeared that even the central block would not be completed. With only two years left on the agreement with the Hermann estate, the future looked bleak indeed. It was at this point that Will Hogg embarked on a fundraising crusade to go on, as he put it, a "gumshoe campaign, highjacking my friends," and asking them to enter their names in his notorious "blue book" of pledges.[55] As A. C. Ford, president of the museum from 1925 to 1930, observed, "What he did was unusual. I know of no precedent anywhere for it. . . . I know of no institution so indebted for its existence to the vision, the generosity, and the zeal of one man."[56]

Hogg, however, had supported the Houston museum long before 1924. According to his diaries, Will expressed interest in the museum as early as February 1918, when his diary notes that he and Mrs. Joseph Mullen discussed art league matters. In 1923, he pledged $5,000, while Ima and Mike pledged $2,500 each, making the Hogg family contribution to the museum the largest. Hogg office memoranda show that he was making inquiries about the progress of the new building in September 1923.[57] In 1924, after receiving a letter, possibly requesting a second donation, that modestly stated "too much or little, or nothing,

Fig. 11 Design by William Ward Watkin for William Clifford Hogg's memorial plaque at the Museum of Fine Arts, Houston, c. 1932

and I'll still believe that you are the dearest, if not the nearest friend, that we who are working for a better Houston has on the list," Hogg called on J. T. Scott, the museum's treasurer, to ask what would be needed to complete not only the main building but also to support the addition of the two wings.[58] As was typical of Hogg, he believed the art league was not ambitious enough and should, instead, return to the original plan of including the central block and the flanking wings.

Hogg was not a native Houstonian, nor were the museum's other generous supporters, such as the Cullinans, Claytons, and Blaffers. And none of them, with the possible exception of the Claytons, had made their fortunes in Houston, a fact that Hogg spinned to aid his strategic campaign. Between March 24 and April 11, 1924, Hogg, who represented himself as "an humble agent of a Committee," made a flurry of personal visits, sent numerous letters and telegrams, and arranged meetings throughout the day and evening.[59] The character of his appeals, some quite relentless, tells much about the history of philanthropy in Houston at the time. For example, Capt. James Baker turned down Hogg's plea for funds on April 2, 1924, but Hogg was not deterred, writing a two-page letter the very next day outlining the reasons that should compel him to subscribe. Ultimately successful in his plea, Hogg played every card he had, drawing on the importance and prominence of the Baker family in the community, and saluting the promise of his family in the future through his two sons (Hogg was prophetic; Baker's grandson, James A. Baker, would serve as secretary of state during George Bush's administration). Hogg added that the art museum was a "potent adjunct to *Rice's* development," invoking Baker's connection with Rice; as attorney to the Rice estate, Baker

had saved William Marsh Rice's fortune—designated to found the university—from Rice's valet who, with a crooked attorney, had murdered Rice and forged a will written to their advantage.[60]

With a relatively small group of prospective donors and a large number of charities to support in Houston, quid pro quos were as inevitable then as they are today. Hogg's solicitations included discussions of reciprocity and tallying, some of which could be described as testy and heated.[61] In all this, Hogg retained his great sense of humor, promising one prospect, for example, that in turn for a pledge, he would "agree to try and quit cussing altogether much less in your presence."[62] This potential donor declined, and his name was added to one of Hogg's organizational lists titled "Already Subscribed but Not Enough."[63] When the campaign closed, Hogg had secured thirty-two subscribers and raised nearly $150,000 in three weeks, more than double what had been raised over the course of two years. He personally contributed the largest amount and, in addition, underwrote several subscriptions for donors who could not meet payment deadlines.[64]

Hogg went on to raise about $20,000 more in 1925 to complete the additional wings and furnish the building, never once taking credit for his accomplishments or attending celebratory announcements of the campaign's success. Instead, he matter-of-factly fulfilled his obligations and then retreated to the pleasures of Europe. Only after he died (when he was not alive to voice his objections) did the museum erect a memorial tribute to Hogg, a marble tablet hung inside Lovett Gallery, adjoining the museum's original entrance. Instead of classical embellishments, stylized magnolia and crepe myrtle—indigenous plants Hogg admired and helped to make a typical feature of Houston's landscape—provided decoration for the tribute (fig. 11). The inscription read, "His interest in art assured the success of this building. His vision was made manifest in many beautifications of Houston. His civic consciousness has become a proud heritage of Texas. His many virtues endeared him to its people." The greatest memorial for him, however, would have been the private letter from a business associate he received while traveling abroad, congratulating him on the success of the building and the 1926 Grand Central Art Galleries exhibition. The letter described the opening-day crowds, the children, the "long-suffering husbands" who unexpectedly enjoyed themselves, farmers and city folk, the "be-spectacled Confederate veteran who wears his medal only on gala occasions, and the solid citizenry of a business and industrial center which ranges all the way from petty merchant to the malefactor of great wealth." He assured Hogg that there was "no hushed mys-

tery about an art museum for them," no "sanctimonious 'museum manner,'" and finally, "No doubt about it—the Houston Museum of Fine Arts is not even a distant relative of a mausoleum. It is a living and popular and useful part of the city's equipment."[65] These are exactly the kind of words that Will Hogg would have wanted to hear about the museum: its democratic spirit (although Jim Crow laws still governed the city, Hogg encouraged the museum to open its doors to the African-American community once a month, a policy it adopted), its liveliness as a public, communal space, and its importance as an integral part of the city's fabric.[66]

I tried to fix up the old place as George Washington would do if he had a bank roll.

THE REFURBISHMENT OF VARNER PLANTATION, which Will Hogg described as an effort "to fix up the old place as George Washington would do if he had a bank roll," was the Hoggs' first colonial revival project and the occasion for their first foray into collecting American art and antiques.[67] For Hogg, it was one among many efforts to build a family community: the Hoggs' home at 4410 Rossmoyne in Montrose; an abandoned project in Shadyside near the museum; the Armor Building in downtown Houston, which included the Hogg Brothers offices; his suite of Park Avenue apartments in New York City; and, finally, Bayou Bend in River Oaks, the garden suburb Hogg helped create—all of which, with the exception of Shadyside, were completed in a little over a decade. From 1916 until 1928, when Will, Ima, and Mike moved into Bayou Bend, their new home on Lazy Lane, all were involved, to one degree or another, in some sort of building campaign, and Will was the driving force behind each one.[68]

The Hogg family had lived in Houston for almost five years before Will made the commitment to stay. In 1909, Will wrote his youngest brother, Tom, "As I wrote Mike the other day,—I am contemplating establishing a home in Houston for you and him, Sister and myself. She is all we have left to tie us together, and we owe it to her to fix her up just as happily as possible."[69] Creating and nurturing home life clearly was one of Hogg's life missions. Hogg's passion for the home was both a condition of his upbringing and an inherent feature of his personality. As his letter to his brother Tom reveals, he felt responsible not only for the family's financial stability but also for establishing a home as a means of generating the warm family circles his father dreamed about before buying Varner Plantation. Hogg's zeal for nurturing home life can be understood also as encompassing more generally the spirit of Progressivism and colonial revival patriotism. Although not a new idea, Progressives advanced the concept that if the environment shaped the individual, then improving one's domestic conditions and surroundings ultimately had a beneficial moral effect on society.[70] Hogg's constant references to home in his letters and in the building campaigns that he would undertake indicate a larger concern for the home as the locus of Progressive values—the virtue of home life as an escape from the modern world, and the house as a model of efficient, practical, and simple design celebrated, in large part, by the wildly popular architectural style of the bungalow.[71] In addition to the rhetoric of an idealized home life, Progressivism participated in the wave of nationalism that swelled in the early decades of the century. Foreign threats from abroad as well as immigrant ethnic tensions at home sparked fears that a homogeneous American culture was breaking apart. Nationalism, with its uglier side—nativism, jingoism, and xenophobia— was a part of the cultural fabric of the time. The colonial revival, which predated Progressive politics, fed these fears through the assertion of a shared colonial past that was either discovered and celebrated or outright invented.[72]

Using several visual cues—freely interpreted Georgian architecture, white exteriors and interiors, wood floors, braided or hooked area rugs, fireplaces around which a cozy group of antique or reproduction furniture could be placed, paneling, and built-in corner cupboards or bookcases for the display of antiques—colonial revival homes could provide instant historical associations with a purer, seemingly uncomplicated past. Many of these interior decorations, although historically incorrect, pervaded home design and were popularized by the photographs of Wallace Nutting, an early antiquarian who photographed imagined "colonial arrangements" and published them in his influential books on early American antiques.[73] The Hoggs not only studied Nutting's volumes on American furniture, their earliest efforts at creating "American" spaces were inspired by them. More than merely a fashion or trend, colonial revivalism satisfied a deep-felt cultural need for asserting a distinguished history based on democratic principles and of stability, purity, and plainness. Thus, while Will Hogg's passion for acquiring eighteenth- and early-nineteenth-century Americana—particularly banjo clocks (fig. 12), Windsor chairs, and American glass—and his dedication to Remington's art are admittedly eclectic interests, his collecting pursuits were actually

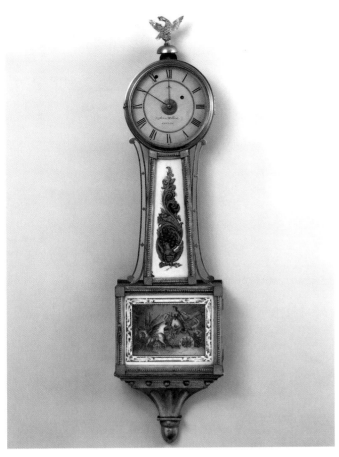

Fig. 12 Shop of Aaron Willard, Sr., or Aaron Willard, Jr., wall clock, c. 1802–30. Gilded eastern white pine, basswood, mahogany, black cherry, 40 x 10 1/4 x 3 7/8 in. (101.6 x 26 x 9.8 cm). The Museum of Fine Arts, Houston, the Bayou Bend Collection, gift of Alice C. Simkins (B.79.290)

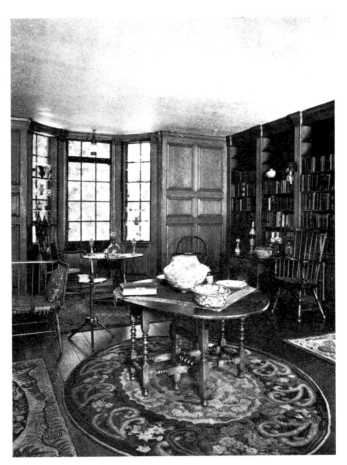

Fig. 13 The library at Bayou Bend (now known as the Pine Room) as it was illustrated in *House and Garden* in March 1931, displaying Native American pottery, American glass, Windsor furniture, and hooked rugs (some of which originally furnished the Hogg Brothers offices)

connected to a politically charged environment of colonial revival patriotism. Collecting both early Americana and Remington's work made sense to Will because these art forms celebrated a nostalgic notion of a better American past and claimed a unique American identity based on simplicity, ingenuity, and efficiency. In both Windsor furniture and Remington paintings, Will also found a certain image of hardiness and masculinity. Furthermore, by collecting Remingtons, Hogg inserted regional lore into a national drama, adding the mythical West to the colonial revival mix. And, taking into consideration Ima Hogg's collecting of Native American objects, which some contemporaries believed to be the only true artistic expression of "American," the Hoggs brought new meaning to the colonial revival impulse (fig. 13).

The Hoggs' embrace of the colonial revival was first explored at Varner Plantation. The refurbishment of Varner began in 1916, ten years after Jim Hogg's death in 1906, during which the property languished. Jim Hogg had firmly believed in the potential of oil reserves in his investment and instructed his children not to sell their property until fifteen years after his death, an echo of his own legislation that lands should not be held by corporations

for purposes of speculation for more than fifteen years.[74] Varner, however, had been much more than a speculative investment to Jim: it represented home. As if to reclaim his ancestral Southern roots, Jim Hogg lived the life of a gentleman-farmer, a modern-day version of what his father had been before the Civil War and an echo of George Washington who, after years of public service, wished for nothing more than to retire to his quiet life of farming at Mount Vernon, a symbolic move that Washington in turn had modeled on the ancient Roman historical figure of Cincinnatus.

After his father's death, Will initially intended to close Varner down. In time, Will renewed his interest in the place, particularly after oil reserves were discovered on the property. In 1913, when control of Texaco fell into New York rather than Texas hands, Joseph S. Cullinan and Will Hogg, then a director, resigned. They joined Judge James Autry to form the Farmers Petroleum Company (later named American Republics), buying oil leases in the Humble field and reopening and drilling in the most productive salt dome in the state. Farmers Petroleum provided substantial dividends, and during World War I when oil prices shot upward, dividends were especially lucrative and helped

Fig. 14 Varner Plantation after refurbishment, c. 1919. William Clifford Hogg Papers, the Center for American History, the University of Texas at Austin (CN10147)

to secure the Hogg future.[75] It was during the war, in fact, that Will Hogg made plans to refurbish Varner, soliciting help from his siblings, except for Mike, who was in the army. Will believed that Varner would make an excellent venue for weekend entertaining and commissioned Houston architect and classmate Birdsall P. Briscoe to draft plans for a major renovation.

Briscoe's plans were not carried out until 1919, after the discovery of oil at Varner. Oil began to gush at Varner beginning in January 1918, and by 1920 one of the many wells drilled on the property was producing close to one million barrels of oil a month. The West Columbia field, as it became known, ranked among the major oil fields in the state, allowing Will Hogg to develop a vast network of investments in cotton, oil, and real estate as well as in industry and the entertainment business. In June 1920 Will reported to Ima with his characteristic good humor, "The oil production continues to hold up very well there, and I think your share of that income, properly invested, will be sufficient to support you comfortably, and perhaps luxuriously, the rest of your days, whether Capt. Mike or I have a cent or not."[76]

When Will Hogg initially commenced his work on Varner, he launched the first of many expeditions to acquire some antiques. His diary entries for March 1916 reveal that he bought "copper and pewter stuff" for Varner, and that same spring he and Ima traveled to New Orleans and visited antique shops together. In those early days of refurbishing Varner, and shortly thereafter in the spring of 1917, when they moved into their Houston home on Rossmoyne, Will and Ima developed their taste for collecting as well as a playful relationship of goading, teasing, and one-upmanship in their quest for old things. For example, in

a letter from Will (in which he refers to himself by one of many family pet names, "Podsnapper") to Ima (in which he addresses her as "Miss Titewadd"), he wrote, "Your mirror letter came this forenoon and I went direct to the Little Shop with a mental condition favorable to the purchase of the Jumel mirror—without haggle or delay. Sold. Sold this very forenoon to an early shopper by the name of Mrs. Jaeger, of comforting underwear fame."[77] It is Varner that nurtured Ima and Will's early passion for collecting antiques, a pastime that would develop as their fortunes increased and as Will continued to add building projects—all of which required furnishing—to his energetic activities.

When finally carried out in 1919, Birdsall Briscoe's plans for the remodeling of Varner were extensively modified. In a burst of colonial revival patriotism, Will Hogg and Briscoe adopted a radical plan that amounted to a complete erasure of Varner's antebellum past and an assertion of a colonial heritage that never existed (figs. 9, 14). The interior spaces of Varner remained virtually intact, but the exterior underwent a complete makeover as it was restuccoed, painted dove gray, and decorated with neoclassical embellishments.[78] Varner's architecture was echoed in the design of the parti as well as the general arrangement of spaces at Bayou Bend, the Hoggs' home in River Oaks designed by John Staub and Briscoe beginning in 1926 (see fig. 2), despite Staub's claim that the 1803 Baltimore house known as Homewood served as his inspiration.[79]

The explanation as to why Will Hogg would want a sham Anglo-colonial heritage for the exterior of Varner has more to do with historical associations than with mere fashion. If the south wing had been constructed, Varner

would have appeared even more similar to the eastern facade of George Washington's Mount Vernon (fig. 15). Later, Will Hogg confessed his thoughts were on Mount Vernon when he admitted, "I tried to fix up the old place as George Washington would do if he had a bank roll." It could not have been sheer coincidence that Mount Vernon, a national symbol for the gentleman-farmer retiring after a long tour of duty in public service, would have become Hogg's model in his plans to refurbish his father's beloved farm. Instead of preserving the Texas heritage of this home, Will Hogg grafted the national onto the local. The remodeling, then, represented to Will Hogg a memorial of sorts to his father's memory and made a visual connection between Washington and his father's retirement to a "simpler" life after one devoted to public service.[80]

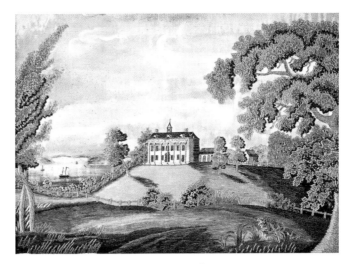

Fig. 15 Nancy Ellis Brewster, *View of Mount Vernon*, c. 1805–10. Silk and watercolor 12 1/2 x 16 3/4 in. (31.7 x 42.5 cm). The Museum of Fine Arts, Houston, the Bayou Bend Collection, gift of Miss Ima Hogg (B.54.15)

Why stop at two hundred acres? Why not buy out the country club? Why not make

this thing really big, something the city can be proud of ?

WHEN WILL HOGG MADE DECISIONS about his private life he considered the public dimension of his actions, always asking himself if he could turn a project into something "really big, something the city can be proud of."[81] Nowhere is this more visible than at Bayou Bend, the home he shared with Ima and Mike, located in River Oaks, the garden suburb he developed as a model planned community. Initially called Country Club Estates, River Oaks was originally a part of the property belonging to the River Oaks Country Club, which offered lots to its members for building country homes. The development of River Oaks, a project first conceived by Mike Hogg and his University of Texas roommate and attorney Hugh Potter, came about in a serendipitous fashion. With Will Hogg involved, the project became hugely ambitious. Combining his desire for an elegant, comfortable home with his goals for urban planning, Will accomplished something Houstonians had never before seen in their city: an enormous planned community with strict deed restrictions and community controls situated within a parklike setting.

Before he became interested in the River Oaks project, Will Hogg had looked elsewhere for a new residence. At about the same time he remodeled Varner, he decided to move from Rossmoyne to Shadyside, a thirty-eight-acre residential development created by Hogg's business partner, Cullinan, at the intersection of Montrose Boulevard and Main Street.[82] Shadyside featured single-family homes reserved by Cullinan for family members, close friends,

and business associates, including the Farishes, Wiesses, Blaffers, Sharps, Neuhauses: a "who's who" of prominent Houstonians in the early decades of the century. Complementing and extending the high quality of architecture represented by Rice Institute, just across the street, and alongside nearby Hermann Park, Shadyside was meant to provide a shining example of how practicality and aesthetics make good bedfellows in public planning. Cullinan aimed high, securing George E. Kessler, a nationally recognized city planner who had created parks and boulevard systems for numerous cities throughout the country and designer of Houston's Hermann Park, to outline Shadyside's development. Kessler and his colleagues ensured that Shadyside would harmonize with its surrounding properties, one of which would be, during the next decade, a Greek Revival building for the Museum of Fine Arts, Houston. Shadyside would be buffered by these elite institutions as well as by the surrounding public parkland. In turn, in an effective strategy of mutual enhancement, Houston's most powerful shapers of the community would lend social cachet to their institutional neighbors in an area termed Houston's "cradle of culture."[83]

The Hoggs were prime candidates for a residence in Shadyside. By 1918, their oil investments afforded them a larger home and Cullinan, Shadyside's creator, was both a business associate and friend of the Hogg family. Furthermore, as friends and business partners, the Hoggs, including Ima, shared their ideas about Shadyside's development

from the very beginning.[84] Will Hogg placed an option on Lot Q, the largest of the lots, a sign of his social ambitions as well as his commitment to the project's larger vision of City Beautiful planning. The Hoggs' plans to build in Shadyside, however, were abruptly halted, causing speculation about Will Hogg's relationship with Cullinan as well as about the neighborhood's relationship to the Hogg family's ensuing development of River Oaks west of downtown Houston.

Hogg, at the suggestion of Cullinan, had corresponded with an architect, James P. Jamieson of St. Louis, about plans for a Hogg home on Lot Q in the spring of 1918 before any of the lots were actually sold. In deference to the war climate, Will Hogg kept his plans tentative, advising the architect in May 1918, "While it may be an opportune time to perfect plans, my forecast of the war problem now is such as to convince me that it would be foolish, if not almost disloyal to undertake the construction under present conditions."[85] At this point, Ima entered a period of ill health, and one year later she moved to Philadelphia, seeking the care of Dr. Francis X. Dercum, a leading neurologist at Jefferson Medical College, who recommended she undertake a "rest cure." Neither Will Hogg, nor anyone else, could speculate how much time would be required for Ima to fully recover (more than two years, as it turned out) and, as a consequence, Hogg's plans for Shadyside ground to a halt. In July 1919, soon after Ima's departure and the close of the war, Cullinan announced that properties within Shadyside were officially available and would be held for sixty days for those who had placed options. Citing Ima's precarious health, Hogg requested an option of six months to one year, which Cullinan denied because it would be unfair to other families on the waiting list. When William Stamps Farish offered to close on Lot Q in September, Cullinan made a deal, and Hogg, furious, resigned his partnership in Fidelity Trust with Cullinan in October and, according to one historian, set out to "develop Houston in another direction."[86] Or, as Houston architect and architectural historian Howard Barnstone has suggested, it was possible that Hogg "was motivated by a growing disaffection with Cullinan and wanted to establish himself miles away from Shadyside."[87]

The rift between Hogg and Cullinan may have been exaggerated in Houston lore, because after Ima recovered from her illness in the spring of 1921, the Hoggs briefly resumed efforts to move into Shadyside.[88] Although the Hoggs ultimately did not move there, Will continued to maintain an interest in the development of Houston to the south of downtown: a paving project encircling Shadyside

(Sunset Road); the planting of oaks along Outer Belt Drive in Hermann Park as a memorial to the dead soldiers of World War I; the purchase of parkland to be sold to the city at cost as an extension of Hermann Park; and, most important, his successful effort in raising money for the new museum building located adjacent to Shadyside.[89] If Hogg had been driven by merely petty differences, he would not have spearheaded efforts to continue the model planning that was developing to the south of downtown Houston.[90] At any rate, focusing on the speculative rivalries between Hogg and Cullinan misses the point of their larger accomplishments: both businessmen responded with energy and commitment to contemporary notions about how cities could expand gracefully and harmoniously. While competition or rivalry may have played a part in spurring Will Hogg and his family to develop River Oaks in the wake of his disagreements with Cullinan, it would obscure the more important point that Hogg had a comprehensive vision for city planning that stemmed from his Progressive reform upbringing.

To modern-day observers who view River Oaks as a "satin slipper suburb" and a haven for Houston's wealthiest citizens, the initial concept of River Oaks as a model for a more democratic residential plan may seem surprising.[91] While Shadyside was designed to remain an intimate enclave for a privileged group of Cullinan's family and friends, River Oaks was developed to accommodate middle- to higher-income families within one enormous planned community. The spectrum of prices for buying in the community ranged from $7,000 for a cottage to $17,000 for a house and $170,000 for a mansion, according to the advertisements. Of course, the cheaper lots on the margins of the community were still unreachable for most of Houston's middle class, and none was accessible to the lower class. In addition, in accordance with the racial and religious prejudices of the time, African-American and Jewish neighbors were not welcome in River Oaks. Still, a contemporaneously innovative concept of economic inclusion initially governed its development.

The original idea for developing River Oaks belongs to Mike Hogg and Hugh Potter, both of whom discussed with Will their ideas about acquiring 200 acres of Country Club Estates for residential development in late 1923 and early 1924. Will shared their enthusiasm but saw a greater opportunity to create a model for civic planning.[92] In the muddy, unpaved properties filled with lovely trees and near the city's worst slums, Hogg envisioned a beautiful neighborhood with gently curving streets punctuated by cul-de-sacs and pocket parks, architecturally harmonious homes, a rural environment protected by underground

Fig. 16 Entrance to River Oaks, from the anniversary edition of *River Oaks Magazine Yearbook,* 1941 (courtesy Houston Metropolitan Research Center, Houston Public Library, mss 0118)

utilities, bans on commercial traffic, and the elimination of alleyways. Reared in the importance of large gestures, Hogg responded to Mike and Potter by saying, "Why stop at two hundred acres? Why not buy out the country club? Why not make this thing really big, something the city can be proud of?" The Hoggs bought out all of the Country Club Estates properties, plus additional acreage on all sides of the golf course, bringing the grand total to 1,100 acres (versus 36 in Shadyside). In addition, Will bought 1,500 acres north of Buffalo Bayou and sold it to the city at cost for parkland.[93] Once called Camp Logan but renamed Memorial Park, it fulfilled Hogg's notions of sensible city planning and, at the same time, provided a buffer for the newly established Country Club Estates, Inc., which was renamed River Oaks Corporation in 1927.

From the beginning, Will Hogg stated his conception of River Oaks (fig. 16): "We are interested in Houston first, the success of River Oaks second, your [the employees'] advancement third, and our own compensation last."[94] When Will died in 1930, the River Oaks project was still

losing money; he had invested three million dollars in the project, but the stock market crash, combined with a relatively slow rate of purchase within this muddy and isolated community, did not reach its fullest success until after he died. However, all elements for success had been put in place. By hiring such distinguished architects and developers as John Staub, Birdsall Briscoe, and engineer Herbert Kipp (formerly of Shadyside), Hogg ensured the architectural integrity and high construction quality of the project. To lure Houston's most distinguished citizens, he announced that an enclave that looped around the bayou within River Oaks called Contentment (renamed Homewood) would become the future site of Will, Mike, and Ima's home. The savvy admen Hogg hired applied gentle, if perhaps over-intellectualized, persuasion, spinning potentially negative features, such as the area's isolation, into appealing attributes (River Oaks was described as a "wildlife sanctuary"). Moreover, Will Hogg buttressed his aspirations for the west end of Houston by converting a red schoolhouse into the loftily named Forum of Civics for promoting the idea that beautification began in the home and, if properly nurtured, would advance the cause of urban planning as well.[95] Further, the Forum of Civics published a glossy magazine, *Civics for Houston,* that forged a sense of shared mission and community, creating an identity of genteel living and right-minded stewardship. The short-lived *Civics for Houston* was a brilliant strategy, presaging newer self-help home magazines while also including rigorous articles on the subject of civic planning. Garden charts by nursery founder Edward Teas, descriptions of common garden pests, interior design tips, and articles titled "Bathrooms Assume a New Importance" shared space with complex arguments about city zoning.[96] Finally, as the mayor-appointed head of the city planning commission (an organization that made recommendations to the city but had no voting authority), Hogg was highly visible in the community not only as a successful and wealthy businessman but also as guarantor of the latest modern ideas on city planning.[97] Potential buyers could take comfort, if this was meaningful to them, in knowing that the developer of their community had the imprimatur of the city.

If Hogg had been fully successful in his venture, River Oaks would be one among many planned communities in Houston. As it is, it remains one of the few examples of a permanent, homogeneous neighborhood built on rigorous community controls and strict deed restrictions within a city where most public planning and attempts at zoning have failed. As architect John Staub claimed, "it's absolutely criminal that somehow Will Hogg's tremendous

efforts on behalf of a beautiful Houston in general and River Oaks in particular have never received appropriate public recognition. He was a man of great vision and generosity. There never was a more civic minded man."[98] Nonetheless, in River Oaks one may discern the defining characteristics of its energetic founder: a crusading spirit, the vision to create well-defined and comprehensive strategies for success, persistence and grit, and the impulse to go for a grand and symbolic gesture that would reverberate throughout the community. In River Oaks, Will Hogg merged civic consciousness with his desire to build a comfortable, elegant home for himself and for his family. He began by wanting to make a home with his family and ended (ultimately unsuccessfully, except for a privileged few) by trying to fashion a greater sense of what the concept of "home" could mean for the Houston community.

Suffice to say that I am planning some new office arrangements here, which will be available in a few months.

Mike and I will set aside an office for you where you can come and attend to your Houston business,

but fully equipped for your comfort and convenience.

IN 1920, WHEN WILL HOGG INVOLVED his sister Ima in his office project in downtown Houston, he likely knew that the "comfort and convenience" he offered her would develop into another staging area for creating colonial revival spaces for their newly acquired American art and antiques.[99] The Hogg family's downtown offices played an important part in its first realized building project from scratch: the Armor Building (also known as the Great Southern Building), an eight-story structure on the corner of Preston and Louisiana streets in downtown Houston begun in April 1920 and completed in March 1921 (fig. 17). The importance of this building as an expression of Will Hogg's Progressive values and colonial revival patriotism has not been measured, in part because the building, unlike the Varner-Hogg Plantation or Bayou Bend, is still privately owned and does not contain its original furnishings. Sold in 1954 by the Trustees of the Hogg Foundation, the building was "modernized" in 1963 with an exterior sheathe of porcelain enamel and cement asbestos board, which obscured its original appearance except for the mostly unscathed penthouse and solarium. Once the building was listed with the National Register of Historic Places and renovations to restore its original appearance began in 1978, interest in the building and its history resumed, with local newspaper articles describing the mysterious penthouse as a legendary site of oil empire business meetings and Roaring Twenties dinner parties, the ghost of a bygone age when "dim lamp lights wink in the windows of the penthouse" and one can "hear the faint music of women's laughter."[100] Now a residential development of lofts, except for the penthouse suite, the building was among the first to receive a makeover in the 1990s downtown renovation of Houston and has been renamed, rather oddly, considering the Hogg legacy of restrained gentility, Hogg Palace.

Designed by the architects Charles Erwin Barglebaugh and Lloyd R. Whitson, the Armor Building was a combination office building and Armor Auto showroom, one of the first of its kind in Houston and an early sign of how the automobile would transform American culture in general and determine Houston's patterns of growth in particular.[101] The Art Deco–embellished building combined all that was current in modern architecture as well as offering such new features as multipaned industrial windows— the first known application in Houston of a common industry feature applied to a downtown office building, presaging the post-Bauhaus-inspired all-glass buildings that would come to dominate the Houston skyline in later decades. Made of red brick trimmed in white and divided into three blocked sections, the building included a one-story showroom, leading to a three-story office building, and a seven-story office building topped by the Hogg Brothers penthouse suite of offices, including a living room, solarium, and roof garden.

The Hogg penthouse suite attracted the most media attention. Newspapers described it as a "home in the clouds" and "something new in the way of bungalows," with its living room and rooftop garden.[102] The penthouse suite and solarium, perched atop one of the taller downtown buildings like a "nerve center for an empire," allowed Hogg and his associates the opportunity to survey the booming growth of Houston, of which they were a part.[103] The position also created the symbolic effect of Hogg's playing watchdog to City Hall, which was located, at the time, across the street. Hogg's idea of a homelike office space and roof garden derived, according to a newspaper report, from a New York skyscraper erected a few years before the Armor Building.[104] Most likely, this inspiration came from Earl Carroll, one of Hogg's New York friends and a theatrical impresario who produced spectacles to

Fig. 17 The Armor Building, c. 1921 (courtesy Houston Metropolitan Research Center, Houston
Public Library, Litterst-Dixon Collection, 2943, mss 1248)

rival Florenz Ziegfeld's revues.[105] Carroll had built a bungalow atop his offices at Seventh Avenue and Forty-ninth Street, and his chic penthouse provoked rumors of Jazz Age excesses. Similarly, persistent stories of raucous parties taking place in the Hogg solarium, which was designed for entertaining, arose because of the brick wall that hid it from the street, a feature that contributed significantly to the building's allure.[106] What made the Hogg Brothers offices extraordinary was its combination of elements: the homelike office and freestanding oval solarium for entertaining; a decorative arts and painting collection that adorned the living room; a rooftop lawn that accommodated a doghouse as well as plans for a butterfly garden (possibly unrealized at the Armor Building but created at Bayou Bend years later)—all situated in downtown Houston.

The Armor Building captured Hogg's fondness for new ideas, technology, and development on the one hand, and his passion for creating comfortable, homelike spaces made meaningful by the historical associations they evoked on the other—in this case, both the colonial revival and a vernacular idiom.[107] Birdsall Briscoe, who had just completed the remodeling at Varner, may have had some influence in the exterior details and features of the penthouse bungalow, with its exposed beams and fascia and general Mediterranean style, as well as the architectural details of the library inside.[108] While the exterior incorporated

current Art Deco elements and the penthouse and solarium exhibited the unaffected bungalow and vaguely Spanish-Mediterranean style, the interior living room expressed a different set of values altogether—the colonial revival. The office living room featured white woodwork with arched panels and keystones above the doorways (similar to Varner's front door), recessed bookshelves with classical molding, a carved Federal fireplace surrounded with black marble trim similar to the fireplace now in the Music Room at Bayou Bend, and French doors leading to the roof garden. It was here that Will and, in large measure, Ima, hung the Remington paintings and placed the hooked area rugs, the Windsor furniture, the case clocks, and the American glass, in an arrangement that marks some of their earliest experiments with gathering and displaying American art.

Hogg made any space he occupied homelike and cozy. Ima later commented that Will "wished everything to be as homelike as possible. When this building [Armor] was erected, he had the soil placed up here, and planted the grass, the flowers, and the trees. He gave it all careful attention and, naturally, was proud of it."[109] During a time when daily business was largely conducted face to face, office buildings such as the Hoggs' provided a useful social and symbolic function. Comfortable rooms projected an image of family warmth and good humor complete with

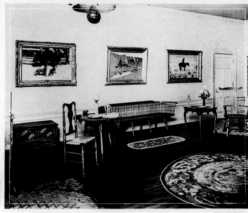

Figs. 18, 19 The library in the Hogg Brothers office, from Dorothy M. Hoskins, "American Furniture of Early Date," *Civics for Houston* 1, no. 6 (June 1928): 6–7 (photos: Frank J. Schleuter, courtesy of the Woodson Research Center, Rice University)

pets, as if Hogg meant to re-create the fun-loving atmosphere of their childhood. Proud of their "home in the sky," Hogg featured anonymously the suite of office spaces in the June 1928 issue of *Civics for Houston* in an article that encouraged the practice of decorating the home with old American furniture, not even mentioning that the rooms photographed were located in an office building rather than a home (figs. 18, 19). The article gives some sense of how the Hoggs might have viewed their arrangements in its statement that the old American home "presented an essentially comfortable and inviting atmosphere, always immaculately clean and orderly, always airy and light."[110] That the Hoggs chose this image rather than the heavy, baronial look of many contemporary offices clearly indicates Ima and Will's growing interest in collecting Americana and in displaying it in ways that revealed their enthusiasm for creating colonial revival spaces.

Miss Hogg once admitted that she had always loved "old things with a history," and she attributed her love of antiques to her years in the Governor's Mansion, particularly the old four-poster bed belonging to Sam Houston in which she had slept.[111] But her collecting enthusiasm, according to her own account, was not awakened until she visited the studio of New York portraitist Wayman Adams

in 1920 and took note of a simply made American chair. She reported that she was surprised to learn that it was American-made and she determined to have one like it, a Queen Anne maple chair with rush seating. She and Will went to Collings and Collings, antique dealers for early American furniture in New York, and found one like it, though more skillfully crafted and in better condition. According to her story, at the time she and Will made the purchase, she presented the idea to her brother of creating a collection of American decorative arts for a public museum in Texas. "Always an ardent ally for anything he felt was good for Texas," she wrote, "he saw the point at once and was ever truly interested as long as he lived."[112] Years later, she had the opportunity to acquire the original "Adams" chair, which is now on view at Bayou Bend as a testament to the "origins" of her collecting impulse. The development of Ima and Will as collectors, however, is more layered and complex—a phenomenon that developed out of the mutually reinforcing effect of their similar passions.

Historian Virginia Bernhard has suggested that Will interested Ima in collecting at precisely the moment she took ill as a means of providing her therapeutic activity and a way of registering his hopes for her (and their) future.[113] Certain letters from Will to Ima indeed suggest that he

may have believed collecting would be restorative to his sister on many levels. For example, he wrote a cajoling letter to Ima when the Armor Building was just under way: "Suffice to say that I am planning some new office arrangements here, which will be available in a few months. Mike and I will set aside an office for you where you can come and attend to your Houston business, but fully equipped for your comfort and convenience. I will tell you about these offices when I see you. . . . If you would like to be a member of the firm of Hogg Brothers, composed of W.C., Miss Ima and Mike Hogg, it is possible Mike and I will take you into partnership with us." He continued in this humorous line, going so far as to have office letterhead printed for "Miss Hogg and Brothers." His concern for her health and, perhaps, his efforts to get her involved and interested in a project, however, converged with more significant factors to bring about an informed passion for collecting.

The Hoggs desired to do something worthy with their oil wealth. Their collecting interests, beginning with the refurbishing of Varner in 1916, could grow and expand once they had a vast fortune to support their acquisitions of Americana, and they believed collecting this material served a useful social value. Their numerous letters to one another on the subject also attest to the great pleasure that collecting brought to both of them. Will shared and encouraged his interest with others by giving a friend an important doll collection and by giving his sister-in-law Alice Nicholson Hogg (later Mrs. Harry Hanszen) a rare collection of perfume bottles, considered to be the most complete in the country at the time.[114] And, obviously, the Hoggs demonstrated a great talent for the endeavor, one that for Ima grew to be a lifelong, successful career.

The Hogg Brothers office living room provided Ima with a space for trying out her new ideas, although Will Hogg remained closely involved.[115] In January 1921, she outlined her plan to Will:

I have been thinking about the large room [library] at the office, and I want to make you a proposal. As I have my own ideas about antiques and furniture, and am fond of collecting them, let me do this. I don't want to embarrass the firm or you—and as I probably will want to be a little extravagant and indulge in it for once in my life—I'd like to borrow the money on interest, and buy the furniture for myself. The firm may use it as long as it likes if it does like—or until I may change my mind. That, however, is not likely. The firm can furnish the carpet and hanging-setting [possibly referring to the collection of Remingtons, which Will had acquired beginning in January 1920], of

course. . . . You'd be amazed at the scarcity of early American things. . . . Anyhow, think over my request, and give me an answer whether or no.[116]

Will immediately responded, "It will be all right for you to furnish the living room at the office just as you want it, as and when you want it," but this did not stop him from continuing to collect himself, and the office living room that Ima mostly arranged contained, in large part, the objects Will collected.[117]

By February 1921, the cajoling relationship that had developed as Will and Ima collected antiques for Varner had clearly grown playfully competitive: "You haven't got anything on me when it comes to auctions," wrote Will from New York, "I went to an auction of early American furniture at the American Art Association rooms last Thursday, Friday and Saturday afternoons. I bought a mass of stuff, particularly sixteen varieties of Windsor chairs."[118] Ima asked Will to find objects for her when he was in residence in New York ("try to locate a real Duncan Fhyffe [*sic*]—American large table") and Will communicated back to Ima his enthusiasm for his finds: "I guess you will give me the loud guffaw—but I got some beautiful things up here. I am considering having the Hepplewhite case I phoned you about for approval. It's *high* but a gorgeous piece of art in that style—the best I ever saw. I got the best A. Willard hall clock I ever saw at any place—it will go where my shoebox and clock now stand."[119]

In March 1921, when Will was still in New York and Ima was finishing the Hogg Brothers office spaces, Will announced, "I don't aim to do anything *new* in the business line—I want to simmer down and take some of the fever out of my silly self. Perhaps travel and books and loafing away will facilitate my effort to good nature and a youthful figger."[120] Considering his numerous activities—overseeing Ima's care in Philadelphia, refurbishing Varner, making speculative plans at Shadyside, orchestrating a move to Rossmoyne, and commissioning the construction of the Armor Building, in addition to attending to his hectic business schedule—the idea to slow down made sense. But Hogg could not and did not relax; instead, he bought two apartments in New York at 290 Park Avenue and filled them with antiques from his buying sprees. During this time, he continued to develop his taste for and knowledge of antiques and American painting. He built a large art and antiques library and reserved two subscriptions (one for himself and one for Ima) for the newly created *Antiques Magazine*. What began as an interest in buying "copper and pewter stuff" for Varner clearly evolved into an enlightened crusade for American art and antiques.

Canvassing yet another adopted city, Will Hogg identified American artworks that he could bring "home" and that would give new meaning to the homelike environment he was creating for his offices in Houston. Indeed, the Armor Building's greatest legacy was twofold: it served as a fertile playing ground for the Hoggs' continuing collecting activities that would find their most comprehensive expression at Bayou Bend, and it functioned as an original showcase for the Hogg Brothers Collection of Remington artworks.

If you feel extra spry when you get in town and want to have some real sport and a chance to criticize me without any restrictions, you . . . could go to the Levy Gallery . . . and ask . . . [them] to show you the Frederick [sic] Remington pictures I bought for Hogg Brothers' offices. You are forbidden to ask what I paid for them.

IN OCTOBER 1920, soon after Will Hogg made his first Remington purchases, he encouraged his sister Ima to review additional acquisitions of the artist's work, playfully warning her to avoid asking the dealer for the prices.[121] In a remarkably short time Hogg established himself as a major collector of Remingtons, one of the first collectors to center on a single artist of the American West. In fact, in August 1923, just weeks after it opened to the public, Will Hogg visited the Remington Memorial Museum in Ogdensburg, New York. According to the ledger, the museum, comprised of the contents of the artist's estate, was closed that day, but an obliging janitor let "D.C. [sic] Hogg of Houston" in the door to inspect the collection and observed that Hogg had been "enthusiastic."[122] Hogg's response is not surprising: his own collection of Remingtons in Houston would soon become the largest of its kind in the 1920s outside Ogdensburg. In Tarrytown, New York, Dr. Philip G. Cole was amassing a collection of works by Russell and Remington at the same time (now the core collection of the Gilcrease Museum in Tulsa, Oklahoma), yet even his collection of Remingtons did not exceed the breadth and grasp of Hogg's.[123] It may be said without hyperbole that Hogg jump-started market interest in Remington, forging an enthusiasm for the artist's works that has only increased over time.[124]

During Remington's lifetime, his patrons (apart from the various magazines for whom he worked) included such close friends and neighbors from the North Country as A. Barton Hepburn and John Howard, who would acquire a few works from him; Gen. Nelson Miles, the politically ambitious and legendary "Indian fighter" whom Remington befriended in exchange for access to the army during his Western travels and whose *Personal Recollections and Observations of General Nelson A. Miles* (1896) he illustrated; and William T. Evans, the esteemed New York collector of American art who acquired Remington's *Fired On* (c. 1907) in 1909 for what is now the National Museum of American Art.[125] Other collectors included newspapermen, bankers, lawyers, and doctors, all of whom might acquire one or two paintings or sculptures but none of whom aspired to assemble a comprehensive collection of the artist's work.

Hogg was the first systematic collector of Remington with a single-minded purpose; his contemporary equivalent would be the New York businessman Malcolm S. Mackay, who began collecting paintings by Charles Russell in 1911 for his Tenafly, New Jersey, home and who had amassed the most distinguished collection of Russells in the late 1920s.[126] As Hogg's childhood friend Guy McLaughlin commented about Will, "To get together, and to keep together the splendid Remingtons of the Hogg collection was a marvelous thing to do."[127] Hogg initiated the pattern of collecting Remingtons, and his highly focused interest spurred later collectors to concentrate exclusively on the art of the American West—Amon Carter, Thomas Gilcrease, Lutcher Stark, C. R. Smith, Sid Richardson, R. W. Norton, to name a few. Moreover, Hogg's stated intention to make his Remington collection a gift to the Houston museum after his surviving siblings decided the time was right also provided an example for these same collectors, who either gave their works to an institution or used them as a core for building their own, the majority of them located in the Southwest: the Amon Carter Museum in Fort Worth, the Thomas Gilcrease Museum in Tulsa, the Stark Museum of Art in Orange, Texas, the C. R. Smith Collection at the University of Texas at Austin, the Sid Richardson Collection in Fort Worth, and the R. W. Norton Gallery in Shreveport, Louisiana.

In assessing the motivating factors behind these figures' collections of Western American art, Remington scholar James K. Ballinger supports the claim that all of them, whom he described as "wildcat oilmen," found "in their own activities the same wide-open freedom that Remington

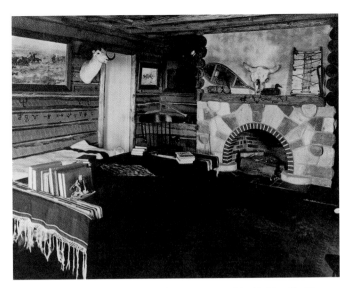

Fig. 20 Malcolm S. Mackay's "Western room" in his Tenafly, New Jersey, home, displaying paintings by Charles M. Russell, c. 1925–30 (courtesy William R. Mackay, Sr., Roscoe, Montana)

saw in the West."[128] These collectors, however, should not be lumped together as merely "wildcat oilmen," even though, for some of them, their resources for collecting Remingtons and the works of other Western artists rose considerably with the discovery of oil on their various properties. Hogg was first a lawyer, a cotton investor, and then, using the oil income generated by his family property, a real estate developer and city planning visionary. Carter, a newspaper publisher, was collecting works by Remington and Russell before he became "oil rich" in 1937. Stark's money came from lumber, and C. R. Smith made his fortune in the airline business, commenting that his inspiration for entering the aviation field was that those in aviation technology "were pioneers, reminding me of the people who took the big wagons West in earlier days."[129] It is probably true that an entrepreneurial or can-do spirit was a personality trait that these collectors all shared and one that they all associated with Remington's West. But the motivating factors behind their collecting deserve closer scrutiny. After all, not all Remington collectors came from the Southwest or were associated with oil, a persistent myth often put to use when elitist connoisseurs condemn the tastes of the newly rich.[130] George H. Harding— whose collections of Remingtons, as well as Renaissance and medieval armor and weaponry, are now housed at the Art Institute of Chicago—was a realtor and politician in Chicago who seems to have been interested in the combative and heroic aspect of Remington's art, which found its archetypal corollary in his collection of armor.[131]

For Hogg, collecting Remington was bound up in the colonial revival enthusiasms he shared with his sister Ima and the Progressive legacy they had inherited from their father's political career. Such collectors of Western

American art as Mackay or the humorist Will Rogers placed their paintings and sculpture in what could be called "Western rooms," complete with saddles, Native American blankets, antlers, trophies, and other Western-themed items (fig. 20). Will Hogg was unusual among other collectors of Western art in that he displayed his collection in a colonial revival setting. Further, Hogg, from the very beginning, intended his Remingtons to be displayed in his offices. He wanted his Remington collection to serve a public function, to express a set of values about his family and its enterprise, and, quite simply but no less importantly, to provide a stimulating office environment, a complement to the rooftop doghouse and puppies, gardens, and other pleasurable features that identified the Hogg offices with a spirit of fun, liveliness, energy, and imagination.

Hogg left no personal records as to why he championed Remington specifically. Given Remington's impact on American culture through the wide dissemination of his imagery by the popular press—*Harper's Weekly, Collier's Weekly,* and *Scribner's Magazine,* to name a few—the artist could not have gone unrecognized by a man of Hogg's education and experience. The earliest documented evidence of Hogg's interest in Remington dates to 1915, when Hogg wrote to New York dealers about the possibility of obtaining autographs of famous Americans, including two drawings by Remington. Given his close association with Joseph S. Cullinan at that time and the fact that Cullinan collected historical autographs of Americans, it may be that Hogg was making inquiries on behalf of his colleague or that both of them pursued similar interests.[132] Although the date of Cullinan's collecting of Remingtons has not been established, he acquired a few of that artist's watercolors as well as his bronze *The Mountain Man.*[133] Although it cannot be determined if one of them took the lead in registering enthusiasm for Remington, clearly the artist was a subject of early interest and discussion among these two educated and enterprising businessmen.

Hogg would have been exposed to the art of Remington prior to his first documented interest in 1915. On his many trips to New York, he was a frequent customer at the Knickerbocker Hotel, whose grill room included, beginning in 1906, *A Cavalry Scrap,* a monumental painting that Hogg undoubtedly would have seen and eventually would come to own (figs. 21, 22). There is no evidence to suggest that Will and Ima ever met Remington, but they did have important acquaintances in common, people with whom the artist's name would have been broached with ease. The Hoggs, for example, were on friendly terms with Gen. Nelson Miles, who evidently felt fond enough of the Hogg family to send them the gift of a fine wolf-

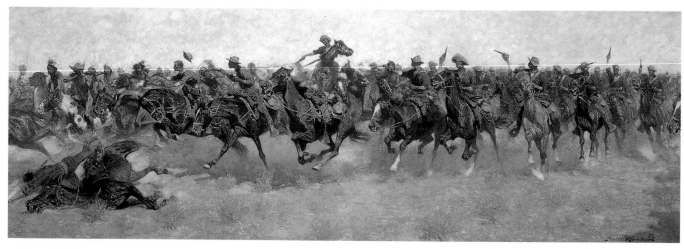

Fig. 21 Frederic S. Remington, *A Cavalry Scrap,* 1906. Oil on canvas, 4 ft. 8 in. x 11 ft. 4 in. (124.46 x 347.98 cm). Jack S. Blanton Museum of Art, the University of Texas at Austin, gift of Miss Ima Hogg, 1943 (G1974.20)

hound (which Ima, to the general's dismay, referred to as a "rabbit dog").[134] But the most important mutual acquaintance would have been, undoubtedly, President Theodore Roosevelt, who, writing from the White House in 1907, defined Remington's accomplishments in authoritative terms: "I regard Frederic Remington as one of the Americans who has done real work for this country. . . . He is, of course, one of the most typical American artists we have ever had, and he portrayed a most characteristic and yet vanishing type of American life. The soldier, the cowboy and rancher, the Indian, the horses and cattle of the plains, will live in his pictures and bronzes, I verily believe, for all time. . . . It is no small thing for the nation that such an artist and man of letters should arise to make permanent record of certain of the most interesting features of our national life."[135]

His tribute to the artist makes it clear that Roosevelt thought of Remington in terms of *preservation,* perhaps even viewing Remington's art as a sociological and ethnological adjunct to Roosevelt's own efforts at land and wildlife preservation.[136] In addition, Roosevelt championed Remington because his art celebrated an American individualism, self-reliance, and stamina that Roosevelt and other men of his privileged background highly valued and considered endangered national characteristics. When Roosevelt was honored at a banquet in Dallas in 1905, former governor Jim Hogg, at his last public appearance before his death, made a speech praising the president, noting similar values: "He [Roosevelt] has been upon the plains, under the blanket, to study the dry regions of the great West, to see the necessity of irrigation. Did you ever know a man who was raised upon the plains, or who had spent his young manhood there in the saddle, that was not opposed to monopoly in every form? He is for the greatest individual Freedom consistent with human rights."[137]

Hogg, an ardent Democrat, admired the Republican president's breakup of the Standard Oil monopoly and the reputation he had earned for his courage and rugged independence as a Rough Rider during the Spanish-American War, including his effort to raise recruits for the regiment in the Oak Bar of the Menger Hotel in San Antonio. This masculine ethos—that virtue, independence, self-reliance, and courage could emerge through exposure to the purifying qualities of an epic Western landscape—was promoted by both Roosevelt and Remington and shared by the Hogg family. While Will Hogg's decision to collect Remington's work may not have derived directly from Roosevelt, the Hogg family's admiration for, acquaintance with, and values shared with Roosevelt would undoubtedly have culturally and socially predisposed Hogg toward Remington's art.

By late 1919 and early 1920, the Hogg family's fortune in oil allowed Will to act on the interest he had earlier expressed in Remington. Once he set his mind to it, Hogg was indefatigable, managing to work in gallery visits dur-

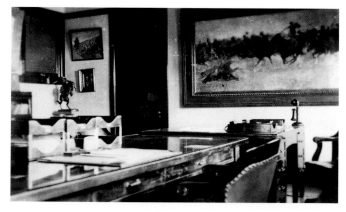

Fig. 22 The Hogg Brothers office showing Remington's *A Cavalry Scrap* and his bronze sculpture *Bronco Buster.* William Clifford Hogg Papers, the Center for American History, the University of Texas at Austin (CN01725)

Fig. 23 "Remington: The Man and His Work, an Appreciation by Owen Wister," *Collier's Weekly,* January 8, 1910, 12

ing his hectic business schedule, which included frequent trips to Chicago, Kansas City, and New York, among other places. Beginning in late January 1920, Hogg made note in his personal diary of viewing two Remingtons at John Levy Galleries in New York. He also recorded in his diary his first purchase, transacted in Chicago on September 15, 1920, acquiring *The Transgressor* (cat. no. 3) for $1,500 and E. I. Couse's *The Tobacco Bag* for $650 from the J. W. Young American Art gallery. The Couse was an anomaly in his collecting of Western American art, and Hogg thereafter focused on collecting Remingtons of various subjects and media rather than a representative sampling of other Western or Taos school artists. Less than two weeks after buying *The Transgressor,* Hogg had acquired about twenty-five works by Remington, including *Bronco Buster* (cat. no. 7) and twelve drawings and paintings from George H. Ainslie Galleries in New York; *The Parley* (cat. no. 17) and *Change of Ownership* (cat. no. 16) from Howard Young Galleries, New York; and *The Emigrants* (cat. no. 19) and *The Lookout* (cat. no. 1) from Levy Galleries.[138] Sharing his enthusiasm for his progress with his sister, he wrote from New York, "If you feel extra spry when you get in town and want to have some real sport and a chance to criticize

me without any restrictions, you . . . could go to the Levy Gallery . . . and ask . . . [them] to show you the Frederick [*sic*] Remington pictures I bought for Hogg Brothers' offices."

Will also encouraged Ima in her own collecting, advising her to be cautious and patient. When he, Ima, and Mike began to make plans for moving into Bayou Bend, Will playfully warned his sister, "Mike says suppress some of your magpie proclivities this Summer so as to leave a little money for next Summer and the Summer thereafter. Seriously speaking, I really believe with what you have and with what you will take away from me [antiques and paintings] that you have a wonderful base laid for furnishing that house already, and remember we are going to play along with you in the antique line the rest of your life, so don't do like I do—get het [heated] up all of a sudden and buy without looking back and then probably be sorry for it the next day."[139] Although Hogg described himself as an impulsive buyer, his approach to collecting Remingtons was actually methodical, and his intensity was similar to the zeal he exhibited in his political and real estate campaigns, which were, in fact, informed by reasoned and measured strategies. At the time he collected Remingtons, no scholarly publications on the artist existed, and no major libraries included compilations of his illustrated materials.[140] Hogg literally pounded the pavement in his pursuit of Remingtons. He tracked down and bought back issues of magazines in which Remington's work appeared, such as *Collier's Weekly* and *Century Magazine,* later pasting these articles and images (many of which are marked and underlined by Hogg) into a scrapbook for display in the Hogg Brothers offices.[141] The January 8, 1910, issue of *Collier's* featuring "Remington: The Man and His Work, an appreciation by Owen Wister" (fig. 23) included an introductory page with a photograph of Remington in his studio and examples of his artwork placed around the page, three of which Hogg would eventually own: *The Emigrants* (cat. no. 19), *The Herd Boy* (cat. no. 20), and *Bronco Buster* (cat. no. 7). Many of the passages are marked, particularly Owen Wister's comment that "Remington is not merely an artist; he is a national treasure." These early articles about Remington's place in American culture fed Hogg's sense of historic preservation. By collecting Remingtons, Hogg believed he was preserving the "vanishing" American life represented within; one could say that he was a preserver reinforcing the mission of another preserver. Tracking down and acquiring the images as he read the accompanying articles only advanced Hogg's own mission.

Hogg also collected the available books by Remington published during the artist's lifetime. For example, an

Fig. 24 Cover of *Drawings by Frederic Remington* (1897)
showing *The Cowboy*

inscription in Hogg's hand dated February 4, 1920, in Remington's book *Drawings by Frederic Remington* (1897) documents Hogg's early study of the artist. In this book, Hogg placed a check mark by those images of which he had bought the original and placed an "x" by those he elected not to purchase or had not yet located, likely the latter.[142] One can imagine that it was with great pride that he ticked off these images one by one as he acquired them, especially *The Cowboy*, the original image for the cover of *Drawings by Frederic Remington* (fig. 24; see also Checklist of Works, p. 135). His diary also mentions those paintings he missed—either because the owner would not sell or a price could not be reached. He tracked down and viewed but did not acquire major works by Remington, including *Return from the Fall Buffalo Hunt* at MacBeth's Gallery (location unknown) and *Stampede by Lightning* from Ray Skofield's collection, and made an offer on *Missing* in a private collection (the latter two now in the collection of the Gilcrease Museum). Even though these works, for whatever reason, did not enter his collection, his doggedness in tracking them down and attempting to acquire them demonstrates his careful research and resolve rather than a "het up" impulsiveness. By 1924 when he, perhaps unaware of his competition, beat the Frederic Remington Art Museum to the punch in acquiring *A Cavalry Scrap*, Hogg had established himself as the premier collector of Remington's art in the country.[143] His collection was remarkably comprehensive, including works in a variety of media and subject matter across Remington's entire career. He was, in fact, a much better collector than he gave himself credit for, particularly considering the complete lack of publications that would have aided him in his search and helped him to refine his collecting.

Hogg's assistance came from the dealers and galleries with whom he was working: George H. Ainslie, John Levy, Howard Young, Grand Central Art Galleries, MacBeth's Gallery, Knoedler and Company, and the department store Carson, Pirie, Scott in Chicago, among others. His friends—John Lomax, Irvin Cobb, Earl Carroll—provided reassurance and also occasionally accompanied him on his buying sprees.[144] Dramatic figures and literary types had always been attracted to the work of Remington, from the artist's friend Augustus Thomas, who first encouraged him to try his hand at sculpting, to John Ford and John Wayne, the Hollywood director and star who considered Remington their inspiration. It was likely that Remington's developed storytelling abilities played a large role in attracting Hogg and his theatrical and literary friends to his art. Also, an appreciation for vernacular literature was on the rise in Texas, celebrated by such writers and friends of Hogg's as Roy Bedichek, J. Frank Dobie (who would write about Remington himself), and Walter Prescott Webb. Hogg's appreciation for Remington coincided with and was reinforced by the growing interest and pride in Texas history, myth, and folklore, which were celebrated in several Remingtons Hogg owned, especially *The Mier Expedition: The Drawing of the Black Bean* (cat. no. 8).[145] Collecting Remingtons and then integrating them into his collection of Americana was Hogg's way of weaving regional subject matter into a national drama. Remingtons provided him, his family, and the colleagues working in his offices in Houston with a powerful identity: a sense of pride in regional roots and traditions based on the very values he and others esteemed as national characteristics.

Hogg would go on to collect Remingtons sporadically throughout the decade, but the bulk of his collection was amassed within a few concentrated years early in the 1920s. He became a known collector in New York, and dealers offered him such varied works of American art as Thomas Moran's majestic scenes of Yellowstone Park or swagger portraits by John Singer Sargent. He turned them all down. Even his sister Ima beseeched him to broaden his interests, writing to him in 1930 that he "should enjoy going to some commercial galleries in Paris. Wish you would get interested in Matisse, Derain and Picasso—great men."[146] Hogg was in Cannes by the time he responded: "Yes, when I return to Paris I'll make a special search for you and study your three modern artists. I met [Kees] Van Dongen at his studio in Paris and afterwards here on my way to Egypt—he's quite the rage in Paris now and is an interesting personality but I don't 'see' some of his work at all. Likewise I've seen specimens of the other three you name in the last few years—and I don't recall that I got any joy out of them either. On the other hand, I 'saw' Choultse's [*sic*] work with

Fig. 25 Edward Hicks, *Penn's Treaty with the Indians*, c. 1830–40. Oil on canvas, 17 5/8 x 23 5/8 in. (44.8 x 60 cm). The Museum of Fine Arts, Houston, the Bayou Bend Collection, gift of Miss Alice C. Simkins in memory of Alice Nicholson Hanszen (B.77.46)

distinct appreciation three or four years ago. . . . he's going to be rated a real artist if not already so."[147] Hogg was likely attracted to the work of the Russian painter Ivan Choutlsé because his landscapes displayed the same moody contemplativeness as those of other American artists Hogg admired, such as Inness, Homer Dodge Martin, and Bruce Crane.[148] Hogg, in fact, assembled a few small-scale works by those artists for his home, and he acquired an important example of American folk art, Edward Hicks's *Penn's Treaty with the Indians* (fig. 25).[149] Despite his sister's encouragement and the few small anomalous American paintings he bought, Hogg did not branch out in his art-collecting habits. Possibly Hogg slowed the pace of his collecting because he had always intended his Remingtons to form a distinct entity in his offices only and had long ago run out of space in which to hang his paintings. He was also consumed with his civic campaigns and the financially uncertain future, at the time, of River Oaks. As his sister remarked to him a few years earlier, "I think you are having the time of your life messing around in politics and forums of civics and no telling what else."[150] With the market collapse of 1929, about one year before his untimely death, the magnitude of his buying sprees would probably have ground to a halt anyway (fig. 26). Had he lived, it is hard to imagine that he would not have embarked on similar collecting campaigns, although it would be difficult to predict whether his sister could have successfully persuaded him to collect "the moderns" or if he would have continued along the lines of preserving earlier American art. But clearly, by the end of the decade, Hogg's enthusiasm for and interest in Remington had been satisfied.

Possibly Hogg limited himself to Remington because he identified with the artist personally and with the bold

character types that he painted. Both he and Remington were cultured, larger-than-life personalities who were known to display a confrontational bravado or witty playfulness. The stark life-and-death struggles of Remington's paintings may have evoked strong emotions with which Hogg could readily identify or may have provided models of behavior for his various political and civic campaigns, which he conducted with a similar dogged determination and sometimes ruthless efficiency. John Lomax even described Hogg in terms that echo Remington's definition of the cowboy, an archetype that over the course of the twentieth century would evolve into one of the country's most popular folk heroes: "Always he fought in the open . . . he struck hard. . . . No one talked back."[151] Perhaps it is characteristic of Hogg's contradictory personae that he could appreciate the Darwinian impulse to survive as celebrated in Remington's art and still augment this determination with a compassionate regard for those in need and a strong personal sense of public duty. In its broad appeal, Remington's art could also be described as unpretentious, a trait that Hogg admired. As Hogg once wrote to his brother Tom, "The uppermost desire of my life is to have all members of the Hogg family live decently and comfortably but not rampantly and 'nouveau-richly,' if you gather what I mean."[152] And his friend Henry Stude seemed to remark on Hogg's determination to be "simple, plain and unassuming" (as Hogg had phrased it himself in 1897) when he described Hogg as a "man of such deep culture that he often sought slovenly companions or language, for fear he'd be thought to be

Fig. 26 Will Hogg walking through a park in Germany with his dog, Gilley, shortly before Will's death in September 1930

without the Common Touch."[153] Hogg's Remingtons may have connected him with those character traits he esteemed and desired for himself and for his family. Whatever the motivating factors behind his enthusiasm for Remington—some of which we may never know—Hogg undoubtedly left his bold imprint in the collection and appreciation of Remington as an important figure in American art and culture.

As he did in his collecting of artworks by Remington, Hogg led by example, generously supporting civic life in Houston and demonstrating his passionate belief in the social value of building heritage, a creative act that combined preservation and imagination. Ima Hogg continued to uphold this philosophy after Will's death in 1930. In 1939, Miss Hogg gave to the museum more than one hundred works on paper by such artists as John Singer Sargent, Paul Cézanne, Pablo Picasso, Emil Nolde, Lyonel Feininger, and Paul Klee; in 1943, she donated the Hogg Brothers Collection of Frederic S. Remingtons; and in 1944, she presented over four hundred objects from a variety of American Indian cultures.[154] In 1957, when she announced that Bayou Bend, the home that she and her brothers built in the 1920s, would be given to the museum, it was a gift that resonated on many levels. In hindsight, the timing of the gift was eerily symbolic; given to the museum only one year before the opening of Cullinan Hall, the museum's grand pavilion designed by the International Style architect Ludwig Mies van der Rohe, Bayou Bend reminded its audiences of the importance of the past, just as Mies constructed an identity for Houston as the city of the future. But perhaps more important, Bayou Bend is a public monument to what "home" represented in the context of the Hogg family's Progressive background: a commitment to the community in which they lived and a recognition that community is meaningless without a sense of history.

1. The Frederic Remington Art Museum, comprising Remington's estate—paintings, sculptures, ethnographic materials, photographs, sketchbooks, private papers, and ephemera—was originally named the Remington Memorial Museum. The museum opened in 1923, three years after Hogg began collecting Remington's works.

2. See p. 4 of Will Hogg's will, dated March 7, 1928 (WCH Papers, Box 2J329). See also Wright 1930b, 6.

3. It was Will Hogg's idea to mount a memorial exhibition, per a Hogg Brothers office memo dated June 5, 1925 (WCH Papers, Box 2J337).

4. Will Hogg's obituary, which mentioned that Hogg was "sometimes called 'Houston's first citizen,'" appeared in the *New York Times* on September 12, 1930.

5. Ima Hogg is the subject of one published biography, Virginia Bernhard's *Ima Hogg: The Governor's Daughter* (Bernhard [1984] 1996),

and is mentioned and discussed throughout the published biography of her father, James Stephen Hogg, by Robert C. Cotner (Cotner 1959). Ima Hogg is the subject of articles too numerous to include in full here, but some notable publications that discuss Ima Hogg as a collector include Winchester 1961; Warren 1966; Warren 1975; Stillinger 1980, 252–53; Warren 1982; Marzio et al. 1989, 14–15, 20–22; and Warren et al. 1998, xiii–xx. Articles or books that discuss Ima Hogg and the architecture and gardens of Bayou Bend include Barnstone 1979, 106–13; Warren 1988; and Hewitt 1990, 234, 237. Discussions of Ima Hogg and philanthropy include Iscoe 1976; and Bonjean and Moore 1982. The papers of the Hogg Family, including James Stephen Hogg, William Clifford Hogg, Ima Hogg, and Michael Hogg, are located at the Center for American History at the University of Texas at Austin. Will Hogg's diaries, which are referred to throughout the text, are located at the University of Texas at Austin (WCH Papers, Box 2J399). The Archives, MFA, Houston, also holds papers of Ima Hogg.

6. Will Hogg is discussed throughout Cotner 1959 and Bernhard [1984] 1996. The only published biographies of Will Hogg include articles (Lomax [1940] 1956; and Wright 1930a and 1930b) and one dissertation in history (Weber 1979). Hogg is discussed in relationship to his activities in real estate development and Houston city planning in Weber and Cook 1980, Fox 1980, and Cook and Kaplan 1977.

7. Ima Hogg, quoted in Marzio et al. 1989, 20–21.

8. The term "Latin Colonial" derives from architect John Staub's article "Latin Colonial Architecture in the Southwest," *Civics for Houston,* February 1928, 6–7.

9. George Fuermann, "Post Card," *Houston Post,* June 26, 1956.

10. The story was told at the home of Hogg friend E. B. Parker and recounted in a letter from John A. Lomax to Edward Weeks, editor, *Atlantic Monthly,* March 22, 1939, in John A. Lomax Family Papers, the Center for American History, the University of Texas at Austin, Box 3D205, Folder 3.

11. O. O. McIntyre, "McIntyre Sings of Bill Hogg, Prince of Hosts: Wealthy Man of Affairs, but Great Cook," *Washington Post,* February 8, 1922.

12. Wright 1930a, 6.

13. Lomax [1940] 1956, 48.

14. This qualifying statement was omitted from Lefevre's final draft (draft of entry, IH Papers, Box 3B122).

15. Reference attached to a copy of a letter written by Will Hogg to Dan Moody, June 19, 1928, and circulated to St. John Garwood (Clayton Papers, Houston Metropolitan Research Center, Houston Public Library, Box 12, Folder 2).

16. "Remarks Made by Will Hogg at Dan Moody Meeting, City Auditorium, Houston, Tuesday Evening, June 8th, 1926," circular (Amon G. Carter Papers, Amon Carter Museum, Fort Worth, Texas, Record Group H), regarding James E. "Pa" Ferguson, an impeached Texas governor trying to regain power. In fact, Hogg had been instrumental in Ferguson's impeachment in 1917, accusing the governor of politicizing higher education at the University of Texas rather than leaving matters in the hands of its academic leaders. Hogg moved temporarily into the Driskill Hotel in Austin and orchestrated the successful impeachment campaign. In one circular, Hogg wrote, "To call our thimblerigging, swashbuckling swaggering Governor a common liar would be the grossest flattery" ("An Interview by Will C. Hogg, A Record and Some Queries," July 19, 1917, WCH Papers, Box 2J315). See Lomax [1940] 1956, 16, and Hendrickson 1995, 157–62.

17. Lomax [1940] 1956, 48.

18. Ibid., 20.

19. *Houston Post,* May 31, 1924, quoted in Weber 1979, 124.

20. The Hoggs descended from Scottish-Irish ancestors who had immigrated to the Virginia colony in the eighteenth century (Cotner 1959, 6–8). Before the Civil War, Joseph and his wife, Lucanda McMath Hogg, held an estate of more than twenty-five hundred acres of prime East Texas real estate, timber, and farmland, as well as twenty slaves. Hogg roots lay in a rapidly rising economy patterned on Old South planter aristocracies. For an account of slavery in Texas, see Campbell 1989.

21. Jim Hogg began his publishing career as a typesetter at the Rusk *Observer,* with stints at a number of newspapers before founding his own paper, the *Quitman News.* Texas was fertile ground for the newspaper industry; by 1860 there were seventy newspapers circulating in Texas with over one hundred thousand readers (Ferenbach 1968, 302).

22. Ferenbach 1968, 615–23.

23. Hendrickson 1995, 122, 125–26. For example, to protect Texas interests, Hogg also passed county and municipal bond laws that provided for levying taxes to pay interest and establish a sinking fund, as well as a law limiting speculation on agricultural and grazing lands to fifteen years, an effort (ultimately unsuccessful) to limit private corporations from holding speculative lands continuously.

24. Ferenbach 1968, 621.

25. Historians have argued over the definition of Progressives, some calling them zealous idealists, naive ideologues, or newly wealthy businessmen seeking to revive the morals of a vanished age with nostalgic romanticism, while others describe a confident rising middle class eager to impose social stability through new strategies of systematization and efficiency (Kennedy 1971, xi. See also Hofstadter 1955).

26. Hendrickson 1995, 128.

27. James Stephen Hogg, quoted in Cotner 1959, 576.

28. Will Hogg's similar avid interest led him to make a variation on this concept when he distributed over sixty thousand free crepe myrtles to the citizens of Houston in the 1920s.

29. Others include William P. Hobby (former governor of Texas) and his wife, Oveta Culp Hobby (chair of the nation's Department of Housing and Urban Development) and their families and John de Menil and Dominique Schlumberger de Menil (prominent civil rights activists) and their families.

30. Sallie Stinson Hogg to her father, James Stinson, May 8, 1895, in Cotner 1959, 458.

31. Will Hogg to Sallie Stinson Hogg, May 16, 1895 (IH Papers, Box 3B118).

32. In Cotner 1959, 517, the author claims that his children's welfare combined with his "search to guarantee to Texans and Americans the better life which would come from the increasing production of the natural resource—oil" guided the former governor once out of office.

33. It was clear from a letter her father wrote to her on her seventeenth birthday what Ima's role would be: "In every feature of your face, in every movement of your hand I can see your mother. Perhaps this of all other causes accounts for my partiality for you. . . . In you I look for a friend and counselor as wise, as faithful, as true" (Bernhard [1984] 1996, 32).

34. Will Hogg to Ima Hogg, January 18, 1899 (IH Papers, Box 3B118).

35. Will Hogg to Ima Hogg, November 27, 1897 (IH Papers, Box 3B118).

36. Will Hogg to Ima Hogg, December 3, 1901 (IH Papers, Box 3B118).

37. Will Hogg to Ima Hogg, May 10, 1902 (IH Papers, Box 3B118).

38. See King 1970, 97–100.

39. King 1970, 119. In 1904, Cullinan organized the Landslide Oil Company, of which Jim Hogg was a stockholder, to develop Humble field, and by 1905, it, too, produced successful wells. This business arrangement is not mentioned in Cotner 1959.

40. James Stephen Hogg, quoted in Texas Parks and Wildlife Department 1983, 84. See this volume for an excellent history of the Varner-Hogg Plantation, including architectural renderings. For Hogg's comments on the importance of home, see Varner-Hogg 1958.

41. Self-sufficiency and efficiency were Jim Hogg's goals as he raised livestock (goats, hens, roosters, ducks, turkeys, geese, sows, mules, and cows) and grew crops (improved varieties of pecans, strawberries, peas, cabbage, squash, pumpkin, potatoes, and corn). Managers, laborers, a cook, and families working the farm on shares helped maintain the property. The two-story brick home with wood trim, built in the 1830s by former owners using bricks fired on the property by slave labor, was filled with furniture moved from the Hoggs' former home in Austin.

42. Will Hogg to Mike Hogg, [c. 1905] (IH Papers, Box 3B118).

43. Will Hogg, quoted in Lomax 1940 [1956], 4.

44. Through major publicity campaigns and personal fund-raising visits, Hogg launched a subscription campaign for $125,000 to promote the values of education. From 1913 to 1917, Hogg served on the Board of Regents and founded the Ex-Students' Association, now known as the "Texas-Exes."

45. Lomax 1940 [1956], 36–37.

46. Will Hogg made a series of personal bequests to his siblings, relatives, friends, and servants, provided endowment funds to universities and colleges across the entire state, and then listed several choices of charitable causes for his executors, Mike and Ima, to make with the residue of his estate. The rest of the estate was given to the University of Texas to found the Hogg Foundation for Mental Health. According to Lomax, "through his [Hogg's] hands for the common good has come seven million dollars. This much is known. Not even his family can tell what he gave away privately" (Lomax 1940 [1956], 25). See n. 2 above. See also Wright 1930b, 6.

47. Wright 1930a, 22.

48. James Chillman, Jr., "Reminiscences" (Archives, MFA, Houston, RG2:1, Series 2, Box 7, Folder 28).

49. The early history of the Houston Art League and the building of a museum is recounted in Erdman and Papademetriou 1972, 3–14; Susie Kalil, "Dynamic Pioneers," in Rose and Kalil 1985, 11–13; Marzio et al. 1989, 11–14; *Museum of Fine Arts, Houston,* Bulletin 1992, 2–39; Billings 1994, 66–86 and passim; and Schneider et al. 1995, 43–46. See also Houston Art League Scrapbook, Houston Art League Records (Archives, MFA, Houston, RG19, Miscellaneous Subjects, Series 5).

50. Fannie Volck to Elizabeth Scheuber, January 11, 1914, in Oglesby 1950, 187.

51. The George M. Dickson Bequest consisted of twenty-five paintings, five bronzes, some ivories and fragments of stained glass, and one colored engraving.

52. According to the deal, Cullinan offered $3,300 of his own money to secure one acre of the property and the remaining 1 3/4 acres were donated by the Hermann estate.

53. Julia Ideson to Elizabeth Scheuber, November 15, 1919, in Oglesby 1950, 187–88.

54. Curatorial liaison of the American Federation of Art, the organizer of the exhibition, to Elizabeth Scheuber, January 25, 1926, in Oglesby 1950, 173.

55. Lomax 1940 [1956], 33–34. This description derives from his fund-raising campaign for the YWCA (which one observer said that Will Hogg "cussed . . . into existence"), but he also used it in reference to fund-raising for the MFA, Houston. Hogg's fund-raising skills were legendary. He raised funds for the Houston Country Club in 1909, just as he was establishing himself in Houston; it was an activity that introduced him to many Houstonians of the business elite. In 1911, Hogg raised $125,000 for the University of Texas's program for higher education, so successful a venture that Texas newspapers speculated that he would or should run for governor. In 1919, he began a $500,000 building campaign for the YWCA.

56. A. C. Ford, "Dedication of the Tablet to William Clifford Hogg, MFA, Houston, January 7, 1933," 3 (IH Papers, Box 3B122).

57. Will Hogg to A. J. Rosenthal (Hogg's secretary), undated, and Rosenthal to Hogg, September 19, 1923 (WCH Papers, Box 2J337).

58. Florence Fall to Will Hogg, March 7, 1924 (WCH Papers, Box 2J337).

59. Will Hogg to Lynch Davidson, November 18, 1925 (WCH Papers, Box 2J337).

60. Hogg also reminded Baker of his standing in the community through his legal practice, Baker and Botts, and his banking and trust interests. Hogg pointed out to Baker that Houston meant "more to you from every *selfish standpoint* than any man in town," and that the majority of subscribers "never made a dollar in this town" but subscribed because they "love Houston passionately," they valued the importance of neighborliness and love of community, and that the amount was relatively insignificant. Finally, Hogg insisted that Baker should contribute "*if for no other reason than to encourage me and a number of younger men to do as big and as fine things as we have the means and the opportunity to do in this town.*" Hogg's youthful idealism (he was actually forty-nine) was a tough reproach for a man of Baker's age and standing; on April 7, Captain Baker entered his pledge of $5,000. See Will Hogg to Capt. James A. Baker, April 3, 1924. See also Baker to Hogg, April 2, 1924 (WCH Papers, Box 2J337).

61. See, for example, correspondence between Will Hogg and Mr. and Mrs. E. F. Woodward: February 25, 1924 (Mrs. EFW to WCH); March 20, 1924 (WCH to Mrs. EFW); March 22, 1924 (Mrs. EFW to WCH); April 14, 1924 (EFW to WCH); April 15, 1924 (WCH to EFW); April 17, 1924 (EFW to WCH); April 21, 1924 (WCH to EFW); April 23, 1924 (EFW to WCH). See WCH Papers, Box 2J337, for complete correspondence regarding this fund-raising campaign.

62. Telegram from Will Hogg to potential donor, April 9, 1924 (WCH Papers, Box 2J337).

63. WCH Papers, Box 2J337.

64. Will Hogg contributed $30,000, while Ima and Mike contributed $5,000 each, bringing the Hoggs' total contribution to $40,000.

65. "HLA" to Will Hogg, January 11, 1926 (WCH Papers, Box 2J337).

66. Will Hogg to Mrs. H. B. Fall, March 2, 1925 (WCH Papers, Box 2J337). Thus, Marguerite Johnston's assurance, "It did not occur to anyone in the league that blacks should be admitted, or that the day would come when black Houstonians would be among the city's most admired artists" is incorrect on the first count (Johnston 1991, 240). Regarding her second statement, she is correct, and yet it is worth noting (in the context of the Jim Crow laws at the time) that the MFA, Houston, hosted the exhibition "Works by American Negro Artists," organized by the distinguished Harmon Foundation, in October 1930. The show was mounted in New Orleans and Houston before traveling west to Los Angeles.

In this same letter to Mrs. Fall, Will Hogg made it known that the museum could borrow the Hogg Brothers Remington Collection for one month a year. Notes scribbled in the margins by Mike Hogg indicate his objection to this plan. Another letter from Will Hogg to A. C. Ford, president of the MFA, Houston, indicated his desire for "a syndicate organized to give the museum at least one authenticated masterpiece of American art each year for not less than five years," March 4, 1926 (WCH Papers, Box 2J337). This effort resulted in the Houston Friends of Art, which was in existence from 1926 to 1951.

67. Will Hogg, quoted in Lomax 1940 [1956], 6. In its plan, Varner Plantation, like Mount Vernon, was a tripartite structure connected by loggias and centering on a two-story square-columned porch.

68. None of the Hogg siblings had children, although two of them, Mike and Tom, married. Bernhard proposes the theory that Aunt Fannie Davis had told Ima (and, one would assume, the other children) that the tuberculosis that had killed their mother was genetic and, therefore, she should not have children (Bernhard [1984] 1996, 31, and see 67). The reasons why neither Ima Hogg (not for lack of proposals) nor Will Hogg (a confirmed bachelor who claimed he was not "fit to marry") ever married could be many (see Guy McLaughlin to Lomax, in which McLaughlin interprets Will Hogg's comment about not "being fit to marry" to mean that his "appraisal of the opposite sex was so high that he felt his own inferiority" [September 22, 1939, John A. Lomax Family Papers, the Center for American History, the University of Texas at Austin, Box 3D205]). We know from numerous accounts and from the existing record that the Hogg siblings, especially Will and Ima, were close, even dependent on one another. Also, although head of the family by age and by self-appointment, Will relied deeply on Mike's level-headedness. The three of them forged a family life together in Houston (although Will and Mike were often away), a cozy threesome for about twenty-odd years, when Mike married Alice Nicholson of Dallas.

69. Will Hogg to Tom Hogg, March 1, 1909 (Archives, MFA, Houston, Hogg Family Personal Papers and Correspondence, 1888–1909, MS21, Series 11, Box 15).

70. See Clark 1986 and B. May 1991.

71. Clark 1986, 171–92. On the bungalow style in Houston, see Stern 1986.

72. The literature on the colonial revival—and such related subjects as nativism—is voluminous. Several helpful sources include Axelrod 1985; Hosmer 1965; B. May 1991; Roth 1964; Stillinger 1980; Kaplan 1983; Rhoads 1976 and 1977; Gebhard 1987; and Higham 1955. Colonial revival impulses included historic preservation campaigns as well as building anew in a colonial image. By the late 1910s and early 1920s, Americans feverishly continued to pursue a nineteenth-century activity widely promulgated at the Philadelphia Centennial exposition of 1876, a nationalist celebration of the simplicity and refinement of American colonial style, with its adoption of forms and elements of Palladian architecture and classically embellished monumental and symmetrical structures. To Americans of the time, colonial or Georgian architecture expressed American values of sincerity, simplicity, and genteel refinement.

73. See Woods 1994.

74. While the Hogg children shared equally in the mineral rights to the property, Ima and Mike retained the surface rights. Will, who was not very interested in Varner at this point in his life, had to enforce on them his belief that they needed to take responsibility for finding a manager for the property.

75. King 1970, 197–99.

76. Will Hogg to Ima Hogg, June 5, 1920 (IH Papers, Box 3B119).

77. Will Hogg to Ima Hogg, January 6, 1917 (IH Papers, Box 3B119). The Hoggs moved into their home at 4410 Rossmoyne in March 1917; it is not always easy to tell if their antiquing during 1917 is for Varner or for Rossmoyne. Except for one photograph dating from about 1920 of Miss Hogg playing the piano, no photographs of the interior of the Hoggs' Rossmoyne home are known to exist.

78. Briscoe reoriented the main entrance away from the winding entrance by way of Varner Creek, a tributary of the Brazos River. The new entrance to the west faced the oil derricks and provided a grander approach to the house. The revised plan included removing the second-story balcony in order to make room for two-story square columns, an enlarged porch, and a neoclassical entrance of overstated grandeur: a fanlight transom with sidelights within an arch with keystone supported by colonettes. The balconet balustrade was underlined with a variety of classical details. The east porch was double-galleried with classically detailed columns and the balcony included an x-patterned balustrade. It is interesting to note that in 1948, Ima Hogg tried to distance herself from the remodeling plans of her brother and Briscoe (she had been living near Philadelphia at the time construction took place). She did, however, admit that she had approved some of the plans. In 1953, she acknowledged that "it distresses me to think any alterations were ever made. It was, of course, from ignorance and a desire to make it more comfortable and practical. But the damage is irreparable." Even Will confessed in 1920, "I am not disposed to brag on the execution of the contract" (Texas Parks and Wildlife Department 1983, 95, 121, 93). Ima Hogg gave Varner to the state of Texas to use as a state park in 1958. The property was renamed the Varner-Hogg Plantation, in reference to its first and last owners.

79. Ibid., 122.

80. That preservation was on his mind is underscored by his simultaneous effort to move the remains of his grandfather Joseph Hogg to Confederate Park in Corinth, Mississippi (Joseph Hogg's buried remains, marked with a wooden plaque, were located outside of Corinth). Will Hogg's father would probably have been his earliest model for preservation. His father created the state's archives for preserving Texas history during his administration as governor and he encouraged the preservation of paintings of Texas history (see Cotner 1959, 585, 352).

81. Alan V. Peden, "Presentations: Hugh Potter," *Houston Gargoyle,* April 10, 1028, 10–11, quoted in Barnstone 1979, 56 n. 16.

82. See Fox 1980; and Barnstone 1979, 6–7.

83. *Houston Gargoyle,* quoted in Museum of Fine Arts, Houston, Bulletin 1992, 6.

84. Fox 1980, 42. Ima Hogg had apparently suggested that a "unifying architectural style" be implemented for the property.

85. Will Hogg to James P. Jamieson, St. Louis, Missouri, May 8, 1918 (Joseph S. Cullinan Papers, Houston Metropolitan Research Center, Houston Public Library, mss 69, Box 59, Folder 1).

86. Bernhard [1984] 1996, 77.

87. Barnstone 1979, 8. Barnstone admits, however, that missing correspondence between the two men at the Houston Metropolitan Research Center and at the Center for American History at the University of Texas makes it impossible to verify this hypothesis.

88. For example, in July 1922, Will wrote Ima, "Chances are Lee [Blaffer] will telephone or see you about Farrishs [sic] House and Lot here. Look into the whole situation very carefully and feel free to make your recommendations. If it looks desirable to you the chances are we might be able to trade in the New York apartments [which Will had bought in 1921] to him" (Will Hogg to Ima Hogg, July 8, 1922, telegram, IH Papers, Box 3B119). It is unknown whether the Farishes indicated a willingness to make their lot available to the Hoggs or if Will planned to approach them with an offer. Whatever the case, nothing happened.

89. Fox 1980, 53–54.

90. Their friendship, however, was tested again in 1927 over control of American Republics (King 1970, 209–10). It should be noted, however, that in his will, Hogg established a scholarship fund at the University of Texas at Austin in Cullinan's name (see n. 2 above). Despite differences between them over the years, Hogg clearly respected, admired, and felt indebted to Cullinan. And Ima Hogg and Nina Cullinan remained on "happy terms" (see Guy McLaughlin to Lomax, March 15, 1940, John A. Lomax Family Papers, the Center for American History, the University of Texas at Austin, Box 3D205).

91. See Meyer 1976a.

92. See Weber 1979, 168; Barnstone 1979, 8–10; Cook and Kaplan 1977; and Weber and Cook 1980.

93. Weber 1979, 181.

94. Ibid., 168.

95. The Forum of Civics building, at the corner of Westheimer Street and Kirby Street, now houses the River Oaks Garden Club. See Weber 1979, 189–90, for a discussion of the disagreements between Hester Scott, head of the Forum of Civics and editor of *Civics for Houston,* and Will Hogg. Correspondence between the two can be found in the WCH Papers, Boxes 2J317 and 318.

96. For example, the August 1928 issue included a comprehensive essay on the city's African-American community, written by C. F. Richardson, editor of the black newspaper the *Houston Informer.*

97. In 1927, Hogg was appointed the head of Houston's city planning commission under Mayor Oscar Holcombe. Very quickly Hogg learned that the city planning commission could make recommendations but had no real authority. Thus, their 1927 comprehensive zoning plan for Houston, like so many others subsequent to this, failed, with the exception of one of its key points: the need to establish a civic center (see Weber 1979, 130–39).

98. John Staub, quoted in Meyer 1976b.

99. Will Hogg to Ima Hogg, June 5, 1920 (IH Papers, Box 3B119).

100. Bill Porterfield, "It's Not Just an Ordinary Place Being Remodeled Eight Floors Up," *Houston Chronicle,* December 29, 1963. Other newspaper articles discussing the penthouse during the 1960s and 1970s include Jim Maloney, "Pappas Is Missionary on Midtown Renewal," *Houston Post,* December 3, 1962; Madeleine McDermott, "Proud Penthouse Lives in the Past," *Houston Chronicle,* July 23, 1973; Barbara Canetti, "Hogg Building Added to Register of Historic Places," *Houston Post,* September 7, 1978; Charlie Evans, "Historic Pappas Building to Be Restored," *Houston Chronicle,* May 21, 1978; and Madeleine McDermott Hamm, "Hogg Building Made Frank Glass a Believer," *Houston Chronicle,* August 26, 1979.

101. Information about the Armor Building derives from Fox 1990,

52, and from A. Wilson 1978. Architectural historian Ann Q. Wilson has suggested that Hogg may have met Charles Erwin Barglebaugh, a Dallas and El Paso architect and engineer and protégé of Frank Lloyd Wright and Charles Burley Griffin, and Lloyd R. Whitson through their advances in oil storage engineering.

102. *Houston Chronicle,* February 6, 1921, 20; rooftop gardens were not a novelty in Houston. The Rice Hotel and the Rossonian apartments featured lawns and gardens in the sky (conversation with Stephen Fox, February 1998).

103. This descriptive phrase derives from A. Wilson 1978, 4, item no. 8.

104. *Houston Chronicle,* February 6, 1921, 20.

105. See Murray 1976, 16–17, in which Murray claims Carroll, founder of the *Vanities,* was "the first man to build a penthouse in New York, where he had a star-swept bungalow constructed on top of the office building at Seventh Avenue and 49th Street—and rumors about the scandalous goings-on at the colorful apartment were the talk of the town."

106. When approached about the possibility that the solarium functioned as a "bagnio," Will Hogg reportedly responded, "I don't care what they think or say as long as Mike and Raymond Dickson [longtime friend and business partner] will visit my grave once in awhile" (Lomax 1940 [1956], 11). In his diaries, Hogg frequently referred to the solarium as a "nuthouse."

107. See A. Wilson 1978, 3, item no. 8.

108. Ibid., and conversation with Stephen Fox (February 1998).

109. Ima Hogg, quoted in Dolph Frantz, "Victory Garden Flourishes atop Eight-Story Houston Building," *Houston Press,* April 22, 1943.

110. Dorothy M. Hoskins, "American Furniture of Early Date," *Civics for Houston* 1, no. 6 (June 1928): 6–7, 23–24.

111. Ima Hogg, foreword, in Warren 1975, vii.

112. Ibid., viii.

113. Bernhard [1984] 1996, 62.

114. Wright 1930a, 23. The rare collection of perfume bottles has been carefully preserved by Alice C. Simkins, the niece of Mike Hogg through his marriage to Alice Nicholson Hogg (later Mrs. Harry Hanszen).

115. Miss Hogg suggested the room's French doors and decorating scheme and specified the details of windows, door facings, and floors. A letter from Ima to Will dated November 8, 1920, makes clear that she is initiating the colonial scheme for the office library (IH Papers, Box 3B119).

116. Ima Hogg ("Missima") to Will Hogg ("Podsnapper"), January 21, 1921 (IH Papers, Box 3B119).

117. Will Hogg to Ima Hogg, January 29, 1921 (IH Papers, Box 3B119). Much of Will Hogg's shopping for antiques was conducted in New York City at Collings and Collings, Weil's, Franke Galleries, Smith and Jones, and the English Antique Shop, among other places.

118. Will Hogg ("Misswillie") to Ima Hogg ("Miss Ima"), February 28, 1921 (IH Papers, Box 3B119).

119. Ima Hogg to Will Hogg, January [8?], 1921; Will Hogg to Ima Hogg, November 1, 1922 (both IH Papers, Box 3B119). This object undoubtedly refers to the wall clock on display at Bayou Bend and listed in Will Hogg's 1934 Park Avenue apartment inventory (fig. 12). See Warren et al. 1998, 114, F83.

120. Will Hogg to Ima and Mike Hogg, March 7, 1921 (postdated) (IH Papers, Box 3B119).

121. Will Hogg to Ima Hogg, October 7, 1920 (IH Papers, Box 3B119).

122. Scrapbook kept by Sarah Raymond, first curator of the Frederic Remington Art Museum (FRAM, Ogdensburg).

123. See Hunt 1967. Cole was a Princeton graduate, medical doctor, and successful tube tire valve inventor.

124. Hogg paid top dollar for his Remingtons in the 1920s, spending nearly fifty thousand dollars on his work during his first year of collecting alone. Had Hogg been alive during the Depression, when prices plunged, he could have bought Remington's paintings at nearly half the sum they would have realized in the 1920s, as did such subsequent collectors as Fort Worth's Amon Carter and Tulsa's Thomas Gilcrease.

125. Saunders 1988, 26. This book provides an excellent account of the history of patronage of Western art, as well as the first scholarly assessment of Will Hogg as a collector of Remington's art (37–38).

126. Ibid., 38.

127. Guy McLaughlin to John A. Lomax, April 12, 1939 (John A. Lomax Family Papers, the Center for American History, the University of Texas at Austin, Box 3D205). In this same letter, McLaughlin commented on the "terrific Americanism" of Hogg and his "perception of the finest and most virile in our art."

128. Ballinger 1989, 152–53. Ballinger mistakenly believes that Hogg collected at the same time as Carter and others when, in fact, his collecting of Remington began in 1920, predating by more than a decade the other collectors he discusses (Carter, Richardson, Gilcrease, and Norton).

129. C. R. Smith, quoted in John Minahan, "C. R. Smith: Reflections," *American Way,* April 1976, 22.

130. See Joseph Nocera, "The Arriviste Has Arrived," *New York Times Magazine,* November 15, 1998, 69.

131. See Harris 1997, 115–20. Harding formed his collection in the 1920s and 1930s.

132. See WCH Papers, Box 2J294; conversation with Emily L. Todd (September 1998).

133. *The Mountain Man* is now in the collection of the Jack S. Blanton Museum of Art, Austin (acc. no. 1986.177). By 1916, when Cullinan established the residential subdivision of Shadyside, he named the major thoroughfares Longfellow Lane and Remington Lane, undoubtedly in tribute to cultural figures he considered American heroes (Hogg himself would echo this sentiment when he initially named the Homewood Addition of River Oaks Contentment, after the painting by George Inness with the same title that he had acquired for his Houston home and exhibited to great acclaim in the museum's opening installation in 1924. The current location of the Inness painting is not known. See Houston Art League Scrapbook, Archives, MFA, Houston, RG19, Series 1).

134. See Cotner 1959, 534.

135. Theodore Roosevelt to Arthur W. Little, in "An Appreciation of the Art of Frederic Remington by Theodore Roosevelt," *Pearson's Magazine,* October 4, 1907, 392–93, 395.

136. See R. Wilson 1971, 153–56.

137. Cotner 1959, 571.

138. See Will Hogg's diary entries for September 15, 17, 21–25, and 28, 1920 (WCH Papers).

139. Will Hogg to Ima Hogg, June 16, 1927 (WCH Papers, Box 2J329).

140. See Hassrick and Webster 1996, 1:21. Merle Johnson, who had

culled Remington illustrations and articles from magazines and books and mounted them on cards, sold one set of his compilation of materials to the New York Public Library only in 1929 and another set to the Denver Public Library in 1932.

141. "Works of Frederic Remington: Hogg Brothers Scrapbook," 1898–1929. Archives, MFA, Houston, Public Relations (RG8), Newsclippings (Series 1), Scrapbooks (Subseries 1).

142. Hogg tended to buy Remingtons in bulk. Like all major collections of Remington's work, Hogg's, too, included some spurious works. A letter Will Hogg wrote to his secretary on July 31, 1924, indicates that he knew that some of his paintings were not right, or "junk" (WCH Papers, Box 2J349). A large percentage of the spurious Remingtons in Hogg's collection came from the George H. Ainslie Galleries in New York. See Hassrick and Webster 1996, 1:29–32, for a discussion of copies, fakes, and forgeries of Remington's work.

143. See Wright 1930a, 6, in which he refers to Will Hogg's painting of *A Cavalry Scrap* in the Hogg Brothers offices: "On the wall of his office was a huge canvas of an Indian fight, twenty feet long. He got it at an amazing bargain, and cussed the Eastern millionaire who had been willin' to sell it for so little." The "Eastern millionaire" was the estate of John Jacob Astor. Letters in FRAM, Ogdensburg, detail the handling of the sale of *A Cavalry Scrap* from the Astor estate. Will Hogg was working through George H. Ainslie, New York, but a mural decorator, William Andrew Mackay, in New York, was trying to sell the painting directly to FRAM in 1924. On May 22, 1924, William "Billy" Mackay wrote to John Howard of the Remington museum: ". . . it is with some depression that I am writing to you. As matters stand today, an Art Museum in Houston Texas closed with Ainslie before the arrival of your first letter with the offer" (FRAM, Ogdensburg, Folder 83.5.28–.31). It is almost certain that William Mackay learned about Will Hogg and the Hogg family through this failed transaction. Three years later, in 1927, he designed and painted the walls of the dining room at Bayou Bend with a scene of flowing dogwood and peonies over gilded canvas.

144. For example, with great enthusiasm, Hogg wrote to Irvin Cobb, "I enclose a new Remington I just got. It's a real peach." The painting (*Aiding a Comrade,* cat. no. 2) was the same one that he wired Ima Hogg to go see the very same day. Will Hogg to Irvin S. Cobb, June 23, 1922 (WCH Papers, Box 2J305).

145. It is interesting to note that all of these writers and folklorists mentioned emphasized the Western character of Texas as an egalitarian frontier rather than as a Southern planter aristocracy—the same kind of frontier elaborated in the work of Remington.

146. Ima Hogg to Will Hogg ("Podsnap"), January 15, 1930 (WCH Papers, Box 2J329).

147. Will Hogg to Ima Hogg, July 22, 1930 (IH Papers, Box 3B119).

148. Hogg's interest in Inness arose at the same time he began collecting artworks by Remington, probably inspired by George H. Ainslie, who had been exhibiting Inness's work. It may also have been piqued by the George M. Dickson Bequest of art to the MFA, Houston, in 1919, which included the Inness painting *Landscape* (1864, acc. no. AL.15), acquired from John Levy Galleries, New York. During the fall of 1920, he visited the Butler Gallery of Innesses at the Art Institute of Chicago. He went on to collect a few small-scale examples of such American landscapists as Inness, Homer Dodge Martin, Arthur Spear, Alexander Wyant, Willard Leroy Metcalf, and Francis J. Murphy. Works acquired by Will Hogg in the museum's collection include those by Metcalf (41.28), Martin (48.11), Murphy (48.12), and Alexander Wyant (TR:22–72).

149. Will Hogg bought Edward Hicks's *Penn's Treaty with the Indians* (c. 1830–40) out of the Jacob Paxson Temple Collection of early American furniture and objects of art sale at Anderson Galleries, New York, January 23–28, 1922, lot 1319 (see Warren et al., 203–4, P42).

150. Ima Hogg to Will Hogg, July 4, 1926, written when she was aboard the SS *Olympic* (WCH Papers, Box 2J349).

151. Lomax 1940 [1956], 48.

152. Will Hogg to Tom Hogg, quoted in Bernhard [1984] 1996, 66–67.

153. Henry Stude to John A. Lomax, April 21, 1939, John A. Lomax Family Papers, the Center for American History, the University of Texas at Austin, Box 3D205.

154. The Hogg family's commitment to the museum continued with Alice Nicholson Hogg Hanszen, the wife of Mike Hogg, and is sustained today by the longtime support and generosity of their niece, Alice C. Simkins. In 1965, Mrs. Harry Hanszen gave 173 pieces of pre-Columbian stone and terracotta. Other gifts include Claude Monet's *Water Lilies* (68.31), Ferdinand Bol's *Woman at Her Dressing Table* (69.4), Benvenuto di Giovanni's *Saint Francis* (70.36), and gifts to Bayou Bend of Worcester porcelains and American silver. She also funded the acquisition of a sideboard, attributed to the New York cabinetmaker Joseph Meeks and Son, at Bayou Bend (Warren et al. 1998, 135–36, B.67.6, F219). Since 1975, Alice C. Simkins has given the museum over seventy-five works of art, including Edward Hicks's *Penn's Treaty with the Indians* (B.77.46), Paul Sérusier's *Landscape at Le Pouldu* (79.255), Jean Metzinger's *Woman with Grapes* (95.221), Edouard Vuillard's *Marcel Aron (Madame Tristan Bernard)* (95.222), as well as English and American ceramics, American glass, pottery of the American Southwest, photographs, American and English silver, prints, and works on paper.

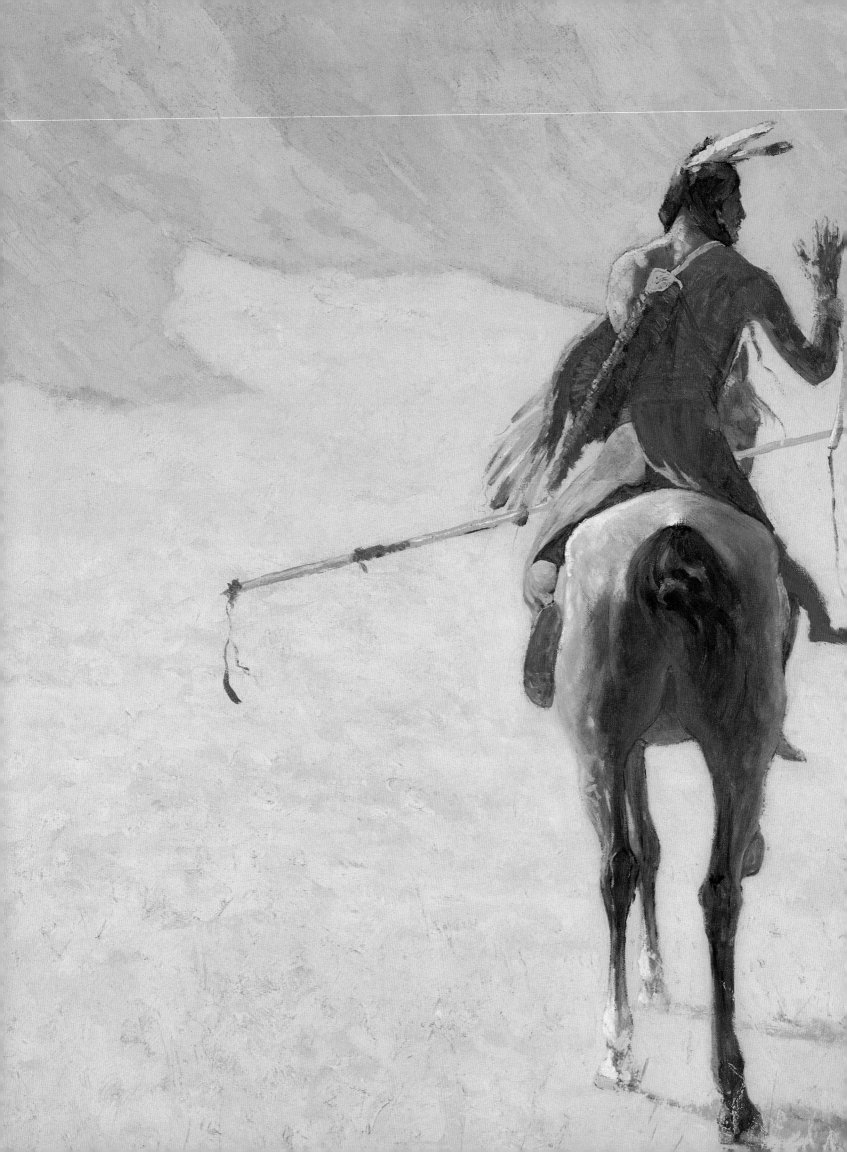

CATALOGUE

1. *The Lookout*

1887

Oil on canvas, 26 x 22 in. (66 x 55.9 cm)

Signed and dated at lower left: Frederic Remington / '87

The Hogg Brothers Collection, gift of Miss Ima Hogg[1]

Acc. no. 43.19

At the time Frederic Remington painted *The Lookout,* he had just started his career as an illustrator for *Harper's Weekly* and other popular magazines, including *Harper's Young People, St. Nicholas Magazine,* and *Outing.* These early illustrations from the mid-1880s initiated an enduring association in popular culture between Remington and the American West and marked the beginning of a classic American success story, achieved through persistence, grit, honed talent, and business savvy.

Born in Canton, New York, in 1861, Remington was the son of Seth Pierpont Remington, a journalist, port collector, and major in the Union Army during the Civil War, and Clara Sackrider Remington, the daughter of a respectable family in Canton, a thriving town in upstate New York. Remington attended two military academies, Vermont Episcopal Institute in Burlington, Vermont, and Highland Military Academy in Worcester, Massachusetts. His college years were spent in New Haven, Connecticut, where Remington attended Yale's School of Fine Arts for one and a half years, taking classes in drawing and painting from John Ferguson Weir and John Henry Niemeyer and playing as a starting forward in the new college sport of American football. Following his father's death in 1880, Remington dropped out of college and spent his inheritance, first on a sheep ranch in Kansas, then on a saloon in Kansas City. Neither enterprise was successful, but the experience of living in the West gave Remington the opportunity to travel throughout the Southwest and Mexico and to record the changing and dramatic terrain, as well as its inhabitants. He then returned to New York to his wife, Eva Caten Remington, whom he had married in 1884, and started taking classes at the Art Students League for a few months, resolving to become an artist.

The year 1887 introduced one of the many paradoxes of Remington's career. Remington wanted to transcend the limiting and somewhat ordinary category of "illustrator." In 1887, the year he painted *The Lookout,* he displayed a watercolor and an oil painting in a public exhibition for the first time, surely a sign of his eagerness to measure public opinion of his work and his ambition to become a great

American painter. His growing reputation as an authority on the West and as an interpreter of Western life was essential to his success as an illustrator, but this association also threatened his quest for artistic fame: in most critical reviews until late in his career Remington the reporter or historian was recognized while Remington the painter was not, as if the two enterprises embodied irreconcilable differences. One of the paradoxes was that Remington's "reports," although usually based on a combination of actual events and regional lore, were artful fictions, as sophisticated and compelling as the literary work of Owen Wister and Theodore Roosevelt, similar purveyors of popular Western culture who operated from the Eastern seaboard and who would later become Remington's colleagues.

In *The Lookout,* a man on horseback surveys the sparse, sunbaked plains below as he poses against a mottled sky and a generic Western landscape, dashes of blue designating distant mountains. Thin washes of paint indicate background topography and thick, impasto surfaces suggest the foreground as a rocky precipice, providing the vaguely Western context for the subject. This early effort is relatively crude in its technique and execution, yet it hints at

Fig. 1 Frederic Remington, *On Outpost Duty.* Illustrated as wood engraving in "Besieged by the Utes, the Massacre of 1879," *Century Magazine,* October 1891, 838. The Museum of Fine Arts, Houston, gift of Dr. Mavis P. and Mary Wilson Kelsey (TR: 302.1–79)

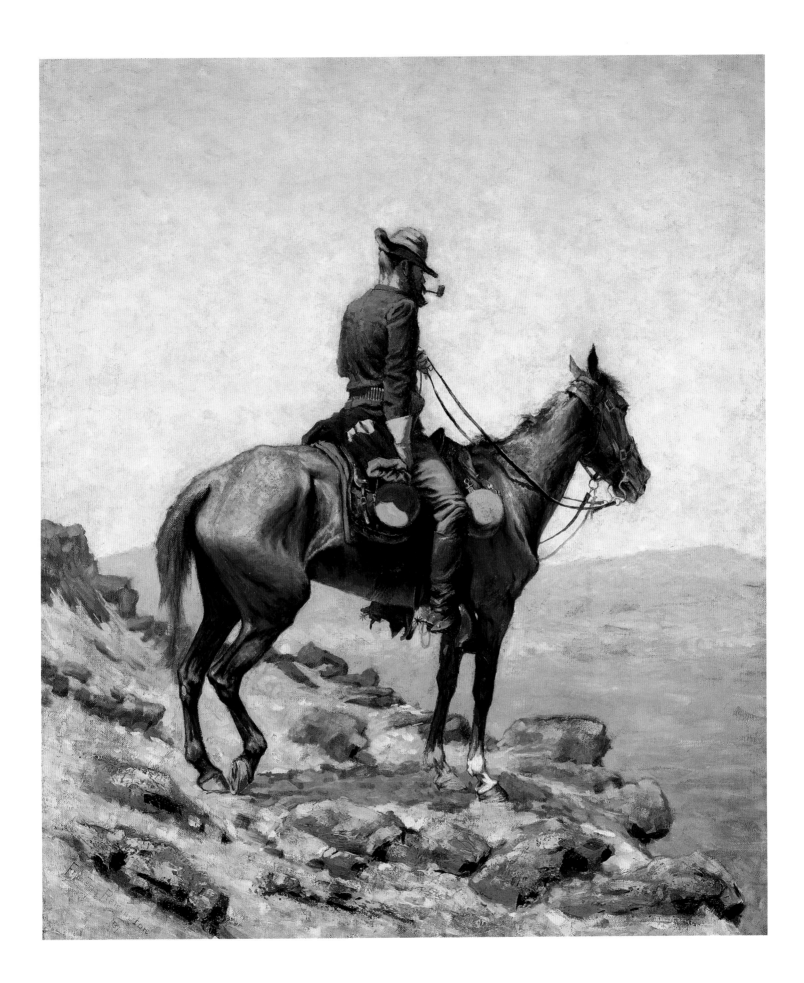

the salient features that would characterize Remington's work throughout his career: patterned mountain backgrounds in blues and purples set off by vast areas of space described in rosy pinks or yellows; conventional, centered compositions; subjects carefully delineated with tight brushwork and minute detail; and, finally, a compelling story line. Like any good history painter, Remington convinced his viewers of the truth of his scenes with meticulously recorded details—the horse's shod hoof, the carefully defined bridle, pannier, canteen, and spurs—all acting as guarantors that Remington knew his subject matter well and had witnessed the scene he depicted.

Minutiae helped to make Remington's paintings look authentic, but it was his gift as an illustrative storyteller that assured his success. Here, for example, the released hind leg of the horse, in combination with the pulled reins of the scout, may indicate two scenarios: either moments before, the horse and rider paused at the edge of the rocky precipice, or the scout is reining in his horse, who switches his hind legs back and forth to relieve boredom. In any case, poised for imminent danger, the scout puffs on his pipe—the only relief from the tedium of his watch. Remington barely etches the figure's expression, yet the subject's gloved hand resting against his holster and his erect posture suggest an alertness that is echoed in the attentiveness of the horse. Both the danger and the loneliness implicit in the rider's activity form the "story" of the painting. Remington also implies two levels of seeing— the viewer watching the scout and the scout watching for foes. By transferring the scout's alertness to the viewer, Remington heightens the element of danger and transforms an ordinary scene of a man on a horse into a study of survival.

To some degree, Remington followed the paths of such earlier American artist-explorers and artist-ethnographers as Frederic Church and George Catlin. He also carried on the traditions of antebellum American genre painters such as Charles Deas, George Caleb Bingham, and William Tyler Ranney. These artists created a colorful archive of Western character types—mountain men, trappers, and other frontiersmen—encountering the dangers and strangeness of the Western territory for the benefit of a largely East Coast male audience.[2] These earlier artists presented Western stereotypes in an attempt to make the vast unknown territories and their inhabitants more easily understood, either as threats to national sovereignty as these territories were becoming states or as sources of egalitarian strength and power. Although he was painting soon

after the West had already been transformed in the name of "progress," Remington captured and categorized vanishing Western types, creating and nurturing a nostalgic view of an essential American manhood based on courage, toughness, and independence—or, as he characterized it, "men with the bark on."[3] The lonely scout of *The Lookout*, poised on a precipice and silhouetted against the sky as he surveys the landscape for signs of possible foes, embodies this manly ideal.

Remington frequently recycled motifs and images from his illustrative work and used them in his paintings. In this instance, however, the painting was used to create a later illustration for the October 1891 issue of *Century Magazine* (fig. 1).[4] Titled *On Outpost Duty,* the slightly altered image accompanied the article "Besieged by the Utes, the Massacre of 1879," which recounted in detail the military campaigns against the Utes, including gruesome descriptions of slaughter alongside warnings to the reader that "with the Indian as a foe we must always be prepared, and especially careful when he seems most friendly and still holds on to his rifle." Either Remington or the engraver modified the rocky precipice, sharpened the background mountain detail, and added such military features to the scout as a scabbard and sword and military jacket. The point in the story where the illustration appears describes a surprise attack on the troops from Utes once believed to have been friendly. The juxtaposition of the image of vigilance alongside text describing the assault thus underscores the importance of military alertness, providing a different context altogether for understanding the original image.

1. Note on provenance: During his energetic first round of collecting Remingtons for the Hogg Brothers offices in Houston, Will Hogg purchased *The Lookout* in September from John Levy Galleries in New York. According to his diaries, that day he paid $7,700 for this painting and *The Emigrants* (cat. no. 19), acquiring in his day's haul one of Remington's earliest oils, an ambitious effort to capture loneliness and danger on the frontier, and a mature tour de force of the life-and-death struggle between white colonists and Native Americans—both classic themes in the Remington repertoire.

2. Johns 1991, 66–99.

3. Remington to Poultney Bigelow, January 29, 1893, in Splete and Splete 1988, 157. *Men with the Bark On* (New York: Harper and Brothers, 1900) is also the title of an anthology of Remington's articles for *Harper's Weekly* from between 1898 and 1900.

4. Hassrick and Webster 1996, 1:83, no. 82.

2. Aiding a Comrade (Past All Surgery)

1889–90

Oil on canvas, 34 x 48 1/8 in. (86.4 x 122.2 cm)

Signed at lower left: FREDERIC REMINGTON

The Hogg Brothers Collection, gift of Miss Ima Hogg[1]

Acc. no. 43.23

Aiding a Comrade is among the first major paintings by Remington to depict horses and riders rushing headlong into the viewer's space. It relates closely to another painting from about the same time, *Dismounted—The Fourth Troopers Moving the Led Horses* (Sterling and Francine Clark Art Institute, Williamstown, Massachusetts).[2] Both were painted after his success with *Dash for the Timber* (1889, Amon Carter Museum, Fort Worth), which featured a posse of cowboys chased by Apaches and riding to the woods for cover (fig. 1). *Dash for the Timber* included two figures riding toward the viewer, a precursor for these slightly later works in which viewer and fictive space col-

lide. According to a letter that Remington wrote to Lt. Powhatan Clarke, a friend who had furnished him with details of army life in the West, the success of *Dash for the Timber* in the exhibition held at the National Academy of Design, New York, during the fall of 1889 had generated new commissions for the artist for works based on similar subjects, including *Aiding a Comrade*.[3] The latter represents a variation on the theme of speed established in *Dash for the Timber*, and, in fact, the artist probably envisioned *Aiding a Comrade* as a serial image related to it. Infrared reflectography reveals that Remington originally placed a wooded landscape at far right in *Aiding a Comrade*, as if

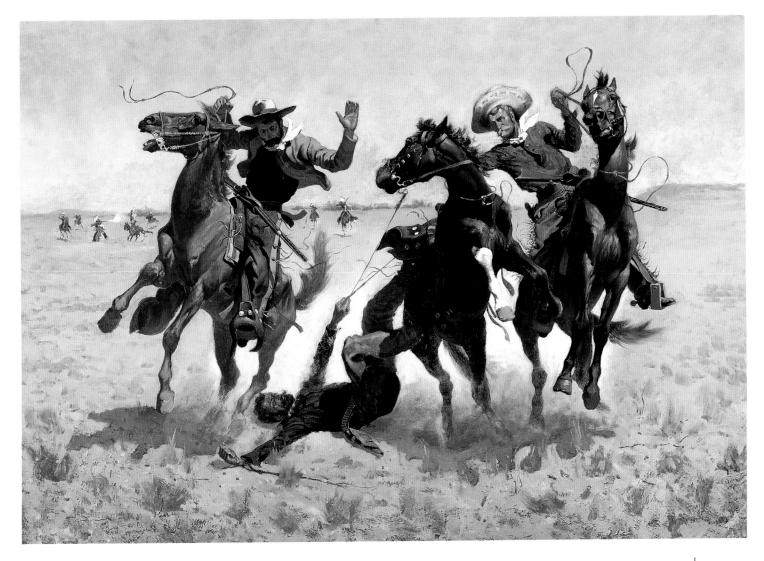

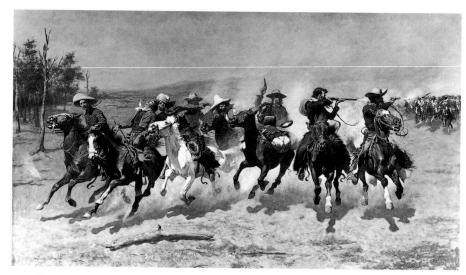

Fig. 1 Frederic Remington, *Dash for the Timber*, 1889. Oil on canvas, 48 1/4 x 84 1/8 in. (122.6 x 213.7 cm). Amon Carter Museum, Fort Worth, Texas (1961.381)

Fig. 2 Rosa Bonheur, *The Horse Fair*, 1853. Oil on canvas, 8 ft. 1/4 in. x 16 ft. 7 1/2 in. (244.5 x 506.7 cm). The Metropolitan Museum of Art, gift of Cornelius Vanderbilt, 1887 (87.25)

these cowboys had just emerged from the woods seen at left in *Dash for the Timber* and were continuing straight into the viewer's space.

Against a parched landscape, three cowboys on horses make their escape from the more vaguely defined Plains Indians chasing them. The central figure tumbles from his horse while the cowboys flanking him make attempts to prevent his crashing fall to the ground. The somber-faced men do not show anguish or terror; rather, they appear calm and unruffled, while the flailing horses with eyes bulging and nostrils flared convey the true fear and pending horror of the scene. Such details as the bright white foreleg of the central horse and the blazing orange inner lip of the horse at right cause the horses to virtually jump out of the picture plane, a strategy for eclipsing the distance between viewer and subject. A white cloud of stirred-up dust provides a neutral background for silhouetting the figures. To lend further immediacy, Remington employs suspense, a literary device common in the eighteenth century and one that eighteenth-century history painters such as

John Singleton Copley employed; the action is frozen at its most perilous moment to heighten the drama and tease the viewer. The painting's original title, *Past All Surgery*, a medical euphemism for hopelessness, however, makes it clear despite the element of suspense that the fallen figure will not stand a chance and that the contested ground on which the figures race will soon be littered with a trampled, bloodied body.

The extraordinary emotional power of Remington's horses—a point that critics have conceded at every stage of his career—owes much to the animal paintings he surely studied in the growing collection of European paintings owned by the Metropolitan Museum of Art, New York, in the late 1880s. While art historians have noted Remington's artistic debt to the scenes of military life and horse pageantry in the work of Jean-Louis-Ernest Meissonnier, Alphonse-Marie de Neuville, and Jean-Baptiste-Edouard Detaille on view at the Metropolitan, Remington undoubtedly also responded to the wild, rearing horses of Rosa Bonheur's *The Horse Fair* (1853), an enormous and instantly

popular painting given by Cornelius Vanderbilt to the Metropolitan in 1887 (fig. 2), as well as to Horace Vernet's *The Start of the Race of the Riderless Horses* (by 1820), which likewise depicted the extreme movements of horses in action. Remington's own photographic archive, including photographs he took with his Kodak and those he purchased, also provided the artist with some assistance in capturing equine anatomy and movement, as well as the effects of bright light on a horse's skin and the patterns of shadows a horse casts on the ground (fig. 3). Equipped with these various approaches to depicting the horse— firsthand observation, the study of paintings by other artists, and documentary photography—Remington quickly emerged as one of the most talented artists to work in the tradition of equine painting, although he applied this talent to genre painting rather than to horse portraiture.

During the spring of 1890, Remington exhibited *Aiding a Comrade* with the American Art Association in New York, where twenty of his works appeared with those of nine other artists, including J. Wells Champney and William Merritt Chase.[4] For the art critic of the *New-York Tribune,* Champney's soft pastels provided the perfect foil for locating Remington's place in the art world at the time:

Fig. 3 Frederic Remington, right, and an anonymous groom observing a horse's movement and the highlighting effects of sunlight and shadows, at Remington's home in New Rochelle, New York, after 1889. Frederic Remington Art Museum, Ogdensburg, New York

> *Mr. Remington, on the other hand, cares nothing for prettiness or refinement of manner, and the ruggedness of his work is emphasized by the contrast with Mr. Champney's extreme suavity. But the work which Mr. Remington is doing will have a historical value. His pictorial record of the conflict between savagery and the agents of civilization in the far West may become of as permanent usefulness in its way as Catlin's ethnographical studies. For Mr. Remington paints the Indian, the trapper, the soldier and their ponies, horses and equipments from actual knowledge, and he represents real phases of a life which is rapidly passing away. He shows us cowboys or prospectors making a dash for the timber with a band of "hostiles," perhaps Apaches, close behind [a reference to* Dash for the Timber]. *The same motive reappears in "Past All Surgery,"* [Aiding a Comrade] *where one of the pursued falls headlong from the saddle, and his comrades, failing to catch him, must keep on in the race for life These studies are illustrative rather than pictorial, but they are true to the life, they are forcibly expressed, and their peculiar value and great interest are unquestionable.[5]*

Having difficulty contextualizing Remington with his peers and judging his works of "peculiar value," the critic positions Remington as a historian, ethnographer, and authenticator of a passing American West rather than as an artist of pictorial values. This view was a mainstay of the

criticism of Remington's work until later in his career. Even more revealing here, however, is the critic's characterization of Remington as one who "cares nothing for prettiness or refinement of manner" and as a painter of the rugged— that is, as a painter dismissive of the so-called feminine traits of refinement and engaged instead in promoting aggressive and primitive ideals of masculinity. Although the critic does not discuss the male/female dichotomy he sets up to describe Remington, his comments are astute, for these were adjectives and descriptions that Remington himself used to describe his own work. For him, a painting was a failure if it looked "too ladylike" or "pretty," terms he used in his diaries.[6] The critic was right in associating Remington with cultural notions of masculinity; he was a major participant in promoting the changing ideals of American manhood in late-nineteenth-century American culture. The fear that men of the urban age had allegedly become soft (they exercised the mind rather than the body) prompted concerted efforts to reinvigorate the American male in order to ensure the nation's continuing vitality. Outdoor adventures and athleticism were promoted as healthy restoratives for the withering effects of big-city industrialization, and many American artists of the time contributed to perpetuating the ideal of the strenuous life.[7] Like his peers Winslow Homer and Thomas Eakins, with, respectively, raw, primal images of the Maine coast and of lean, muscular boxers and scullers, Remington redefined American art along traditionally masculine lines.

Remington may have been viewed by the public as he was by the *New-York Tribune* critic: first and foremost, as an ethnographer and historian of the American West. But his scouts, trappers, and soldiers had relevance in the modern world, too, for they represented a new set of ideals championing a primitive masculinity predicated on stoic courage and steely grit. When the critic described the cowboys' "race for life," the phrase resonated on two levels: the effort to escape the Native Americans—the "savages" of the West—and a Darwinian struggle for survival through aggression, cunning, and what Theodore Roosevelt would characterize as the "wolf ris[ing] in a man's heart," adopted behaviors calculated to revitalize the American male.[8] By employing suspension as a narrative device and creating a head-on collision between viewer and fictive space, Remington thrusts the viewer into the action and provides vicarious and exotic terror far from the familiar safety of the East Coast and its urban centers. Remington's *Aiding a Comrade* thus contributed to a growing library of therapeutic images that sought to reclaim and reestablish male virility in American culture.

1. Note on provenance: On June 23, 1922, Will Hogg sent a telegram to his sister Ima, who was then visiting New York, requesting that she "Go to Howard Young Galleries, 5th Ave., and see new Remingtons I just bought and write me what you think of it" (IH Papers, Box 3D, 119). Her response is unknown, but Will's telegram surely implies excitement and pride at his newest acquisition, and indicates that collecting was a serious and shared activity between the siblings. *Aiding a Comrade* is one of the Remingtons Hogg bought that summer at Young's and

ranks among the very best of his collection.

2. At about the same time, Remington also painted at least two black-and-white images that similarly depict head-on confrontations: *Indian Horse-Race-Coming over the Scratch* (c. 1889, collection of Cindy and Alan F. Horn) and *Dragging a Bull's Hide over a Prairie Fire in Northern Texas* (c. 1888), known from a wood engraving that appeared in *Harper's Weekly,* October 27, 1888, 826–27.

3. Remington to Lt. Powhatan Clarke, December 1, 1889, in Splete and Splete 1988, 74.

4. American Art Association, *American Paintings: Catalogue of Paintings Exhibited by the Following American Artists: J. Wells Champney, A.N.A.; William M. Chase, A.N.A.; Charles Melville Dewey; C. Harry Eaton; F. K. M. Rehn; D. D. Millet, N.A.; Robt. C. Minor, A.N.A.; H. R. Poore, A.N.A.; Frederick [sic] Remington; Carleton Wiggins at the American Art Galleries* (New York: American Art Association, 1890), 6, no. 19. The painting was exhibited with the title *Past All Surgery.* Remington exhibited the painting once more during his lifetime, in 1898 at the Albany Historical and Art Society (*Loan Exhibition of Oil Paintings and Water Colors* [Albany, N.Y., 1898], 13, no. 57).

5. "The American Art Galleries: The Work of Ten American Artists," *New-York Tribune,* April 8, 1890, 10, col. 1.

6. For example, these gendered adjectives appear in Remington's diaries for the entries dated August 19, 1907, and February 22, 1908. The artist's diaries, dating from 1907 until his death in 1909, are located at the Frederic Remington Art Museum (hereafter cited as FRAM), Ogdensburg, New York.

7. On this subject and its relationship to the art of Winslow Homer, see Burns 1995, 28.

8. Theodore Roosevelt, quoted in Kathleen Dalton, "Theodore Roosevelt and the Idea of War," *Theodore Roosevelt Association Journal,* 7 (Fall 1981): 7, quoted in Rotundo 1982, 306. See also Michael S. Kimmel, "The Contemporary 'Crisis' of Masculinity" in Brod 1987. For Remington in the context of theories of social evolution, see chap. 1, "Stirring and Crawling," in Nemerov 1995, 7–52.

3. The Transgressor (The Apache Trail; Tio Juan Hanging There Dead!; The Way of the Transgressor)

1891
Oil on canvas
33 1/8 x 23 1/8 in. (84.1 x 58.7 cm)
Signed at lower right: FREDERIC REMINGTON
The Hogg Brothers Collection, gift of Miss Ima Hogg[1]
Acc. no. 43.12

In *The Transgressor,* a bright blue cloudless sky sets off the bold expanse of a barren cliff, indicated by pink and beige scumbled paint laid on with a palette knife. The steep diagonal sweep of the cliff suggests its imposing height and leads the viewer's eye toward the pitiless figure of a man strung up with rope and left dangling over the edge. At lower left, a group of men on horseback in the distance makes its way over a narrow trail toward the figure. Except for the shadows indicating the crevices of the cliff and a tiny agave plant emerging against the blue sky, the scene is one of desolation, unrelieved and unmarked by extraneous detail, the unforgiving topography reinforcing the brutal and grisly subject matter.

Remington was well aware of the sensational aspects of this painting, describing in a letter of September 1891 to his friend Lt. Powhatan Clarke, "I have done *horror*—"The Mex. Sheapherder [*sic*] in Apache Land—dead withered body hanging by one leg over a cliff. . . . It's a regual [*sic*] 'ladies faint' of a picture."[2] Summoning contemporaneous gender assumptions about weak female sensibilities, Remington clearly aimed to shock and titillate his audience with tales of violence on the western frontier. Indeed, in the 1893 exhibition in which it appeared—Remington's first solo exhibition—critics singled it out, one calling it "remarkable."[3]

According to Remington's letter to Clarke, *The Transgressor* was inspired by a story he had heard "years ago in Arizona."[4] Two years after Remington conceived the painting, Maurice Kingsley published "Tio Juan," a story that described the same event for the February 1893 issue of *Harper's Monthly,* using Remington's image as an illustration for the story. Kingsley's account described Apache violence and savagery in the desert southwest of the Mexico-Texas border. While playing cards with a group of vaqueros and other "exotic" types, Diamond Brand Bill met a frightened child who told the gruesome tale of how his grandfather Tio Juan was killed by Apaches. Kingsley vividly

described Tio Juan's tedious existence as a Mexican sheepherder, doomed to lead "an unending round of lifeless life." Kingsley continued, explaining that one day Tio Juan, who had heard the sound of galloping horses and suspected the approach of Apache foes, ordered his grandson to run. When the boy returned a day later, he discovered the food stolen, the sheep scattered, the dogs murdered, and, finally, he saw the body of Tio Juan suspended from a cliff "hanging there dead." The terrified boy raced to the town of Ojo Caliente and begged a group to return to the scene to bury Tio Juan; the men on horseback who appear at the lower left of the canvas illustrate this passage in the story. Kingsley described their discovery of the corpse with explicit detail:

> the brown body hanging, ghastly, against the white cliff. . . . the poor corpse, baked and shrivelled in the fierce heat of that ovenlike atmosphere. . . . One ankle, cut through flesh and sinew to the very bone, sustaining the whole weight of the body by the rawhide dangling from the old maguey plant, showed it had been suspended there alive. This was Apache work. . . . the mummy form, with eyeless sockets and drawn parchmentlike skin, drained of blood and moisture, was placed under a pile of stones.

Kingsley's tale of Western primitivism and atrocity was inspired by Remington's painting, in which the figure of an emaciated man with a long beard, stringy hair, and gleaming teeth and wearing sandals and a sheepskin around his waist, suggests a half-man, half-beast low on the scale of human evolution, and reddish brown pigments touched with white in the figure's face indicate gouged eyes and exposed viscera. The gruesome text and painting complement one another, evoking a West populated by wild Mexicans and savage Apaches, as well as comical white men and vaqueros at least civilized enough to make a proper burial for a poor man. And yet, despite Kingsley's condescension toward most of the characters, including the

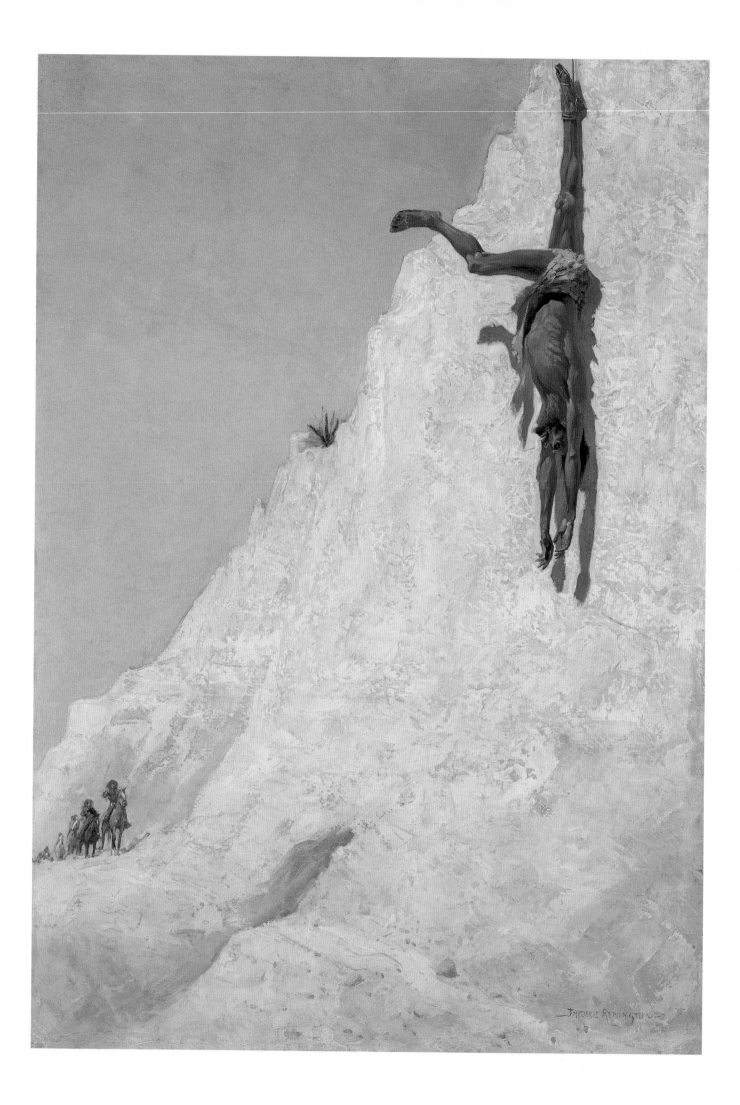

animal-like Tio Juan, the sheepherder may be perceived with sympathy. Tio Juan is, after all, the victim of the most fearsome of foes described in American pulp fiction and film: the Apache. In fact, both in the text and the painting Tio Juan, described as a pious, kind, poor man, connotes the Christian martyr, an image that has been a staple in European art since the Renaissance and one that provided an opportunity to display an artist's skill in rendering the male nude. That Remington concerned himself with the effectiveness of the figure is demonstrated in another letter to his friend Clarke, in which he asks, "Did you see Tio Juan—last Harper's Magazine? How do you like the anitomical [sic] study?"[5] Tio Juan's poverty allowed him little food or clothing, but as an element of the story, the sheepherder's condition provided Remington with the opportunity to exercise his skills in detailing a human figure with all its muscles and bones carefully defined. Remington undermined the traditional concept of the Christian martyr—often depicted as a male nude pierced by arrows or raised upside down on a cross—by creating a counterpart in a Mexican sheepherder of the Western frontier. In this early painting, Remington imaginatively ingratiated Western character types into the elite echelon of Old Master painting and confirmed the estimation, as one critic wrote, that "Mr. Remington is a new and original force in our American art."[6]

1. Note on provenance: According to Will Hogg's personal diary, *The Transgressor* was the first documented purchase of a Remington painting for his new offices. On September 15, 1920, he acquired this painting for $1,500 and E. I. Couse's *The Tobacco Bag* for $650 from J. W. Young American Art in Chicago. Like the occasional painting by George Inness or Willard Metcalf that Will Hogg collected for his New York apartment or Houston home, the Couse was an anomaly in his collecting, and Hogg thereafter focused on collecting Remingtons of various subjects and media rather than a representative sampling of Western or Taos school artists.

2. Remington to Lt. Powhatan Clarke, September 8, 1891, in Splete and Splete 1988, 121–22.

3. American Art Association, *Catalogue of a Collection of Paintings, Drawings and Water-Colors by Frederic Remington, A.N.A.* (New York, 1893), no. 30, as *The Apache Trail*. The artist's first solo exhibition and sale, it was accompanied by an exhibition of artifacts that helped to forge, as well as reinforce, Remington's status as an authentic chronicler of the West; this painting was purchased by H. S. Bloodgood. The reviewer of the *New York Sun,* in "Frederic Remington's Paintings and Studies," January 9, 1893, 6, called the painting "remarkable," and the reviewer for the *New York Times,* January 7, 1893, 4, mentioned but did not discuss the painting.

4. Remington to Clarke, September 8, 1891, 121–22.

5. Remington to Clarke, January 24, 1893, in Splete and Splete 1988, 163.

6. "Frederic Remington's Paintings and Studies," 6.

4. Scouts Climbing a Mountain

1891

Oil on canvas, 43 x 20 in. (109.2 x 50.8 cm)

Signed at lower right: FREDERIC REMINGTON / 1891

The Hogg Brothers Collection, gift of Miss Ima Hogg[1]

Acc. no. 43.11

In this painting, Remington chose a narrow, vertical format because it was ideally suited to convey the radically tilted landscape, marked by dangerous winding trails, that he had encountered on his trip to the Dakota Territory. Here, Cheyenne scouts, as part of the United States irregular army, ascend a steep butte to join the rest of the army at its summit. In the foreground, a scout turns in his saddle, perhaps responding to a potential danger in the viewer's space, but also meeting the gaze of the viewer. Remington underscores one of the painting's themes, observing and being observed, by including a figure holding binoculars at the upper right of the canvas directing his gaze toward the viewer.

This painting demonstrates, in comparison with earlier works, Remington's increasingly sophisticated handling of paint in loosely suggested landscapes and crisply delineated figures with more dramatic impasto and highlights. Tufts of thick white paint on the fetlock of the foreground horse, bright highlights showing the sleekness of the horses, and thick shadows of mottled lavender bring immediacy to the scene and intensify the effect of the painting's vivid realism. The pink, blue, and green highlights in the desert terrain and the sumptuous combinations of smoky blue and bright red in the scout's uniform and blanket indicate Remington's development as a colorist.

The subject of *Scouts Climbing a Mountain* emerged from a trip Remington took in 1890 with Gen. Nelson Miles and a group of Indian commissioners to the Cheyenne Agency of Lame Deer, and from there to the Wyoming and Dakota territories. During this trip Remington observed a new feature of military life, Lt. Edward Casey's creation of the first irregular uniformed army of Cheyenne scouts. Remington was favorably impressed by this development, devoting illustrations and an article on the subject titled "Indians as Irregular Cavalry," which was published in the December 27, 1890, issue of *Harper's Weekly.* This painting, however, relates thematically to those used to illustrate "Lieutenant Casey's Last Scout"—an article appearing in *Harper's* one month later, on January 31, 1891, describing Remington's adventures traveling with Casey and the Cheyenne scouts through the Dakota Badlands during

Miles's campaign to subdue the Sioux.[2] *Scouts Climbing a Mountain,* which was never published, was not used to illustrate this article, but it is a variant of *Watching the Dust of the Hostiles* (fig. 1), which was reproduced in conjunction with the article "Lieutenant Casey's Last Scout." Remington either painted the Houston version for a private patron or he painted it and several others for the story and selected *Watching the Dust of the Hostiles* for publication because it better satisfied the needs of the article. The published illustration depicted and identified both Lt. Casey (holding binoculars) in the foreground and, to the immediate right of him in profile, Remington himself. This arrangement underscored Remington's role in the journey as an observer and guaranteed to his audience that he witnessed the scene: he studies Casey surveying the area for hostile Sioux.

In *Scouts Climbing a Mountain,* Remington subdued the narrative and biographical detail of the published illustration by depicting Casey and himself surveying the landscape at upper right, making them almost incidental to the larger action of the painting. Instead, he focused on conveying the danger of the steep climb to the stronghold,

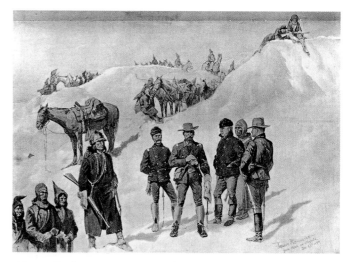

Fig. 1 Frederic Remington, *Watching the Dust of the Hostiles from the Bluffs of the Stronghold.* Illustrated as halftone in "Lieutenant Casey's Last Scout," *Harper's Weekly,* January 31, 1891, 89. The Museum of Fine Arts, Houston, gift of Dr. Mavis P. and Mary Wilson Kelsey (91.1430.181)

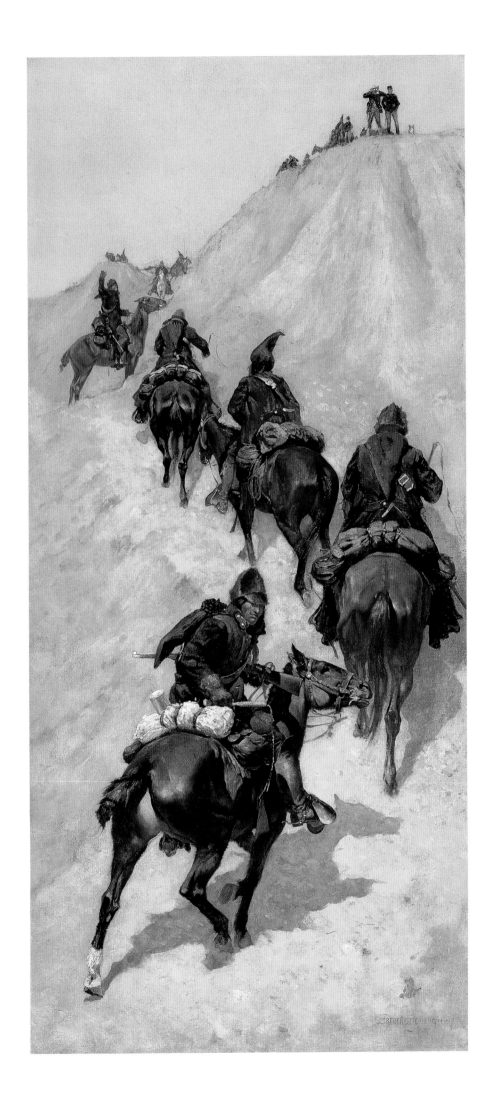

noting in his 1891 article, " . . . I see a trail winding up-ward. I know these warriors are going up there, but I can't understand precisely how." Remington impressed upon his readers the strangeness and disorienting nature of the Badlands topography, describing the details in painterly terms and noting that only the coloristic style of Thomas Moran, the late-nineteenth-century landscape painter of the American West, would be able to capture their extraordinary colors: "They are somewhat as Doré pictured hell. One set of buttes, with cones and minarets, gives place in the next mile to natural freaks of a different variety. . . . The painter's whole palette is in one bluff." Remington's use of richer color in this painting, while revealing his development as a colorist, may also reflect a literal transcription of the changing tones and hues of these Badlands and the artist's intent to capture their uniqueness through an unusual format and brighter palette.

Remington's shift in perspective in *Scouts Climbing a Mountain* focused attention on the Cheyenne scouts, whom Remington believed served a useful purpose in the army. In fact, his 1890 article on the scouts amounted to a diatribe against the corruption of the Indian Bureau and the War Department, both of whom he faulted for the dwindling Native American populations and for the indolence he observed in those living on reservations. In contrast, Remington celebrates what he perceived as the foresight of the United States Army in its attempt to solve the "Indian problem" by enlisting them as irregulars and teaching them skills—in short, putting them to work: "Let our army," he wrote in the 1890 article, "have the fruits of its works; and let us preserve the native American

race, which is following the buffalo into painted pictures and printed books." Remington's attention to these scouts casts *Scouts Climbing a Mountain* into a political light and demonstrates his support of a project he deemed a worthwhile solution to the "unchristian. . . . inhuman . . . vile" manner in which the Indian Bureau conducted its affairs. In more than style and technique, these paintings on the theme of the Indian scout of the 1890s stand in marked contrast to Remington's later works, painted after the "Indian problem" had been "solved" through removal. While the later works sound an elegiac note of nostalgia, *Scouts Climbing a Mountain* and related works demonstrate Remington's role as an active participant in political events of the day and show how his work supported the affairs of the United States Army and could serve immediate political ends. In fact, it should be noted that in "Lieutenant Casey's Last Scout," Remington does not mention, for reasons unclear, that the very day he and Casey observed Sioux enemies from the stronghold, the United States Army massacred about two hundred men, women, and children at Wounded Knee, not far from where they stood.

1. Note on provenance: Will Hogg bought *Scouts Climbing a Mountain* on November 8, 1922, for $800 from George Ainslie of Ainslie Galleries, New York (WCH Papers, Box 2J349). The invoice for the painting indicates that the work originally belonged to the Abbe collection in Springfield, Mass. Possibly the painting belonged to the family of Dr. Robert Abbe, the New York City doctor who performed an emergency appendectomy on Remington shortly before he died on December 26, 1909.

2. See Hassrick and Webster 1996, 1:371, no. 1214, and 351, no. 1138.

5. *The Hussar (Private of Hussars; A German Hussar)*

1892–93

Oil on canvas, 28 x 23 in. (71.1 x 58.4 cm)

Signed at lower right: FREDERIC REMINGTON—

The Hogg Brothers Collection, gift of Miss Ima Hogg[1]

Acc. no. 43.13

In 1892, Remington made his first trip to Europe, visiting Berlin, St. Petersburg, Tilset, Paris, and London. The artist traveled with his Yale classmate Poultney Bigelow to gather information for a series of articles for *Harper's Weekly* about European army life that Remington would illustrate and Bigelow would write. This image, titled *Private of Hussars,* appeared in an article not by Bigelow but by Remington's friend Lt. Powhatan Clarke. The article, "Characteristic Sketches of the Germany Army," was published in the May 20, 1893, issue of *Harper's Weekly,* accompanied by twelve other illustrations by Remington. Clarke's article gave a sparkling account of the pageantry and order of the German army and, at the article's end, revealed his agenda: he described the German army with its organization and abilities as a foil for the United States Army, which he characterized as small, incompetent, and mired in bureaucracy. He lamented that frontiersmen had evolved into city clerks and that Texas Rangers had become sheepherders. Clarke argued that the American male, and by extension the United States Army, should be better prepared for war, despite the happy condition that it was not "necessary for us to put our necks under the yoke of this century's militarism." When Remington visited Germany and met Emperor William II, Germany was fast becoming the leading military power in Europe, and many believed that Russia and Germany would go to war. Clarke's prose provided detailed information and Remington's images gave visual form to European politics at the time, particularly of German military prowess—and the combined text and imagery helped promote a war culture that would develop in the United States later in the decade.

This image of rider and horse recalls similar images in the Hogg Brothers Collection, including *The Lookout* (cat. no. 1) and *The Blanket Signal* (cat. no. 9). The painting also brings to mind the equestrian portraits of eighteenth-century British art, most notably and sympathetically realized by George Stubbs. But while Stubbs's horse portraits were private images indicating the status of the horse's owner, Remington's works had a martial context appropriate to his mission of reporting European, as well as

American, military life. The scenes of military life and horse pageantry made by the French artists of the Second Empire, such as Meissonier, Detaille, and Neuville, likely served as some of Remington's artistic models.[2] More specifically, this painting of a private of hussars (a member of light-armed cavalry) in profile was probably based on studies of the horse maneuvers Remington observed during a four-day trip at Emperor William II's horse farm in Trakehnen.[3] Judging by the numerous photographs in his personal collection of the impressive pageantry and military displays of the German army—images that he himself took as well as purchased—Remington likely relied on these documentary sources as well. In *The Hussar,* Remington appears most interested in horse anatomy and the private's uniform, indicating the horse's sleekness and musculature through dabs of gray and reddish yellow paint and carefully detailing the specifics of the uniform and accoutrements—the polished boots, the sword and scabbard, and the insignia. In an 1894 interview, Remington recalled the appeal of European uniforms, noting, "When I was over in Europe I did the German army and am enthusiastic in my admiration for it. The uniforms of the Germans are as complicated as the robes of the Catholic Church, and it is no end of difficulty to digest them."[4]

Like *The Transgressor* (cat. no. 3), *The Hussar* was included in Remington's American Art Association exhibition and sale of 1893.[5] Reviewers noted the illustrative quality of his work, one commenting that the show included "illustrations of army life in America and Europe [that] form so pleasing a feature in the weekly and monthly press."[6] And, given the contents of the exhibition, their comments were appropriate. The exhibition consisted of over a hundred works, comprising a catalogue of types—so-called half-breeds, trappers, frontiersmen, Native Americans, as well as members of the German infantry, uhlans (Polish lancers or cavalrymen), hussars, and dragoons. The exhibition appeared so documentary in nature (an exhibition of Native American artifacts accompanied the show) that the critic for the *New York Sun* started his review by noting that Remington was "an extraordinarily

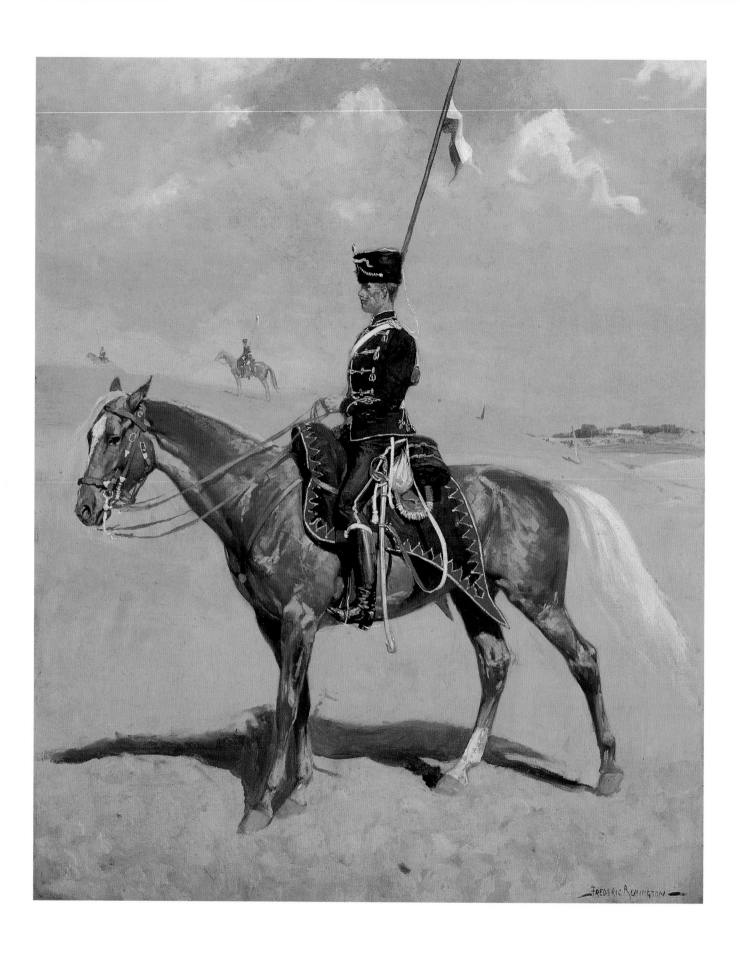

gifted reporter. He has a positive genius of facts. His eye catches with the celerity and certainty of the quick shutter all that the lens of the camera sees and very much besides."[7] His detailed paintings, such as this one, reinforced the strong relationship between Remington and the camera that was noted in much of the criticism; the still relatively new medium of photography was already accepted as an unmediated conduit of truth and authenticity. While the *New York Sun* reviewer commented on Remington's detail, he also allowed the artist some measure of wit: "Besides his Western pictures, Mr. Remington shows now for the first time some of the results of his recent trip to Europe. He has found especial pleasure in recording some of the military types of Germany and Russia, which are excellent in character and in detail and show that the painter of the tragedy of 'The Last Stand' is not without some sense of humor in his observations of the warrior dandy in times of peaceful movements." *The Hussar* is a more dignified image of military pageantry than some of the prancing military men Remington painted. Whether serious or wry, these images of the European military accorded him, in public opinion, the same measure of expertise as his images of the West.

1. Note on provenance: According to a label on the back of the frame giving the address of Ainslie Galleries in New York, Will Hogg acquired *The Hussar* from Ainslie's, likely one of a group of works he bought in New York on September 21, 1920. According to his personal diaries for that day, Hogg bought "1 bronze Bronco Buster and 12 drawings and ptgs of F Remington at Ainslie's Galleries, 615 Fifth Ave.," but his diaries also relate that on October 18, 1920, he bought "some Remingtons," not identified in the entry or in his papers, from Ainslie. This painting is loosely related to three watercolors of similar subjects in Hogg's collection, *A Call to Arms, An Amoor Cossack,* and *A Haircut in a Cavalry Stable* (see Checklist of Works, p. 133).

2. See Peter H. Hassrick, "The Painter," in Shapiro and Hassrick 1988, 73–77.

3. In one of Remington's sketchbooks from his 1892 European trip, he noted down a list of pictures under the heading "Trakenan Horse farm," which includes "the Hussar Orderly," possibly a reference to the Houston painting (FRAM, Ogdensburg, Sketchbook 71.812.7, unpag.).

4. Remington, quoted in Alpheus S. Cody, "The Rise of Remington," *New York Herald,* January 14, 1894, 13.

5. American Art Association, *Catalogue of a Collection of Paintings, Drawings and Water-Colors by Frederic Remington, A.N.A.* (New York, 1893), no. 42, as *A German Hussar.*

6. *New York Times,* January 7, 1893, 4.

7. "Frederic Remington's Paintings and Studies," *New York Sun,* January 9, 1893, 6.

6. *The Flight (A Sage-Brush Pioneer)*

1895
Oil on canvas, 23 x 33 in. (58.4 x 83.8 cm)
Signed at lower right: Frederic Remington / copyright 1895 Harper Bros.
The Hogg Brothers Collection, gift of Miss Ima Hogg
Acc. no. 43.8

The Flight, which features a mustachioed cowboy bran-dishing his pistol, is the second in a series of five images Remington painted to illustrate Owen Wister's article "The Evolution of the Cow-Puncher," the first celebrated state-ment of cowboy mythology. If such images of sturdy cowboys chased by "savage Indians" appear clichéd to contemporary eyes, it is because Remington and Wister immortalized the figure of the larger-than-life heroic cow-boy, and the popularity of the cowboy type endured in the work of countless imitators who promoted it in pulp magazines, plays, and Hollywood movies. Remington met Wister, a Harvard-educated Philadelphian, at Yellowstone Park in 1893, and they embarked on a series of projects for *Harper's Monthly,* Wister providing the prose and Remington the illustrations. "Cowboys are cash," Remington once said, and by September 1894, Remington wrote in his staccato prose to Wister of his hope that cow-boy culture would be the subject of their collaboration: "Great & rising demand for— a cow-boy article.— '—The Evolution & the Survival of the Cowboy.'"[1] About a month later, he seemed impatient, writing to Wister, "make me an article on the evolution of the puncher—the passing as it were."[2] Remington's subsequent letters to Wister provided the latter with information about the cowpuncher, which Wister ultimately used only selectively. Remington told Wister that the cowboy "did not exist as an American type" at the time of the Mexican War, but he "was later a com-bination of the Kentucky or Tennessee man with the Spanish. / In Civil War he sold cattle to Confederate Armies—but was a soldier in Confed army but as pure thing he grew up to take the cattle through the Indian country from Texas to meet the R.[ail] R.[oad]—at Abilene. . . . These were his palmy days—when he literly [*sic*] fought his right of way—he then drove to the north and stocked the ranges—then the thing colapsed [*sic*] and he turned 'rustler'—and is now extinct except in the far away places of the Rocky Mountains."[3]

The Flight (titled A *Sage-Brush Pioneer* when it appeared in *Harper's Monthly* in September 1895) and its companion, *The Fall of the Cowboy* (fig. 1), coupled with

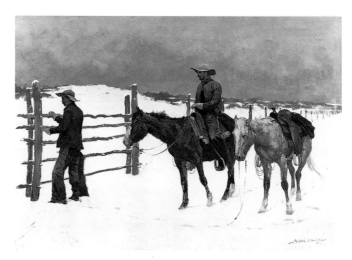

Fig. 1 Frederic Remington, *The Fall of the Cowboy,* 1895.
Oil on canvas, 25 x 35 1/8 in. (63.5 x 89.2 cm). Amon Carter Museum,
Fort Worth, Texas (1961.230)

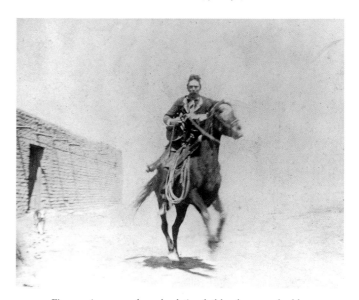

Fig. 2 A man on horseback (probably photographed by
Frederic Remington in Mexico, 1893). Frederic Remington Art
Museum, Ogdensburg, New York (1918.160.485)

Wister's prose, embodied this romantic prototype of American masculinity won and lost. In the former, Remington allows the viewer to see only a fragment of what he envisions as a larger event. The cowboy, clearly inspired by a photograph Remington took during a trip to Mexico (fig. 2), is probably one of several (unpictured) cowboys riding to escape the pursuing Native Americans at

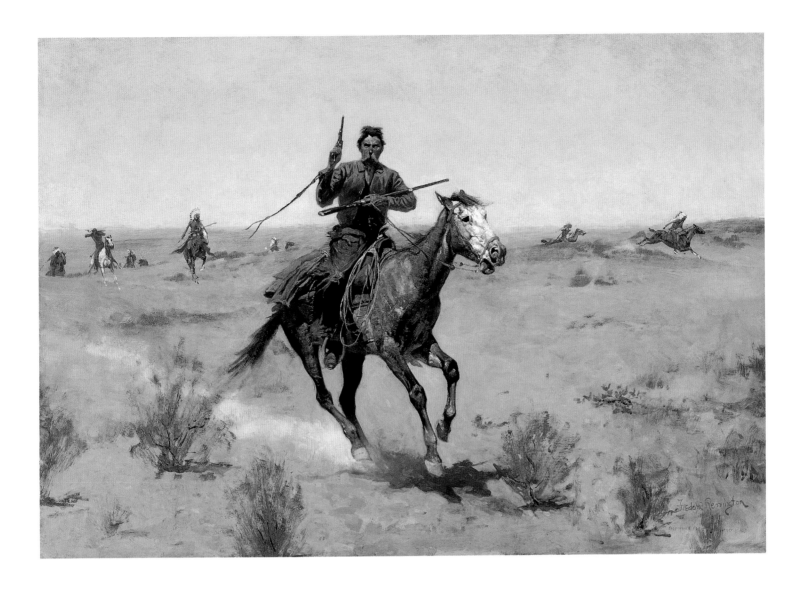

far right. The scattering of peripheral subject matter allowed Remington the opportunity to spotlight the cowboy type described in Wister's text: the brave loner who will confront the viewer directly with a penetrating gaze despite his imminent peril. As in most of Remington's landscapes, topographical details are generalized. A hazy blue sky, for example, sets off the pinkish gray desert plains, with sagebrush and scrubby flora indicated by quick flicks of a dry brush. The cowboy, his accoutrements, and the spotted gray horse are tightly painted, and bright highlights illuminate the cowboy's forehead, the reflective surfaces of his pistol and rifle, and the horse's bright blaze, which seems to propel the animal forward into the viewer's space.[4] The horse's extended tongue and bulging eyes display its fatigue and provide contrast to the cowboy's stoic demeanor as he manages the physical hardship of simultaneously leading his horse and shooting his guns. Remington pulls the composition together with a quirt (a riding whip), a rifle, and the trailing dust, all of which point in different directions, leading the viewer's eye toward the background pursuers and back again to the central, heroic

figure silhouetted against the sky.

For Remington, the cowboy was a hybrid of cultures, yet Wister curiously transformed him into a Saxon lord from England, a modern medieval knight transported from the round table of Camelot to the arid plains of Texas, a Rob Roy of the Red River in the lore of Sir Walter Scott. Wister clearly aimed to assume the literary mantles of Sir Thomas Mallory and Sir Walter Scott by invoking them and their immortal characters in the creation of this new breed, and his phenomenal success was assured by his publication in 1902 of *The Virginian,* which became the bible of cowboy mythology. As he wrote in "The Evolution of the Cow-Puncher":

> *No doubt Sir Launcelot bore himself with a grace and breeding of which our unpolished fellow of the cattle trail has only the latent possibility; but in personal daring and in skill as to the horse, the knight and the cowboy are nothing but the same Saxon of different environments, the nobleman in London and the nobleman in Texas; and no hoof in Sir Thomas Mallory shakes the crumbling plains with*

quadruped sound more valiant than the galloping that has echoed from the Rio Grande to the Big Horn Mountains.

Wister's theory of the cowboy's origins clearly troubled Remington, who wrote to him, "Strikes me there is a good deal of English in the thing—I never saw an English cowboy—have seen owners.—/ You want to credit the Mexican with the [*sic*] inventing the whole business—he was the majority of the 'boys' who just ran the steers to Abiline Kansas [*sic*]."⁵ Despite Remington's reservations, Wister insisted that the lineage of the cowboy type was Saxon: "It was no new type, no product of the frontier, but just the original kernel of the nut with the shell broken," although in the final draft he did contradict himself, conceding that "the Mexican was the original cowboy, and that the American improved on him." Wister's reconstruction and insistence on a Saxon pedigree allowed him to make a connection between the fate of the American cowboy and the rise and fall of the cultures of medieval knighthood as well as the independent-minded rebels of late-seventeenth- and early-eighteenth-century Scotland.

"The Evolution of the Cow-Puncher" outlined the characteristics of this Americanized Saxon breed: a "spirit of adventure, courage, and self-sufficiency." Wister asserted, "No soldier of fortune ever adventured with bolder carelessness, no fiercer blood ever stained a border." As if to evoke Remington's stoic figure in the painting, the gaze of the cowboy "rested with serene penetration upon the stranger; they laughed seldom, and their spirit was in the permanent attitude of war. Grim lean men of few topics, and not many words concerning these; comprehending no middle between the poles of brutality and tenderness." The complementary text for the Houston painting is the section in which Wister discusses the shared activities of the cowboys, whose lives are spent "watching for Indians, guarding huge herds at night, chasing cattle, wild as deer, over rocks and counties, sleeping in the dust and waking in the snow, cooking in the open, swimming the swollen rivers." In other words, the "pioneer" represents to Wister what Remington would have described as the "palmy days" of the cowboy. And if *The Flight* represents his golden age, the somber and eerie *The Fall of the Cowboy,* the last in the series, represents his decline, the fence and barbed wire sig-

naling the end of the open range.⁶ As Wister notes, "[the cowpuncher] has been dispersed, as the elk, as the buffalo, as all wild animals must inevitably be dispersed. Three things swept him away—the exhausting of the virgin pastures, the coming of the wire fence, and Mr. Armour of Chicago [meat packer], who set the price of beef to suit himself. But all this may be summed up in the word Progress. . . . Such is the story of the cow-puncher, the American descendant of Saxon ancestors, who for thirty years flourished upon our part of the earth, and, because he was not compatible with Progress, is now departed, never to return."

This text alongside a cycle of related images—Remington and Wister's effort to create a national narrative based on regional quasi-history—becomes a romantic epic of the rise and decay of civilizations. In light of this interpretation, Remington's series can be seen as a regional version of Thomas Cole's *The Course of Empire* (1836). Cole's sublime vision of man living in harmony with nature is replaced by Remington and Wister's nostalgia for the lonesome cowboy subsisting on the harsh nature that formed his terse and lean personality. Just as corruption and excessive civilization tipped the balance between man and nature in Cole's golden age, "Progress" spelled the end of Remington and Wister's era of the cowboy.

1. Remington to Poultney Bigelow, [1895], in Splete and Splete 1988, 269; Remington to Owen Wister, September 1894, in Splete and Splete 1988, 253.

2. Remington to Wister, September or October 1894, in Splete and Splete 1988, 255.

3. Remington to Wister, October 20 to 30, 1894, in Splete and Splete 1988, 258–59.

4. Peter H. Hassrick (conversation with the author, February 1999) has suggested that the features of the cowboy are remarkably similar to those of the figure in *The Trooper* (c. 1895, collection of William B. Ruger, Newport, N.H.).

5. Remington to Wister, February 1895, in Splete and Splete 1988, 265.

6. See Vorpahl 1978, 193–202, on the unity of Remington's images. The five images used to illustrate the story are *The Lost Cavalier* (private collection); *The Flight; What an Unbranded Cow Has Cost* (Yale University Art Gallery, New Haven); *There Was No Flora McIvor* (Akron Art Museum); and *The Fall of the Cowboy.*

7. Bronco Buster

1895, this version cast July 30, 1906
Bronze, green over brown patina, lost-wax cast
22 5/8 x 22 3/4 x 15 1/4 in. (57.5 x 57.8 x 38.7 cm)
Signed at front, top of base at right: Copyright by / Frederic Remington
Inscribed at rear, top of base along right curve: ROMAN BRONZE WORKS N.Y.
Inscribed on underside of base: 49
The Hogg Brothers Collection, gift of Miss Ima Hogg[1]
Acc. no. 43.73

Remington earned instant fame as a sculptor with *Bronco Buster,* copyrighted in 1895, one year after the artist had taken up the medium of sculpture. Remington's introduction to sculpture would have been as an art student at Yale's School of Fine Arts, but it was not until years later that his friend Augustus Thomas, a New York playwright, theatrical impresario, and New Rochelle neighbor, encouraged Remington to try his hand at modeling. In 1913, Thomas recounted the observation he had made while watching Remington paint, that Remington conceived his art "with a sculptor's degree of vision," that he did not "mentally see [his] figures on one side of them" but "all around them."[2] Remington had always imagined the West in theatrical terms, voicing his observation, "I knew the wild riders and vacant land were about to vanish forever. . . . I began to try to record some facts around me, and the more I looked, the more the *panorama* unfolded" (emphasis added).[3] Working in three dimensions allowed Remington, literally, to picture the West and its inhabitants with the comprehensiveness, constantly changing focus, and continuous movement implied by the panoramic view. Perhaps what Remington meant, in part, when he said that in bronze he would "endure" or that in bronze he was "damned near eternal if people want to know about the past" was not only that his skill as a sculptor and the nature of the medium would offer longevity but also that comprehensiveness and totality could be achieved with the multiple viewpoints implied in sculpture.[4]

With the help and advice of Frederic Ruckstull, a sculptor of public monuments who was also Thomas's childhood friend, Remington spent almost a year modeling the two-foot-high sculpture of a bucking bronco and its rider. He wrote to his friend Owen Wister, "I have always had a feeling for 'mud' [Remington's phrase for modeling], and I did that [*Bronco Buster*]—a long work attended with great difficulties on my part. I propose to do some more, to put the wild life of our West into something that burglar won't

have, moth eat, or time blacken."[5] After Remington's *Bronco Buster* debuted, with a full-page discussion, in the October 19, 1895, issue of *Harper's Weekly,* the critic Arthur Hoeber admired the "masterly way" in which Remington handled the clay, "with great freedom and certainty of touch. . . . it is quite evident that Mr. Remington has struck his gait." His success led Remington to sculpt twenty-one figures over the next fourteen years—horse thieves, mountain men, Cheyenne warriors—all riding spirited, noble steeds. It is a sign of the esteem accorded Remington as a sculptor that his bronzes, not his paintings or watercolors, were the first to enter museum collections.[6]

In 1900, Remington left the Henri-Bonnard foundry that had, through the sand-cast process, produced the first sixty-four versions of *Bronco Buster.* The artist began working with the newly established Roman Bronze Works foundry in Brooklyn that, using the lost-wax process, produced about one hundred life casts, as well as about nineteen in the larger version (height 32 3/8 in.) produced after his death. The lost-wax process, which revealed greater detail and varying surface textures, allowed the artist to continue making alterations—the richly indicated fur of the bronco, for example, would have been achieved by dry brushing the wax positive—as well as to make specific changes to each version. The Houston cast, for example, produced in 1906, is only one of eight that features woolly chaps, an innovative addition to the rich variety of surface textures ranging from smooth leather saddlebags to thickly encrusted chaps.

A constant recycler of his images, Remington devised the rearing bronco type from such earlier illustrations as *A Daring Plunge,* which accompanied James B. Fry's 1887 book *Army Sacrifices,* to the more recent and closely related *A Pitching Bronco,* which appeared in the April 30, 1892, edition of *Harper's Weekly.*[7] His photograph album containing animal images also shows a rearing horse (fig. 1), revealing one of the countless instances in which

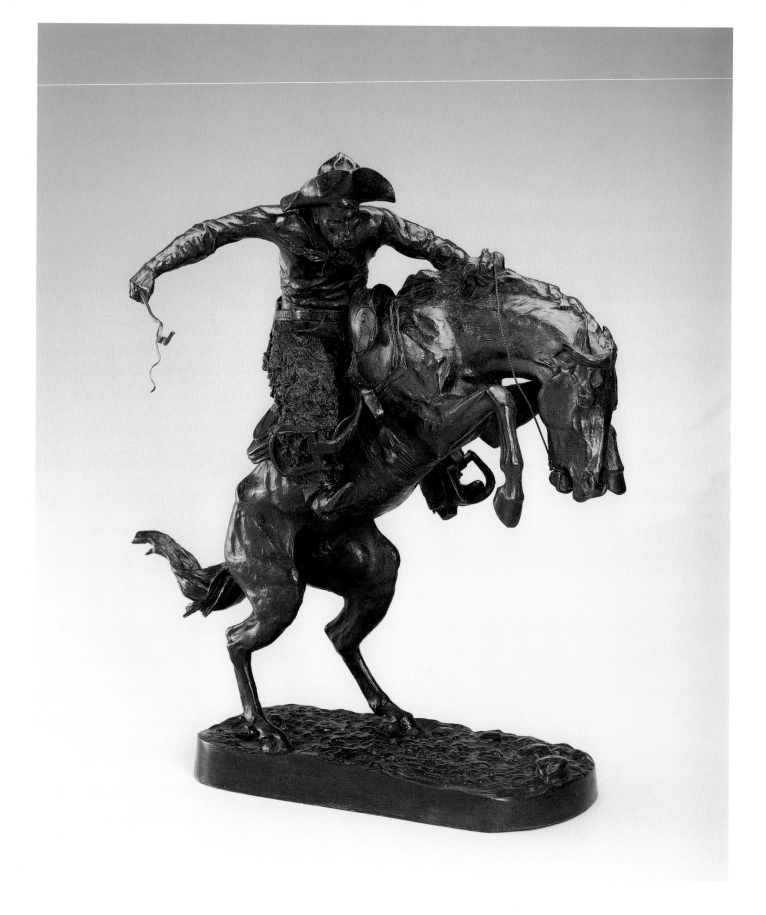

Fig. 1 A rearing horse, from an album in Frederic Remington's collection, "Frederic Remington: Book of Animals & c." Frederic Remington Art Museum, Ogdensburg, New York (71.830, p. 22)

Fig. 2 Frederick William MacMonnies, *Bacchante with Infant Faun,* 1893 (this version cast c. 1920). Bronze with greenish black patina, height 67 1/4 in. (170.8 cm). The Museum of Fine Arts, Houston, museum purchase with funds provided by the Long Endowment for American Art (98.252)

Remington turned to photographs to study details of anatomy and posture.[8] Remington's *Bronco Buster* also shares a certain bravado with the sculptures of his colleagues and acquaintances Augustus Saint-Gaudens and Frederick MacMonnies, both of whom modeled graceful, sprightly female nudes precariously poised on one foot.

Such sculptures as Saint-Gaudens's *Diana* (1892) or MacMonnies's *Bacchante with Infant Faun* (1893; fig. 2) may well have influenced Remington's composition as they were, at the time Remington modeled the bronco, very much in the public eye. The cantilevered construction of *Bronco Buster* and the innovative compositions of his later bronzes suggest Remington's determination to forge new territory within the structural limits of sculpture. Unlike his contemporaries, whose technically daring work had the graceful nude woman as their subject, Remington chose more violent subject matter, as evidenced here. He portrayed the attempt to tame wild nature: the horse rears in rebellion, a bit grips its mouth, taut reins jerk its head, and spurs tear into its hide. Without the distancing effect evoked by painted two-dimensional spaces, the sculpture assumes a permanent and immutable quality that emphasizes its brutal nature. With fierce energy and movement, then, Remington's *Bronco Buster* subverted the previous model for delicately balanced figures first established in American sculpture in the graceful lines of goddesses and bacchantes. In *Bronco Buster,* Remington revealed forcefully that his worldview was one of struggle—between winners and losers, and between tamed and untamed nature—while simultaneously earning enduring fame and artistic recognition for this iconic vision of Western life.

1. Note on provenance: According to his diary, Will Hogg acquired "1 Bronco Buster" from Ainslie Galleries, New York, on September 21, 1920. He expressed interest in acquiring more Remington sculptures, writing in January 1921 to one of the then major retailers of fine art statuettes, Tiffany and Co., New York, about an exchange of photographs of Remington sculptures. Despite his interest, Hogg acquired only one Remington bronze, the *Bronco Buster,* perhaps the most commercially successful nineteenth-century American sculpture.

2. The story is recounted in Thomas 1913, 361.

3. Frederic Remington, "A Few Words from Mr. Remington," *Collier's Weekly,* March 18, 1905, 16.

4. Remington to Owen Wister, January 1895 and October 25, 1895, both in Vorpahl 1972, 160, 165.

5. Remington, quoted in *Century Magazine,* October–November 1895, in Samuels and Samuels 1982, 227.

6. For example, in 1905, the Corcoran Gallery of Art, Washington, D.C., acquired Remington's *The Mountain Man* (1903) and *Coming through the Rye* (1902). In 1907, the Metropolitan Museum of Art, New York, acquired four bronzes: *Bronco Buster, The Cheyenne* (1901), *The Mountain Man,* and *Dragoons 1850* (1905). It was not until December 1909, the month Remington died, that a museum acquired a Remington painting: William T. Evans purchased *Fired On* (1907) for what is now the National Museum of American Art. These are the only Remingtons acquired by museums during the artist's lifetime.

7. For *A Pitching Bronco,* see Ruckstull 1925, 528; and Shapiro 1981, 39.

8. Michael Edward Shapiro, "Remington: The Sculptor," in Shapiro and Hassrick 1988, 182–83.

8. *The Mier Expedition: The Drawing of the Black Bean*
(Prisoners Drawing Their Beans)

1896

Oil on canvas, 27 x 40 in. (68.6 x 101.6 cm)

Signed at lower right: Frederic Remington— / copyright 1896 / Harper Bros.

The Hogg Brothers Collection, gift of Miss Ima Hogg

Acc. no. 43.14

In a letter to his friend the author Owen Wister, Remington related that he was "Just back from Texas & Mexico, got an article—good illustrations but I tumble down on the text—its a narrative of the Texas Rangers— ."[1] *The Mier Expedition: The Drawing of the Black Bean* was among seven pictures that Remington used to illustrate the article he referred to in his letter to Wister, "How the Law Got into the Chaparral," which appeared in the December 1896 issue of *Harper's Monthly.* Remington's explanation was the Texas Rangers themselves, an irregular army, and the Colt revolver, images of which bracketed the text like bookends.

Remington based his article on the reminiscences of one of the original Texas Rangers (formed by Capt. Jack Hayes in the 1830s), Col. "Rip" Ford, whom Remington met in San Antonio on his journey in 1896. Colonel Ford, who could "tell you stories that will make your eyes hang out on your shirt front," told Remington about the exploits of the Rangers in their glory days "when the Texans, the Comanches, and the Mexicans chased one another over the plains of Texas, and shot and stabbed to find who should inherit the land." Two stories in the text described the Rangers' principal foes: the Mexicans—represented in the text and illustration by an action-packed view of *The Charge and Killing of Padre Jarante,* with the padre swept off his horse by gunfire—and the Comanches—described in the text and image in *We Struck Some Boggy Ground* (R. W. Norton Gallery, Shreveport, Louisiana), which shows a somewhat ragtag army, some brandishing Colt revolvers, charging a Comanche encampment. While these illustrations displayed high drama on the chaparral, *The Mier Expedition: The Drawing of the Black Bean* (titled *Prisoners Drawing Their Beans* in the magazine) offered a quieter scene in the fight for survival that characterized the Texas Republic.

Remington introduced the story of the Mier expedition in a roundabout fashion; it was not really a Texas Rangers story per se, but its potential as a dramatic story with visual appeal must have attracted him, because he enfolded it

Fig. 1 Charles McLaughlin, *Texians Drawing the Black Beans at Salado.*
Illustrated in Green [1845] 1935, between 170 and 171

into his narrative. And, after all, it was among the most tragic and brutal of confrontations between Texas and Mexico during the life of the Texas Republic. Remington introduces the character "Big Foot Wallace," a colorful and infamous Texas Ranger who perfectly expressed the author's lifelong romantic notion of a heroic Western past displaced by degenerate "civilization": Wallace, Remington wrote, "belongs to the past, and has been 'outspanned' under a civilization in which he has no place, and is to-day living in poverty." The reader learns that Wallace, before he became a Texas Ranger, was "captured in the Mier expedition, [and] he walked as a prisoner to the city of Mexico, and did public work for that country with a ball-and-chain attachment for two years. The prisoners overpowered the guards and escaped on one occasion, but were overtaken by Mexican cavalry while dying of thirst in a desert. Santa Anna ordered their 'decimation,' which meant that every tenth man was shot, their lot being determined by the drawing of a black bean from an earthen pot containing a certain portion of white ones. 'Big-foot' drew a white one."

The illustration refers to this short passage in the text, providing a glimpse into events not elaborately detailed in the text, but presented only briefly and matter-of-factly.

Remington's image of the event mimics this same terse description, allowing the structure and composition of the painting, rather than dramatic human expression, to convey the tension and anxiety of the scene. In the painting, strong orthogonals of the pavement and roofline lead the viewer's eye toward the quiet action in the midground: a prisoner, surrounded by uniformed Mexican officers and the rank and file, places his hand into the earthenware jar to draw a bean. A long line of prisoners waits behind him, doomed to repeat the same small but consequential gesture. A paunchy officer with his hand on his hip, a comrade with arms crossed, and a guard at right become stand-ins for the viewer, assuming the casual expression of dispassionate observers and providing a foil for the taut, scraggly, desperate prisoner. In the dark corners of the distant arcades, other figures hover, sit, or talk; some are attentive, while others are oblivious to the action as it unfolds. Remington uses a minimal palette of reddish brown, gray, and white with bits of blue, lavender, and red, all muted, to suggest the hot, dry climate. The clay color of the embellished leather *ranchero* dress of the Mexican officers is repeated in the tile and exposed brick. The white of the sunbaked stucco is echoed in the uniforms of the rank

and file who dot the right side of the canvas, the repetition providing congruity as well as weighty monotony to the scene.[2] Details of the costumes and earthenware props lend interest to the picture, but Remington, ever the consummate storyteller, directs the viewer's attention particularly to the hand reaching into the jar for a bean—prolonging the tension indefinitely by giving no clue as to its deciding color.

Remington likely learned the account of the black bean lottery from Rip Ford, or perhaps Bigfoot Wallace himself, of whom Remington provides a brief, physical description: "His face is done off in a nest of white hair and beard, and is patriarchal in character." Accounts of the Mier expedition from its survivors were also published, including Gen. Thomas Green's *Journal of the Texian Expedition against Mier* (1845), which included sketches by Charles McLaughlin, a surviving prisoner (fig. 1). Remington may have studied Green and McLaughlin's publication as well as heard oral accounts, for such accurate details as the handkerchief covering the jar have the ring of authenticity.[3] Further, Remington may have met or known of the San Antonio painter Theodore Gentilz, who painted a version of the event, *Shooting of the Seventeen Decimated Texians at El Salado, Mexico* (copyrighted 1885, private collection). In any case, it is a perception of Mexican brutality and Texan sacrifice that Remington seeks to celebrate in the image. Remington may not have known or chose to ignore that this group of prisoners was an unauthorized splinter group of the army that, more than anything, was set on plundering Mexican towns—first Laredo, then Mier. The black bean drawing occurred in the wake of Sam Houston's victory at San Jacinto, which, while establishing Texas's independence from Mexico, did not settle the borders of the vast territory. Fighting continued between Mexico and Texas, and in December 1842, this splinter group of Texans (including some Texas Rangers) captured the garrison at Mier across the Rio Grande. When threatened by approaching Mexican troops, the Texans reportedly offered to surrender if they were treated as prisoners of war. While marching as prisoners of the Mexican Army, they managed to escape from Hacienda Salado in February 1843. However, they fared badly in the harsh topography, and several succumbed from the struggle to forage for food and water,

putting sand in their mouths to eke out water and drinking their own urine.[4] Those who survived were captured and sentenced to death by Gen. Antonio López de Santa Anna but, in response to political pressure, he reduced the sentence to one in ten prisoners, using the black bean lottery as a means of determining their fates. Although offered as an act of clemency, the black bean lottery was promoted in the United States as an example of Mexican brutality and inhumanity, a concept Remington's painting underscores through its arrangement of Mexican figures that surround and close in on the prisoners.

One of the doomed prisoners wrote, "Mexico / Dear Mother, I write to you under the most awful feelings that a son ever addressed a mother for in half hour my doom will be finished on earth for I am doomed to die by the hands of the Mexicans . . . that every tenth man should be shot we drew lots I was one of the unfortunates."[5] Those who survived, like Bigfoot Wallace, were used by the Mexican Army to repair the roads and were then transferred to Perote Prison, a high-security prison outside Mexico City, where they were released by Santa Anna in September 1844. The bones of the "unfortunates" were disinterred in 1847 and eventually buried at Monument Hill in La Grange, Texas, home of the highest-ranking officer slain.

1. Remington to Owen Wister, March 6, 1896, in Splete and Splete 1988, 281. Remington exhibited the painting at Hart and Watson, Boston, in 1897.

2. Remington's illustrations of the various costumes of the Mexican army appear in an article by Thomas A. Janvier, "The Mexican Army," in *Harper's Monthly,* November 1889, 813–27.

3. Obviously, Remington would pick and choose the details that satisfied him as an artist, leaving enough of them as guarantors of the painting's "truth." He probably knew, but did not choose to depict, the fact that the prisoners were handcuffed and approached the jar two at a time. They also approached a bench, not a table, where a scribe recorded the color of the bean they selected. See Nance 1998, 283–97, for an exhaustive account of the Mier expedition, including the various accounts of the survivors. See Ratcliffe 1992, 57–58, for a discussion of this painting. See also Haynes 1990.

4. See Green [1845] 1935, 163–64; Nance 1998, 237–60; and Texas State Historical Association 1996, 4:714–16.

5. R. H. Dunham, a prisoner at Mier, to his mother, March 25, 1843 (MFA, Houston, object files).

9. The Blanket Signal

c. 1896

Oil on canvas, 27 x 22 in. (68.6 x 55.9 cm)

Signed at lower left: Frederic Remington

The Hogg Brothers Collection, gift of Miss Ima Hogg[1]

Acc. no. 43.16

The Blanket Signal adds to Remington's repertory of mounted solo figures engaged in various military activities. Unlike *The Lookout* (cat. no. 1), which features a scout in partial profile surveying the plains below for signs of danger, or *The Hussar* (cat. no. 5), which emphasizes foreign military pageantry and display, *A Blanket Signal* introduces a figure that is a hybrid of elements: one of the Native Americans employed by the United States Army as irregulars, a military trend Remington had strongly supported in "Indians as Irregular Calvary," an 1890 article he wrote for *Harper's Weekly* (see cat. no. 4).

In the painting, a Crow scout sits astride his mottled gray horse near the top of a hill and raises a brightly colored, two-toned blanket with his right hand while balancing a rifle and reins with his left. The broadly brushed landscape—its spiky grass indicated by swipes of a dry brush—with its lively, thick, cloudy sky, improves on the landscapes Remington conceived earlier in his career. The figures and props remain tightly controlled and detailed: the horse's musculature and trimmed mane; the wrapped tail and "A" brand (for A Troop of the Irregular Cavalry) on the horse's hindquarter; the Crow's wrapped and feathered hair, pronounced square jaw, long earrings, and decorated gloves. Such subtle elements as the rawhide that hangs near the figure's foot, curving in a graceful calligraphic line to suggest its narrow sides, indicate the kind of nuanced detail that Remington developed to lend credence and authority to his images. By silhouetting the figure against the sky and omitting all but the most cursory suggestion of landscape details, Remington heroizes this frontier type. Balance and symmetry—the mounted figure is centered on the canvas in profile and at eye level, and the rifle positioned parallel to the picture plane forms a right angle to the raised hand with dangling quirt—help to evoke a sense of stability and order that emphasizes the message of the scene: efficient communications on the plains and the employment of reliable Native American scouts to achieve the United States Army's ends.

Remington did not publish *A Blanket Signal* during his lifetime, but it bears a resemblance to several early as well as later published subjects. In the March 1891 issue of *Century Magazine*, Remington illustrated *A Friendly Scout Signaling the Main Column*, which depicts a Native American scout raising a buffalo skin to signal a warning.[2] This same image was developed further in a painting titled *The Buffalo Signal* (1900, private collection) and in a related work in bronze, *The Buffalo Signal* (1901, National Cowboy Hall of Fame and Western Heritage Center, Oklahoma City), both of which portray a brave waving a buffalo skin in the wind as a signal. All of these images owe a debt to one of Remington's earliest illustrations, *Signalling the Main Command* (fig. 1), which appeared in *Harper's Weekly* in 1886 accompanying the article "Plains Telegraphy" and portrayed a group of officers and scouts raising a flag to signal distant cavalry. All of these images illustrate the necessary reliance on codes to deliver information across large expanses of "untamed" land. The very title of the 1886 article, "Plains Telegraphy," helps to underscore the significance of this rudimentary but effective means of frontier communication; in the absence of electronic transmitters for something as sophisticated as Morse code or telephones, a new "plains" language based on hand gestures, flags, blankets, buffalo skins, and smoke developed, and it could mean the difference between life and death. The 1886 article points out:

> Its [plains telegraphy's] home station is in the pair of keen eyes behind the field glass with which at frequent intervals the commander sweeps the horizon. At certain hours he expects a signal, news or no news, but his lookout is never long neglected. To the eye of the ordinary observer, not a veteran plains campaigner nor a plains Indian, hardly anything could be more hopeless than an undertaking to trace or find man or beast across the treeless, trackless solitudes traversed by our hard-working cavalry. It is weary, tantalizing toil. . . . yet the dull monotony of the long hunt is broken by occurrences of intense interest and dramatic effect.

This plains "semaphore" was the language of survival on the Western frontier, where Native American languages mingled with English and Spanish and often made any

Fig. 1 Frederic Remington, *Signalling the Main Command.* Illustrated as wood engraving in "Plains Telegraphy," *Harper's Weekly,* July 17, 1886, 452. The Museum of Fine Arts, Houston, gift of Dr. Mavis P. and Mary Wilson Kelsey (91.1430.94 and 95)

kind of reliable communication difficult. Remington's image seems to imply that any other kind of communication is unnecessary; so-called primitive lands call for a rudimentary, shared language that sweeps across the shifting boundaries of contested territories. Thus, Remington's image derives its power from the vast distance it suggests on multiple levels: the distance between signaler and audience, between viewer and painted figure, between refined and rudimentary forms of communication, and between the largely Eastern consumers of the image and the West they imagined.

1. Note on provenance: A letter written by Will Hogg to his secretary dated July 31, 1924, indicates that this painting, which he referred to as "an Indian Chief," was bought in Kansas City (WCH Papers, Box 2J349). It is not known whether he acquired the painting from a previous owner directly or if he worked with a dealer, possibly Findlay Galleries.

2. *A Friendly Scout Signaling the Main Column* appeared in John G. Bourke, "General Crook in the Indian Country," *Century Magazine,* March 1891, 648; see Hassrick and Webster 1996, 1:376, no. 1232.

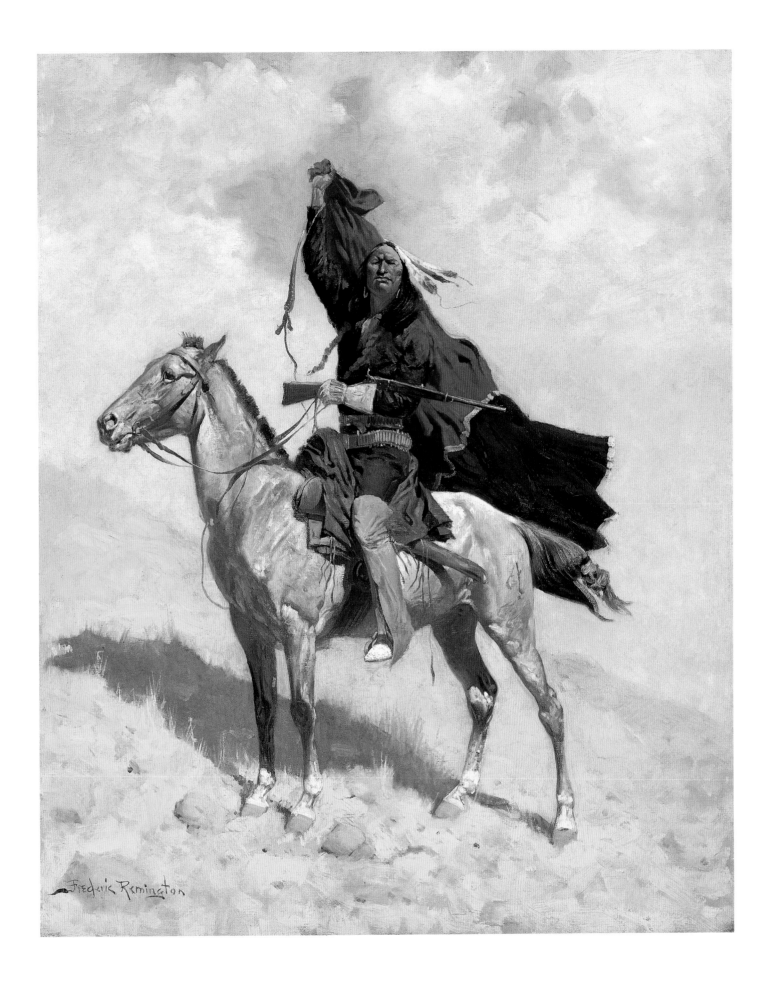

10. The Going of the Medicine-Horse (Indian Fire God)

1897

Oil on canvas in black and white, 40 x 27 in. (101.6 x 68.6 cm)

Signed at lower right: Frederic Remington— / copyright 1897 / Harper Bros.—

The Hogg Brothers Collection, gift of Miss Ima Hogg

Acc. no. 43.53

When Remington held his first solo exhibition and sold his work in the early 1890s, the black-and-white oils met with more enthusiasm and commanded higher prices than his works in color. Two factors explain this trend: Remington's greater maturity, experience, and facility working with the illustrator's palette of black and white, and the familiarity of the black-and-whites to his viewing public, which was already accustomed to seeing his work *en grisaille* and understood his work in the context of reproduction rather than as paintings hung in fine-art exhibitions. As one critic confessed in 1893, "Mr. Remington's fame is founded on his black and white illustrations. His paintings are not so familiar to the public and it is doubtful if his brush work will add interest to what is the essential charm of his pictures."[1] The image, not the art object itself, contributed to Remington's appeal most in the early to middle years of his career. Nonetheless, an active market for Remington's black-and-whites emerged in the 1890s and continued well after his death because of the mass appeal of the illustrations.

Because these images were always intended for the reproduction process, technology imposed limitations on Remington's style. The black-and-white paintings that were used to make halftones required flat, nonreflective surfaces that would not compromise the photoengraving process. The purpose of halftones was to capture the full range of tones between black and white, so that forms appeared to have volume rather than mere linear definition. Remington's palette of black and white often forced him to achieve a greater range of effects with minimal means. In *The Going of the Medicine-Horse,* for example, Remington left one area unpainted so that the buff-colored primed canvas carried a bright spot of color—translated into a range of gray in the photoengraving process—to create an eerie effect in the burning coals of the fire.

For Remington, the medium of black and white enhanced the mythic and mysterious story the painting illustrated: his first work of fiction, "The Great Medicine-Horse: An Indian Myth of the Thunder," which appeared in *Harper's Monthly* in September 1897. Remington had told his friend Poultney Bigelow that he had "a 'hummer'

in next Harp mag September 1897—dialect by God—and that will give Alden [the editor] a hemorage [sic] unless it's a top roper."[2] *The Going of the Medicine-Horse* is one of three images plus a frontispiece that were used to illustrate Remington's story of a meeting in a tepee that included Remington himself, a guide named Sun Down Leflare, and Itsoneorratseahoos, known as Paint. The story contains three levels of communication: the strange noises of Paint, who "spoke slowly, with clicking and harsh gutturals [sic], as though he had an ounce of quicksilver in his mouth which he did not want to swallow"; the embellished translation of Sun Down, a "crossbred, red and white, so he never got mentally in sympathy with either strain of his progenitors"; and the written and illustrated story of the "encounter" for the readers of *Harper's Monthly* by Remington himself, who allows that the story is as much a product of Sun Down as of Paint. The story is created and re-created at three different levels, enlarged and expanded at the second turn and faithfully related last, or so he would imply, by Remington. Myth, history, and spectacle merge not only to relate an entertaining story of the source of thunder and lightning but also to highlight a relationship between the author as an objective observer and the translator as a brilliant mythmaker trapped between two cultures, part of neither but dependent on both.

Paint, through Sun Down, recounts a story that occurred long ago in Crow history during the time of his "fader's fader," or grandfather. The Crow left their home in search of horses, captured them, and then were pursued by those who had owned them, as well as by the Cheyenne and Sioux they encountered on the way home. Paint's grandfather spotted a fine red horse among the herd, caught it, and escaped from the charging Sioux.[3] Months later he found his way home, and when he did, the red horse—the only red horse among black, spotted, or roan—was kept in the medicine man's lodge. There he became a kind of magical horse, siring plenty of red colts, assuming the role of medicine chief himself, siring even more colts with the Crow women, and ushering in the days of plenty, which

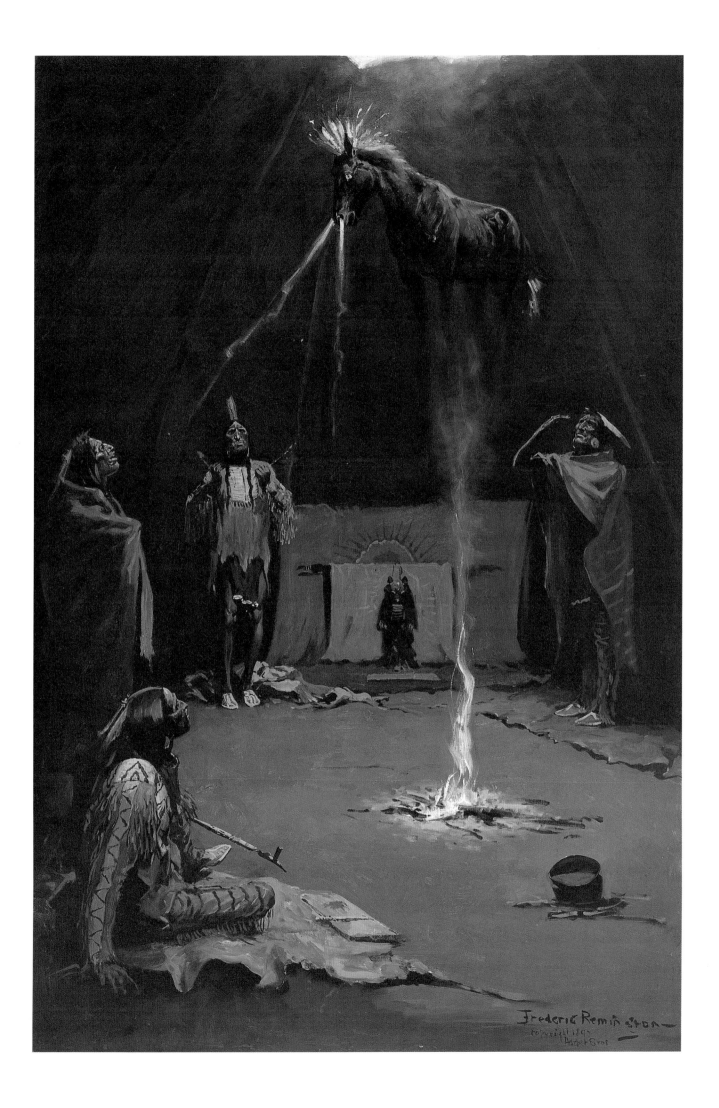

were characterized by good trading, lingering buffalo, mild winters, and lots of scalp-gathering:

> all 'dese . . . was medicin'-horse work. But in de moon een which de geese lay deir eggs de great horse he was rise up een de curl of de smoke of de big lodge—he was go plum t'ro de smoke hole. De chief ask him for not go, but he say he was go to fight de T'under Bird. . . . So he went 'way, un since den he has never come back no more. But Paint says lots of ole men use for see heem go t'ro air wid de lightnin' comin' out of his nose, de T'under Bird always runnin' out of hees way.

Remington's illustration depicts this moment of the story: when the miraculous medicine-horse begins to levitate in the medicine lodge and disappear through the smoke hole. The bulging eyes and snorting nostrils of the horse prefigure Sun Down's later explanation of the lightning emitted through the animal's nose. With brief, thin strokes of white to gray paint, Remington makes the forms seem to emerge from the murky darkness of the background. The light, brightest near the fire on the floor, emits enough radiance to coax from the shadows the cone shape of the tepee; the painted animal skins in the distance; four Native American figures, some wrapped in blankets, some dressed in decorated shirts (Remington owned hundreds of Native American and military artifacts from which he drew), either sitting on animal skins or standing on the hearth gazing at the miraculous event. Because Remington

begins the story as he and Sun Down enter the tepee to meet the old warrior and then sit by the burning fire to smoke and talk, the illustration both provides a literal transcription of the event in Sun Down's story and suggests the very space in which Remington first heard the story. In effect, he conflates the "real" space of Paint's tepee with the "unreal" space of the medicine-horse, so that the tepee itself, in word and text, generates two myths: Paint's and Remington's own fictitious story. In this manner, Remington mythologizes and dramatizes his own experience, another compelling example of how the artist (and author) created stories that reinforced his status as an authority of Western culture.

The Going of the Medicine-Horse also appeared in the January 8, 1910, issue of *Harper's Weekly,* with an extended discussion of Remington and his career by Charles de Kay following Remington's death.[4] *The Going of the Medicine-Horse* was one of only six works by Remington illustrated in this early overview of his career.

1. *New York Sun,* January 9, 1893, 6.

2. Remington, quoted in Samuels and Samuels 1982, 257.

3. In his notebook, Remington describes the medicine-horse as a "white thoroughbred" (69.748.4 verso, FRAM, Ogdensburg).

4. Charles de Kay, "A Painter of the West: Frederic Remington and His Work," *Harper's Weekly,* January 8, 1910, 14–15, 38.

11. Disbanding Gomez's Army

1899
Oil on canvas in black and white, 27 x 40 in. (68.6 x 101.6 cm)
Signed at lower right: Frederic Remington
The Hogg Brothers Collection, gift of Miss Ima Hogg
Acc. no. 43.44

During his European travels in 1892, Remington expected Russia and Germany to go to war and was disappointed when peace prevailed, denying him the opportunity to see combat (see cat. no. 5). Reared on stories of his father's heroic exploits during the Civil War, Remington harbored romantic notions of warfare and had already lived "a life of longing to see men do the greatest thing which men are called on to do. . . . The creation of things by men in time of peace is of every consequence, but it does not bring forth the tumultuous energy which accompanies the destruction of things by men in war. He who has not seen war only half comprehends the possibilities of his race."[1]

The Spanish-American War of 1898 gave Remington the chance to witness war and to test his nationalist conception of American superiority. Fueled by reports of the Spanish oppression of Cuba, Americans enthusiastically supported the Cuban revolutionary cause, and Remington played a key role in the mounting hysteria. William Randolph Hearst, owner of the sensationalist newspaper the *New York Journal,* commissioned Remington and Richard Harding Davis to travel to Cuba in 1896 to cover the hostilities between Cuba and Spain as colonial Cuba struggled for independence. When Remington reported that "Everything is quiet. . . . There will be no war," Hearst reportedly fired back, "You furnish the pictures and I'll furnish the war."[2] In February 1897, Remington and Davis engineered an exaggerated "report" about espionage and the body searches of Cuban women on American ships. Remington's illustration included a nude woman surrounded by three predatory-looking Spaniards conducting a search. The story caused a furor and was later retracted (the search had been conducted by women), but stories of Spanish atrocities continued to circulate. With the mysterious sinking of the battleship *USS Maine* in Havana Harbor in 1898, the war that had seemed inevitable finally erupted, providing opportunities for Remington to travel to Cuba again and to enjoy several more adventures: participating in a naval blockade, traveling on a torpedo boat, muddling through the interminable wait for action, accompanying United States troops in the

invasion of Santiago, and, while he did not witness it, lurking nearby when the Rough Riders charged San Juan Hill. All of these experiences found their way into articles for *Harper's Weekly* and *Harper's Monthly,* the *New York Journal,* and *Collier's Weekly.*

Remington's illustration labeled "Disbanding Gomez' Army, United States and Cuban Officers Inspecting Cuban Troops near Havana, Prepatory to Mustering Them out of Service" appeared in a two-page spread in *Collier's Weekly* on April 15, 1899.[3] Remington had returned to Havana in February 1899 as a war correspondent for *Collier's Weekly,* with which he would develop a long and lucrative relationship over the next decade. The purpose of this trip was to depict the United States Army occupation of Cuba in the wake of the Treaty of Paris that had ended the brief war. This painting, in addition to three others in the Hogg Brothers Collection, was produced for this commission and was intended to record this stage of postwar activity (see Checklist of Works, pp. 135–36).

Remington's confession, "I am as yet unable to decide whether sleeping in a mud-puddle, the confinement of a troop-ship, or being shot at is the worst," demonstrates the range of experiences he depicted for his readers.[4] During the Spanish-American War, he also excelled in portraying the monotony of army life. In *Disbanding Gomez's Army,* Remington conveys the boredom as well as the tension in the life of a soldier. Distant palm trees indicate the scene's tropical location and add a note of "exoticism" that is matched in the uniforms and physical appearance of the Cubans, all of which would have appealed to American curiosity. The Cuban and American officers standing in shadow separate them from the rank and file and provide contrast to the soldiers whose white uniforms reflect the intense sunlight.

The scene of troops being released provided Remington the opportunity to paint a large group of figures engaged in a variety of poses and activities—smoking, talking, leaning on guns, including one resting his elbow on a rifle to create a support for his head—many of which derive from a photograph Remington took in Cuba of soldiers watch-

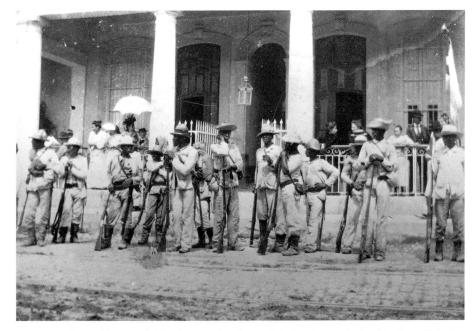

Fig. 1 Cuban soldiers, probably photographed by Frederic Remington during his trip to Cuba in 1899. Frederic Remington Art Museum, Ogdensburg, New York (1918.76.160.582).

ing a parade (fig. 1). Boredom clearly emerges as the common denominator for all the participants. And yet, the fact that very few of the soldiers are engaged in conversation heightens the air of expectation. The principal figure, an officer with his back toward the viewer, holds the attention of the other two officers as well as of the men who are aware of his actions. The viewer cannot see what he is doing—perhaps checking off names—and the fact that his actions are obscured adds to the suspenseful nature of the painting. At a time when Remington's style began to change in response to the general tenets of Impressionism (loosened brushwork and a more spontaneous and suggestive appearance), he may also have been influenced by both the European and American Impressionists' fascination (exemplified by Edgar Degas and Childe Hassam) with allowing only a view of the back of a figure to carry the emotional weight of the painting.

1. Frederic Remington, "With the Fifth Corps," *Harper's Monthly,* November 1898, 962.

2. The account comes from *New York Journal* reporter James Creelman's reminiscences, *On the Great Highway* (1901), and is related in Samuels and Samuels 1982, 249.

3. The image and title appeared on pages 12–13 but did not illustrate any article or story.

4. Remington, "With the Fifth Corps," 962.

12. *The Defeat of Crazy Horse (The Defeat of Crazy Horse by Colonel Miles, January, 1877; Winter Attack on an Indian Village)*

c. 1901, possibly c. 1896
Oil on canvas in black and white, 27 x 40 in. (68.6 x 101.6 cm)
Signed at lower right: Frederic Remington
The Hogg Brothers Collection, gift of Miss Ima Hogg
Acc. no. 43.35

This gruesome image of the Indian Wars illustrated the article "The United States Army" in the November 1901 issue of *Scribner's Magazine.* The purpose of the article was to provide a general history of the army following the Civil War. Its underlying theme, however, was to demonstrate the army's "inestimable service as the advance agent of civilization" in conquering the West. The author asserts that "the work of the army during the thirty years following the Civil War will receive due credit as a factor of the first importance in bringing the United States to its present commanding position among the great powers of the world." The article reflected the sentiments of many Americans who were basking in the postwar glow of the Spanish-American War, which had thrust the United States on the world's political stage and initiated its brief flirtation with imperialism.

The event pictured in the magazine was titled *The Defeat of Crazy Horse by Colonel Miles, January, 1877,* and was not discussed in the text but was referred to indirectly in the section of the article discussing the campaigns against the Sioux following Custer's 1876 defeat at the Little Bighorn. Like many Remington images illustrating texts of the period, the painting was synecdochic; it was a part (one event in subduing the Sioux) standing in for the whole (the campaign against Native American "hostiles"). Here, Remington brings home the horror and violence of Colonel Miles's campaign against Crazy Horse, conveying the harsh conditions, danger, bleakness, and tragedy that, in the context of the article, symbolize the entire war against the Native Americans. In the painting, the army fires against hostile Sioux whom the viewer cannot see. Soldiers swing open the flaps of tepees and, looking for Crazy Horse's followers, are poised to shoot. In the foreground, Remington juxtaposes a dead horse with an animal skin, a visual reference to the soon-to-be defeated foe, who leaves only a trace of his former self behind. Swirls of blinding snow surround the tepees and transform them into apparitions that vanish into thin air. What nature has

not claimed, the firing soldiers in the foreground will level.

Remington expresses unparalleled violence and horror through the power of suggestion—the dead horse, the ghostlike tepees, and the shots that blast from the guns and speed toward some unseen victim. It is the kind of image that suggests Remington's disappointment with combat in the wake of the Spanish-American conflict when, at last, he had witnessed war; instead of finding glory, he recoiled at, as he phrased it, "broken spirits, bloody bodies, hopeless, helpless suffering."[1] This image captures his horror and, perhaps, ambivalent feelings about the army's methods of Indian removal. Compared with Remington's early boyish images of war that emphasized pageantry and glory, and the images he painted to illustrate Miles's *Personal Recollections and Observations of General Nelson A. Miles* (1896) depicting dead horses, falling soldiers, and shooting forces, *The Defeat of Crazy Horse* suggests grimmer realities.[2] The Native American scout, now part of the army, holds on to his gun and is reloading it, but he is not depicted aiming and shooting. Instead he is frozen, as if with the recognition that he might kill, if not his own people, his own kind. Like Sun Down Leflare, the translator of *The Going of the Medicine-Horse* (see cat. no. 10), the scout is caught between two cultures, complicit with one yet still tied to the other. In this regard, he becomes the tragic hero, poised to understand the deeper message about the plight of his race, even as he pauses to reload his rifle. This is not to say that Remington disapproved of the government's policy of Indian removal. Remington, like most of his generation, held racist views about Native Americans and believed strongly that they should be bent to the will of the white man or destroyed. At the same time he recognized the dramatic potential in the stories of their plight and cultivated romantic notions of a vanishing race, seeking to preserve Native Americans in paint, often with nostalgic sympathy. When Remington painted this picture, however, the government policy of removal had, in effect, already been realized.

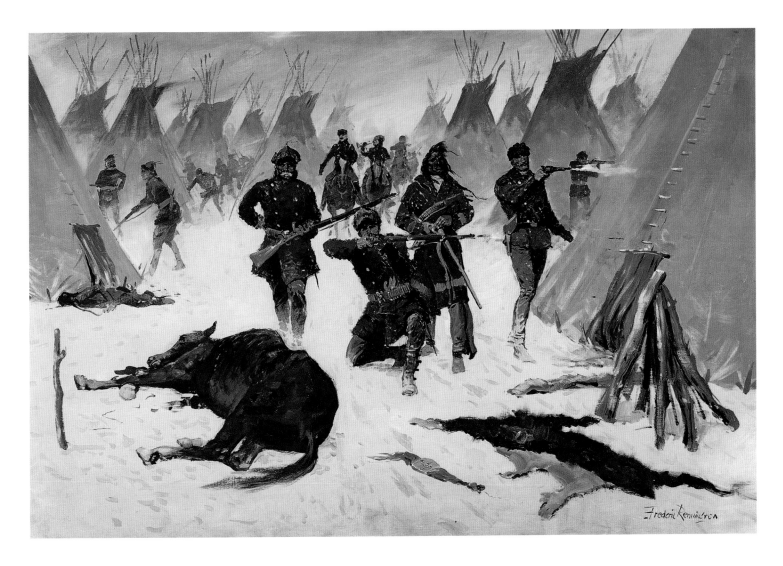

Remington may have learned the specifics of this event in the Sioux campaign from Miles himself, whom he befriended in 1886 and for whom, in return for access to the army, Remington provided sympathetic articles and illustrations detailing the general's military activities (see cat. no. 4). Major Edward Casey, who had participated in the campaign, may have also provided details. Remington's version of the event conforms loosely to Miles's *Personal Recollections,* in which Miles recorded the severity of the Montana weather during the winter of 1876–77 and his intent to ready his army "as if I were organizing an expedition for the Arctic regions" (218). In the valley of Wolf Mountain in Montana Territory on January 8, Crazy Horse and other warriors led an attack on Miles's troops, outnumbering the United States Army by two to one. While the Native Americans called out to the troops, "You have had your last breakfast," Miles's army pulled out two howitzers and began shooting (237). The Sioux braves retreated in a panic, and Miles commented on the implications: "While the engagement was not of such a serious character as to cause great loss of life on either side, yet it demonstrated the fact that we could move in any part of the country in the midst of winter, and hunt the enemy down in their camps wherever they might take refuge" (239).

Some Sioux surrendered at that time but Crazy Horse did not. Miles dispatched John Brughier on an expedition to pursue Crazy Horse into the Little Bighorn valley, where he "found the Indians encamped in the deep snow and suffering greatly from the cold, while their horses were dying from exposure" (239). Presumably, this is the moment of Miles's account that Remington illustrated in *The Defeat of Crazy Horse by Colonel Miles, January, 1877* (it actually occurred in February) when, according to Miles, many of Crazy Horse's people were found to be peaceful and ready to surrender. Crazy Horse himself did not surrender until the following May. The real defeat of Crazy Horse, which Miles does not mention in his account nor does Remington imply in his image, occurred in September, when Crazy Horse was shot and killed by Indian Agency police.

1. Frederic Remington, "With the Fifth Corps," *Harper's Monthly,* November 1898, 975.

2. Miles 1896. This painting, however, is stylistically and thematically similar enough to the series of illustrations that Remington executed for Miles's book that this painting may have been created for that series but not included in the final selection of illustrations.

13. *The Mule Pack (An Ore-Train Going into the Silver Mines, Colorado; Colorado Ore Train)*

1901
Oil on canvas in black and white, 27 x 40 in. (68.6 x 101.6 cm)
Signed at lower right: Frederic Remington / Colorado / copyright by *Harper's Weekly* 1901
The Hogg Brothers Collection, gift of Miss Ima Hogg
Acc. no. 43.56

The Mule Pack dates from Remington's first trip to Colorado and was the final picture bought by *Harper's Weekly,* putting to an end a relationship that had lasted about fifteen years.[1] The image appeared in a two-page spread in *Harper's* on March 2, 1901, and, unlike past illustrations appearing in the magazine, did not relate directly to a text, article, or story. This arrangement would develop with *Collier's*: double-page spreads of images freed, to varying degrees, from textual support and existing in their own right (see cat. nos. 15, 16, 18, and 19). This new arrange-ment centered attention on the artwork itself instead of on its illustrative aspect. However, in this issue, Remington's picture did visually enhance a nearby article, "Tales of the Mush-Ice Heroes," without participating in it directly. The article by John R. Spears gave accounts of ice storm rescue efforts on the Great Lakes and appeared in the magazine immediately before *The Mule Pack,* so that Remington's picture, a mining scene in Colorado, reinforced the same sense of danger and heroism in the face of harsh snow conditions.

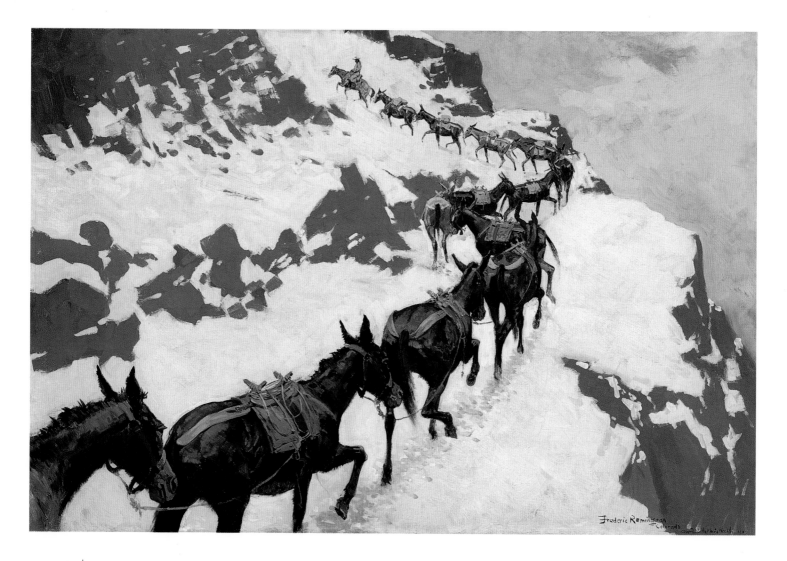

In 1900 Remington made arrangements with Maj. Shadrach Hooper, general passenger agent of the Denver and Rio Grande Rail Road Company, to receive free travel and accommodations for a sketching trip to Colorado and New Mexico, where he visited Denver, Ignacio, the Ute reservation, Española, and Taos. Presumably Remington supplied something in return—a painting or good publicity or both—for these arrangements between artists and railroad companies were just beginning to gain ground. By 1903, the Atchison, Topeka, and Santa Fe Railroad acquired its first painting in exchange for providing free travel for artists visiting the West. The paintings would be reproduced in magazine advertisements and on dining car menus so that the artist also found his work being promoted. In addition, the railroad developed a corporate art collection and art colonies in the Southwest were stimulated. Remington does not appear to have participated in this kind of relationship, but his reputation as a nationally recognized artist traveling to the West may have alerted the railroad companies to the mutually beneficial relationship that could develop as more and more artists—particularly those of the burgeoning colony at Taos (which Remington visited on this trip)—purveyed the Western experience in their art.

Remington's letters to his wife during this trip indicate his interest in the dramatic climatic conditions he observed in Colorado. On October 29, he reported, ". . . the country is black with snow clouds—This is a snow country. I left over a foot on the mountains—everyone is coming out of them except miners who expect to stay all winter and are provided. . . . I hope for some stories—I have only one so far but I have some good illustrations."[2] It is possible that he painted a sketch of *The Mule Pack* at this time as the miners were clearly on his mind. And yet, including this painting, Remington painted few pictures about this aspect of the Western experience in his art, possibly finding miners and mining lacking in dramatic or heroic potential. While Remington had depicted numerous animal trains throughout his career (see, for example, cat. no. 4), *The Mule Pack* is an anomaly in Remington's choice of subject matter: long, sinuous lines of mules hitched together making the monotonous and dangerous journey back and forth

to the mine, picking up and delivering loads of ore. Abstract blotches of white and dark gray indicate form and substance—rocky outcroppings, steep precipices, and patches of snow—in strikingly bold, flat patterns that emphasize Remington's developing painterly technique of free brushwork, reduced detail, and sense of rhythm.

At about the same time that he painted *The Mule Pack*, Remington noted to his wife, "the Utes are to [sic] far on the road to civilization to be distructive [sic]" and "I dont want to do pueblos—too tame."[3] He finally admitted to her, "Shall never come west again— It is all brick buildings—derby hats and blue overhauls—it spoils my early illusions—and they are my capital."[4] Of course, Remington did travel west again, but this trip in 1900 confirmed for him that he was not interested in painting contemporary scenes of the West or even elaborating on newer subjects but, rather, that he would continue to cultivate the nostalgic "illusions" of the West that had been his source of artistic inspiration as well of fame and income. At the same time, however, from this same journey he developed a more mature color sensibility, remarking to his wife, "I am dead on to this color and trip will pay on that account alone—."[5] The Colorado trip may have been undertaken with the idea of gathering material for stories, but it clearly developed into one that focused on the painterly effects of mood, feeling, and rhythm that would characterize his art until his death in 1909.

1. Remington's last illustration for *Harper's Monthly* appeared in June 1901, part 2 of Woodrow Wilson's "Colonies and Nation: A Short History of the People of the United States." See Checklist of Works, p. 136, for a related image from part 1 of the series.

2. Remington to Eva Remington, October 29, 1900, in Splete and Splete 1988, 316. His sketchbook for the Colorado trip includes a list of subjects under the heading "Picture" (FRAM, Ogdensburg, Sketchbook, 71.812.5). Included on the list is "25 mule ore trains on mountain trail," perhaps an early, cursory reference to the Houston painting.

3. Remington to Eva Remington, November 4, 1900, and November 6, 1900, in Splete and Splete 1988, 317, 318.

4. Remington to Eva Remington, November 6, 1900, in Splete and Splete 1988, 318.

5. Remington to Eva Remington, November 4, 1900, in Splete and Splete 1988, 318.

14. Days on the Range ("Hands Up!")

c. 1902
Oil on canvas in black and white, 40 x 27 in. (101.6 x 68.6 cm)
Signed at lower right: Frederic Remington—
The Hogg Brothers Collection, gift of Miss Ima Hogg
Acc. no. 43.48

Days on the Range served as a frontispiece for Alfred Henry Lewis's book *Wolfville Days* (1902),[1] one of the many volumes this popular humorist and novelist published about cowboy life in southeastern Arizona. Remington had supplied Lewis's novels with illustrations before, eighteen for the first volume of the series, *Wolfville* (1897). *Wolfville Days,* however, included only this one illustration, an indication of Remington's relatively new effort to concentrate on painting rather than illustration.

Like Remington, Lewis was a relatively well-educated young man when he initially traveled west, working as a wandering cowboy at about the same time Remington first explored the Montana Territory. A lawyer by training, Lewis began writing short stories about cowboy life in Arizona. The success of these stories led to a career as a journalist working for William Randolph Hearst (through whom he and Remington may have first made contact) and writing novels, the most popular of which featured the storyteller "Old Cattleman," a colorful native of the fictitious town of Wolfville.

Days on the Range relates to "When the Stage Was Stopped," the nineteenth chapter in the book. In the painting, a cowboy aims a revolver straight at the viewer. The accompanying title for the illustration, *"Hands Up!"* refers, of course, to the mustachioed man on a horse who points his gun and demands surrender. By having the cowboy aim the gun straight at viewers (and readers), Remington extends the action into their space, putting them on the alert. This interactive aspect is a fitting pictorial device: Old Cattleman's stories involve all sorts of tricks, disguises, delays, and surprises.

In a roundabout and long-winded manner, Old Cattleman relates a story about stagecoach robberies and banditti holdups near Wolfville. In his pronounced cowboy patois, he relates, "Thar's rooles about stage robbin'. . . . It's onderstood by all who's interested . . . that the driver don't fight. He's thar to drive, not shoot; an' so when he hears the su'gestion, 'Hands up!' that a-way, he stops the team, sets the brake, hooks his fingers together over his head, an'

nacherally lets them road agents an' passengers an' gyards, settle events in their own onfettered way" (299). Lewis and Remington thrust the viewer/reader, then, into the position of passenger or the stagecoach driver "Old Monte," the town drunk who, according to stage robbery rules, at least is "plumb free to make what insultin' observations he will, so long as he keeps his hands up an' don't start the team none ontil he's given the proper word"(299). Once the rules are explained to the reader, Old Cattleman relates a story about how some of the townspeople of Wolfville— Cherokee, Peg-Laig, Jack Moore, Enright, and others— begin to suspect that a visitor from Buffalo by the name of Davis may be one of the robbers preying on the Wells Fargo coaches coming through town. They set up Davis by letting him know that a Wolfville store "aims to send over to Tucson a roll of money the size of a wagon hub" and that no guards will be accompanying Old Monte, just one passenger (308). Davis holds up the stage, takes the Wells Fargo chest, "accepts a watch an' a pocket-book from the gent inside, who's scared an shiverin' and scroogin' back in the darkest corner, he's that terror-bit" (310). But soon after the coach moves on, its load lightened considerably, "a Winchester which starts the canyon's echoes to talkin'" starts firing and killing the bandits. The reader learns that Jack Moore had disguised himself as the "shiverin'" passenger, and as soon as the coach had turned a corner came creeping back to kill the bandits. By the time the reader has finished the story, Remington adds a new angle to this confrontational image, structuring it so that the reader/viewer is placed in the role of either the hero, Jack Moore, or the endearing drunk, Old Monte. Introducing this clever relationship between text and image, Remington provides a more compelling experience for the viewer/reader and, not least, reveals his own considerable wit.

1. Alfred Henry Lewis, *Wolfville Days* (New York: Frederick A. Stokes, 1902).

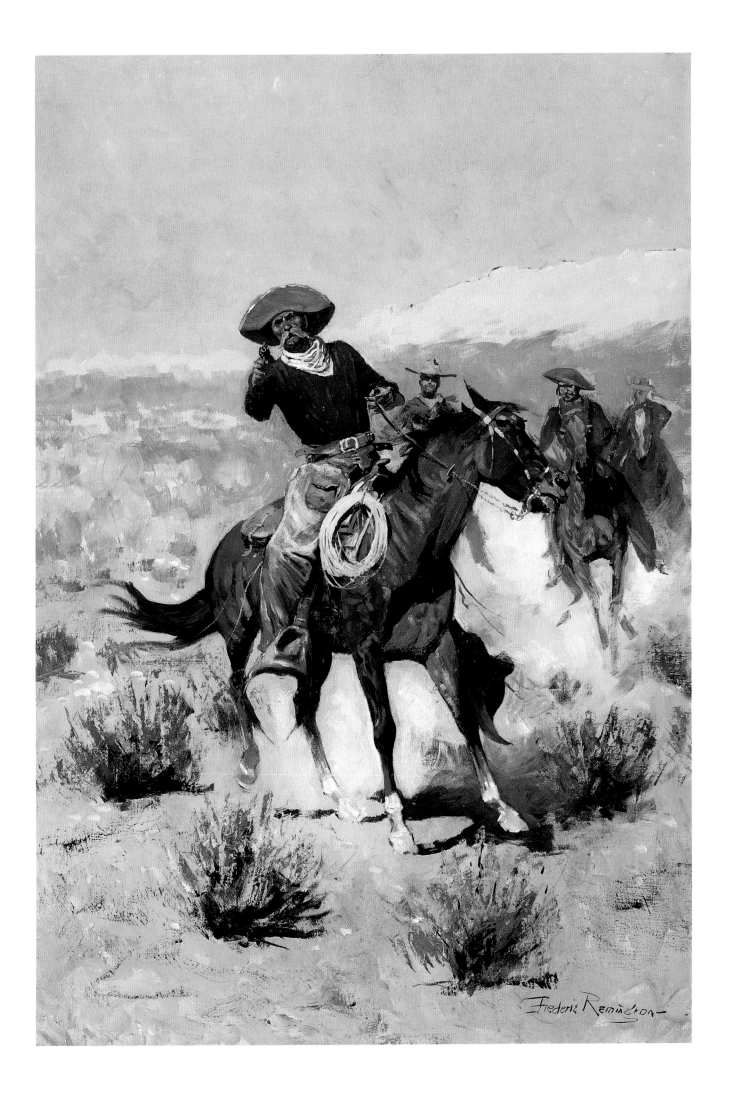

Frederic Remington

15. *Fight for the Water Hole (An Arizona Water Hole; A Water-Hole in the Arizona Desert)*

1903
Oil on canvas
27 1/8 x 40 1/8 in. (68.9 x 101.9 cm)
Signed at lower right: Frederic Remington— / copyright 190[?] By Frederic Remington
The Hogg Brothers Collection, gift of Miss Ima Hogg
Acc. no. 43.25

In 1903, *Collier's Weekly* entered into a four-year contract with Remington to produce twelve paintings a year for twelve thousand dollars. According to this agreement, *Collier's* would reproduce one painting each month as a full-color double-page spread. This new arrangement signaled a turning point in Remington's career and provided him with three important benefits: financial security, the freedom to choose his subjects without any textual considerations, and the opportunity to disseminate his work to

his audience in color instead of the usual black and white. *Fight for the Water Hole* is the second painting in this commission and was published December 5, 1903, in *Collier's* Christmas issue.[1] Most Remington authorities acknowledge that *Fight for the Water Hole* is arguably the masterpiece of Remington's career.

The alliance with *Collier's* encouraged Remington to experiment with color and light. The results were seen in the artist's looser brushwork, refined compositions, and

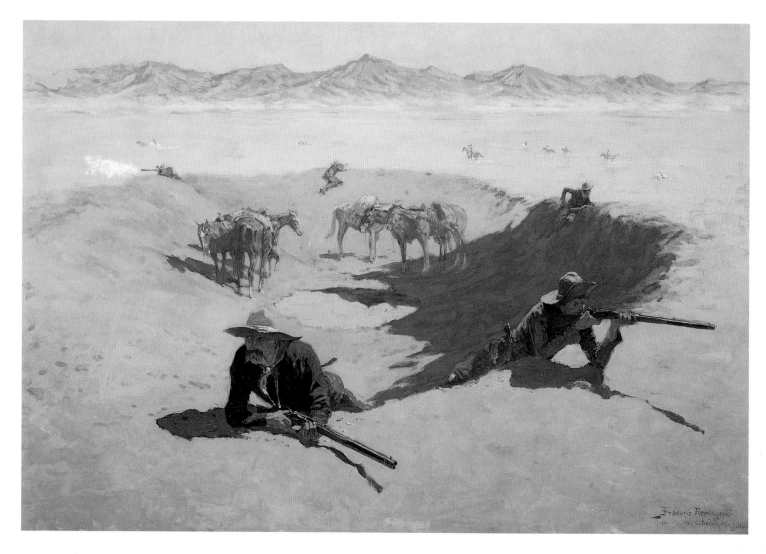

Fig. 1 The Pool, Sierra Bonita Ranch, Arizona, from Remington's photo album *A Snow-Shoe Trip to California*.
Frederic Remington Art Museum, Ogdensburg, New York (71.834)

bolder palette, as well as in the developing psychological qualities of his art. The artist's freedom to choose his subject matter was also important—especially now that this choice was no longer dictated by the magazine's narrative needs. As Remington confessed in 1909, just weeks before he died, "I stand for the proposition of 'subjects'—painting something worth while as against painting nothing well—merely paint. I am right—otherwise I should as soon do tit tatting, high-art hair pins or recherchia ruffles on women's pants."[2] Indeed, Royal Cortissoz, a New York critic and early enthusiast of Remington's art, conceded the artist's greatest ability was "to put his subject accurately before you and make you feel its special tang."[3] But after about 1900, when critics continued to write about the importance of subject matter in Remington's art (as they had in the 1890s), they did so in ways that acknowledged the artist's development as a colorist. For example, Samuel Isham, in *History of American Painting* (1905), acknowledged Remington as the "authoritative chronicler of the whole western land" and, as if to describe *Fight for the Water Hole,* noted "The raw, crude light, the burning sand, the pitiless blue sky, surround the lank, sunburned men. . . . The subject is more to him than the purely artistic qualities displayed in its representation."[4] Isham did not discount the artist's "artistic qualities"; he merely perceived subject matter to be of greater importance to the artist and worthier of note than technique. In fact, by both focusing intently on his subjects and experimenting with color, Remington began to produce works that are now considered the most powerful and poignant of his career.

In *Fight for the Water Hole,* Remington divided the canvas into broad bands of color, from pinkish blue to yellow,

to lavender, and to blue, and punctuated the scene with a shallow pool of blue water at its center. He placed the viewer slightly above the action, looking down and across a scorching desert plain, with purple mountains rising in the distance. Against this background, five gunmen, positioned along the edge of a vast hole, engage in battle with Native Americans, one of whom, at far right, has already been downed. In the distance at left, one gunmen fires his rifle; to his right, another aims to shoot a figure who aims back at him with his gun. The distant figure at right pauses and stretches his arm back, perhaps to reach for more ammunition. The two figures in the foreground comprise a study in contrasts. While the one on the right aims carefully to shoot, the figure at left, who has been firing in a similar direction, pauses briefly and casts his beady eyes to his right, toward an unseen foe in that direction. A trail of beige paint to his left indicates that a bullet has missed its mark just a few feet away from him, and carefully rendered spent shells suggest that this gunfight has been going on for some time. Six horses, protected by the hole, seem oblivious to the gunfight. They wait quietly in the center, their shadows captured in the reflective surface of the pool. A large shadow on the right side of the hole, mirroring a large cloud formation above, ominously signifies the idea of passing: specifically, the ever present threat of death in the Western territories during the Indian Wars and, generally, the "passing" of the West itself.[5]

In conceiving the landscape of the painting, Remington used a photograph—kept in his scrapbook of similar *aides-mémoires* and probably taken by himself—of a water hole at Sierra Bonita Ranch, Arizona (fig. 1).[6] The artistic challenge of making a desert hole the subject of a painting evi-

Fig. 2 John Twachtman, *Emerald Pool, Yellowstone,* c. 1895. Oil on canvas, 24 1/4 x 30 1/4 in. (61.6 x 76.8 cm). Wadsworth Atheneum, Hartford, Connecticut, bequest of George A. Gay, by exchange, and The Ella Gallup Sumner and Mary Catlin Sumner Collection Fund, 1979.162

dently intrigued him, because he then developed this landscape concept into a sketch of the water hole with water, desert, and mountains but without figures (Buffalo Bill Historical Center, Cody, Wyoming). This subject had likewise intrigued his peer John Twachtman, whose mid-1890s paintings of the Emerald Pool at Yellowstone National Park similarly explored the challenge of depicting a deep crevasse on a two-dimensional surface (fig. 2). The motif of a circle of death is one that Remington used as early as 1888, in *Last Lull in the Fight,* and had repeated, reserving it in particular for his most gruesome scenes of battle on the frontier, such as *The Last Stand* (1890, Woolaroc Museum, Bartlesville, Oklahoma) and a later version of *Last Lull in the Fight* (c. 1903, private collection).[7] Obviously, the motif derived from the common military strategy of forming a circle in order to shoot in all directions and to protect the group from all sides, but it also seems to have appealed to Remington on a pictorial level. Using the circle of death, with its implied movement in all directions, Remington could suggest the panoramic quality of the West that had always fascinated him (see cat. no. 7). Moreover, the revolving movement implied by action arranged in a circle gives these paintings, including *Fight for the Water Hole,* a whirling or dizzying sensation reminiscent of the steam-operated merry-go-round popularized in the United States at the end of the nineteenth century.

Fight for the Water Hole underscores the point that Remington's art invites multiple narrative and symbolic interpretations—that its meaning is, in short, elastic. For example, the title Remington used when exhibiting this painting at Noé Art Galleries in New York in 1903 was *A Water-Hole in the Arizona Desert,* which implies that such scenes of violence could occur at any water hole in the Arizona desert. This title confirms the artist's indebtedness to the photograph that assisted him, rather than to any specific historical event (see below). For the Christmas edition of *Collier's* in which the image appeared, the editors changed the title to *The Fight for the Water Hole.* The new title cast the painting in a narrative light, conveying the rarity and, thus, importance of water holes along the desert and the territorial fights for them for survival, even (or especially) for an example so desperately inadequate as the one pictured here. This new narrative diverged significantly from the one Remington initially had seized on for this painting. The story that likely inspired Remington was the widely publicized account of the Buffalo Wallow Fight that occurred in September 1874 in the Texas Panhandle during the Indian Wars. Col. Nelson Miles had ordered some scouts, including Billy Dixon, to carry dispatches to a distant fort (see cat. no. 22). When the group of men was attacked by Comanche and Kiowa warriors, Dixon and the others ran to a buffalo wallow (about ten feet in diameter),

Fig. 3 James E. Taylor, *Rescuing a Wounded Comrade—Heroic Exploit of Amos Chapman.* Illustrated
as engraving by Charles Speigle in Dodge 1883, facing p. 632. Bayou Bend Collection and Gardens Library,
The Museum of Fine Arts, Houston, Hogg Brothers Collection, gift of Miss Ima Hogg

quickly threw up dirt around the sides to create a bulwark, and defended themselves using the wallow as protection. The fight, therefore, was not about water; the wallow was used instead as a shield against enemy fire. After several days of fighting (in which the water gathered in the wallow would have become a necessity), Dixon left the group in search of help and, after locating United States troops nearby, saved the remaining wallow fighters. Colonel Miles awarded the surviving scouts the Medal of Honor for their "skill, courage and determined fortitude."[8] Remington could have learned this account from Miles himself, but it is more likely that he read it in Richard Irving Dodge's *Our Wild Indians* (1883), a copy of which Remington owned and whose illustrated account of the event, including a wallow of sorts at left, probably appealed to him (fig. 3).[9] Remington, of course, did not envision this painting as a literal recording of a specific event. The subject of *Fight for the Water Hole,* thus, is not the Buffalo Wallow Fight of Texas history, but the event conceivably sparked Remington's interest in exploring the dramatic possibilities occasioned by an extended skirmish around a desert hole.

Remington's art, because of its compelling power, tended to convince its viewers that the action described was real. In 1909, for example, Remington received two letters from John J. Clinton, the chief of police of Abilene, Texas. Clinton found the painting "so realistic" that he claimed he had been one of the participants in this fight (a skirmish different from the Buffalo Wallow, Clinton's fight took place in Van Horn, in West Texas).[10] He wrote to find out who had provided Remington with the story because he was anxious to make contact with a fellow survivor of this similarly dramatic event of over twenty-five years before. Evidently Remington responded to Clinton's letter, because Clinton wrote Remington again and mentioned that he wished to reply to Remington's request for an account of the Van Horn incident.[11] Remington himself was disdainful of viewers who took his paintings to be a recording of specific events (he once confided in his diary, ". . . some well bred boys called and they take my pictures for veritable happenings and speculate on what will happen next to the puppets so ardorous are boys imaginations").[12] Nonetheless, because so many generations of viewers have appreciated Remington's paintings as literal records of the past, it has been difficult to gain a fuller understanding of the artist's work. In the last decade, scholars finally have begun exploring possible readings of his art by situating the artist within the industrial, urban age in which he lived. One of the most compelling interpretations of this painting, offered by Remington scholar Alexander Nemerov, argues that this image of a "last stand" operates as a metaphor for one of Remington's social (and racist) concerns: that waves of immigrants reaching the shores of New York threatened to outnumber the Anglo-Saxon capitalist elite.[13] Remington's water-hole gunmen fighting Native Americans in the 1870s may be interpreted as the Anglo-Saxons defending their country against foreign "invaders" at the turn of the century.

Fight for the Water Hole attracted public attention as soon as it was first exhibited in New York in 1903. The art critic of the *New York Mail* commented, "There is dignity, of a rough kind, in the large compositions of many figures, entitled *The Parley* [see cat. no. 17], and the same may be said of *A Water-Hole in the Arizona Desert*, with its warlike occupants shooting at their approaching foes. . . . The drawing of horses and men is expressive, but, above all, one feels the innate power of the subjects and their handling."[14] Besides its widespread distribution in the *Collier's* Christmas issue of 1903, the painting gained currency when it was used as a frontispiece in Theodore Roosevelt's fourth volume of *Winning of the West* (1904). Charles de Kay, in his memorial tribute to Remington that appeared in *Harper's Weekly* on January 8, 1910, just a few weeks after the artist's death, initiated a discussion of Remington's art with a description of *Fight for the Water Hole:* "Remington's talent for telling a dramatic incident of frontier life is shown in such a picture as that of cowboys at a water-hole besieged by Indians, who are riding round and round at a distance, watching for a chance to snipe the man who exposes head or shoulder above the low mound in which the coveted water lies."[15] And, years later, national literary figure and Texas folklorist J. Frank Dobie claimed the painting was "near the climax of Remington's paintings of violence."[16] Every major scholarly publication of the artist includes a discussion of this painting, although not all scholars acknowledge the justification of its iconic status.[17] With some irony—a painting about a point around which everything else revolves—*Fight for the Water Hole*, in 1991, became the center of an intense debate involving art historians, historians, and senators about the significance of westward expansion in American history and the role of the art museum in conveying its meanings.[18] In the last ten years, *Fight for the Water Hole* has become one of the most discussed and reproduced paintings in American art history and cultural studies, powerfully emblematic of Remington's view of the West as a place of confrontation—among peoples and against nature—and of loss and nostalgia.[19]

1. The first painting published for this contract was *His First Lesson* (1903, Amon Carter Museum, Fort Worth, Tex.), which appeared September 26, 1903. See Jussim 1983, 88.

2. Remington to Al Brolley, December 8, 1909, in Splete and Splete 1988, 435. Here, in choosing activities and ornaments associated with women, Remington sets "art-for-art's sake," or the Aesthetic Movement, in gendered terms. For Remington, "merely paint" is feminine; paintings that assert subject matter are masculine.

3. Royal Cortissoz, one of the leading art critics of the time, included a chapter on Remington in his book *American Artists*. See Cortissoz [1913] 1923, 233.

4. Isham [1905] 1942, 501.

5. Alexander Nemerov also suggests that the hole and the placement of figures around it emblematize a clock, underscoring the painting's theme of passing time (Nemerov, "Doing the 'Old America,'" in Truettner 1991, 329–30; and Nemerov 1995, 31).

6. Ballinger 1989, 111, 113.

7. *Last Lull in the Fight*, painted in 1888, is known by its engraving, published by *Harper's Weekly*, March 30, 1889, 247. Remington submitted this painting to the Paris International Exposition of 1889 and it won a second-class medal.

8. Col. Nelson Miles to Billy Dixon, December 24, 1874, in "The Buffalo Wallow Fight," in Dixon [1914] 1935a, 11.

9. The book is included in Remington's book inventory (97.5.43, FRAM, Ogdensburg) as well as in Will Hogg's collection of rare books on the American West, especially on the history of Texas. Another image, *Indian Self Torture—Endurance and Defiance of Pain*, facing p. 150, in Dodge 1883 is remarkably close to a number of Remington's images on a similar theme, for example, *Sundance* (1888, private collection, New York State) and *The Sundance* (1909, FRAM, Ogdensburg). Dodge's account of the event credits Amos Chapman, rather than Billy Dixon, with the event's heroic moments (see Dodge 1883, 629–32). Dodge's account should be compared with Billy Dixon's in Dixon 1935a, 3–11, and with the account appearing under "Buffalo Wallow Fight" in Texas State Historical Association 1996, 1:816–17.

10. John J. Clinton to Remington, January 6, 1909 (FRAM, Ogdensburg). In this letter, Clinton says that he was one of the defenders of the water hole under Bigfoot Wallace's command. He notes that "the surroundings are so perfect that I feel sure some one of the Defenders described it to you, and as they became scattered, I would thank you to give me his name and address if living." The skirmish at Van Horn, unlike the Buffalo Wallow Fight, was over the water hole, only one of two on the route from Fort Davis to Fort Bliss. It is possible that Remington could have known about this story as well, inasmuch as he probably knew Bigfoot Wallace personally (see cat. no. 8).

11. John J. Clinton to Remington, February 27, 1909. The typewritten account that Clinton enclosed with his letter appears to have been written by someone else.

12. Remington's diary notes, July 10, 1907 (FRAM, Ogdensburg). Yet Remington also prided himself on the historical accuracy of his paintings. See, for example, an account of Remington's criticism of the work of Charlie Schreyvogel in Samuels and Samuels 1982, 300–301; and Jussim 1983, 93–96. The West was as contested a territory for artists as it was for colonizers.

13. See Nemerov in Truettner 1991, 287, 297–303. This reading was also elaborated in the wall text for the exhibition (see Wallach 1994, 92). Nemerov's interpretation of the painting is developed in Nemerov 1995, in his discussion of the artist and social evolution; here, he describes the hole as "a clock, cave, and grave—a last ditch" (31). Nemerov also offers a thought-provoking account of the "hole" in sexual terms (41) and considers the painting within the context of the period's emerging interest in the newest frontier: outer space (75).

14. Unpaginated clipping dated April 9, 1903, with handwritten notation "Mail"(FRAM, Ogdensburg).

15. Charles de Kay, "A Painter of the West: Frederic Remington and His Work," *Harper's Weekly,* January 8, 1910, 14.

16. J. Frank Dobie, in Remington 1961, xviii.

17. Oddly, James Ballinger engages in a discussion of how the painting is not a masterpiece, citing its problems with scale and perspective and a physically impossible reflected image in the pool (Ballinger 1989, 111–13). Ballinger concludes that the painting is not convincingly "real," not considering that these features have been manipulated for artistic effect. It is, in fact, Remington's manipulation of scale that provides the painting's panoramic quality. However, the painting is reproduced as both the cover and the frontispiece of Ballinger's monograph.

18. The debate arose from the exhibition *The West as America* at the National Museum of American Art, Washington, D.C. (see Truettner 1991). For reviews of the exhibition, see, for example, Trachtenberg 1991, Wallach 1994, Goetzmann 1992, May, S. 1991, Tyler 1992a and 1992b, and Truettner and Nemerov 1992.

19. For example, the painting was featured prominently in the section on American art of the West in Robert Hughes's popular television series *American Visions* (see Hughes 1997, 203–5).

16. Change of Ownership (The Stampede; Horse Thieves)

1903

Oil on canvas, 27 x 40 in. (68.6 x 101.6 cm)

Signed at lower right: Frederic Remington— / copyright 1903 By Frederic Remington

The Hogg Brothers Collection, gift of Miss Ima Hogg[1]

Acc. no. 43.17

Generally, Remington's arrangement with *Collier's Weekly* allowed him the freedom to select subject matter without the textual considerations demanded of illustrations for articles or stories. Nonetheless, Remington conceived his paintings in narrative series, and the inscriptions accompanying these images, written either by Remington or his editors, guided readers toward a specific interpretation of the picture that was not necessarily visually implicit. Here, against an eerie background light of green and yellow skies with lavender mountains in the distance, a large herd of galloping horses, guided by Native Americans waving animal skins in the air, charges across an open plain. Remington's title for the work used for copyright, *Change of Ownership,* indicates in wry language that the viewer is looking at horse thieves, and the caption used for the September 10, 1904, issue of *Collier's Weekly* expands on this notion and heightens the excitement with a new title, *The Stampede* (fig. 1).[2] The inscription noted that the painting was the seventh in a series of paintings by Remington "illustrative of the Louisiana Purchase period" (see cat. no. 19) and that

> It was a frequent occurrence in the early pioneer days for a band of Indians to rush a corral or the camp of an emigrant train, shouting wildly and waving their blankets, thus frightening the horses, who would break from the tethers and gallop in mad flight across the prairies, to be captured ultimately by the Indians.[3]

This caption provided a story for the reader so that Remington, to some degree, did not rely on imagery alone to convey content. Whether written by the artist or an editor, the captions ensured that an audience would understand the image in narrative terms: in this case, a ploy Native Americans devised to steal horses in the lawless open-range battle between white settlers and indigenous natives, a story Remington would later elaborate in his bronze *The Horse Thief* (1907). For Remington's audience, the caption underscored the popular conception of the West as a simple confrontation between cowboy and Indian, and it also deflected attention from the artwork

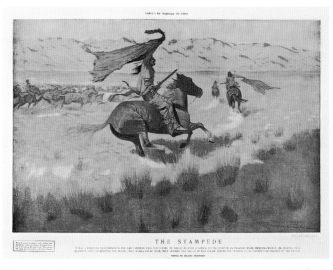

Fig. 1 Frederic Remington, *The Stampede.* Illustrated as color halftone in *Collier's Weekly,* September 10, 1904, 14–15. Amon Carter Museum, Fort Worth, Texas

as a painting on its own terms.

The painting centers on the horse and figure in the foreground, a familiar trope in Remington's paintings. A Native American sits astride his galloping horse and waves a blanket or animal skin (see cat. no. 9). Remington took this scene of Native Americans on the rampage from early similar images, such as *Waving Serape to Drive Cattle,* which appeared in an article about Mexican cowboys at the rodeo in the March 1894 issue of *Harper's Monthly.* In contrast to these previous works, however, here the repeating rhythms of waving animal skin, flying feathers, and windblown hair, mane, tail, and chap fringe in *Change of Ownership* coalesce to suggest the speed, power, and skill of the horse and rider, merging them into one image of "wild" nature. The figure's silhouette against the mountains emphasizes his open mouth, illustrating the "yelling loudly" of the caption. The most subtle and nuanced feature of the painting, however, is the magnificent horse: sleek, taut, and strained, veering sharply toward the left, its left hind leg digging into the soil and disappearing into the dust. Sunlight flashes across its hind quarters and neck, but its face is in shadow as it turns from the viewer.

Remington's relationship with the horse and his genius

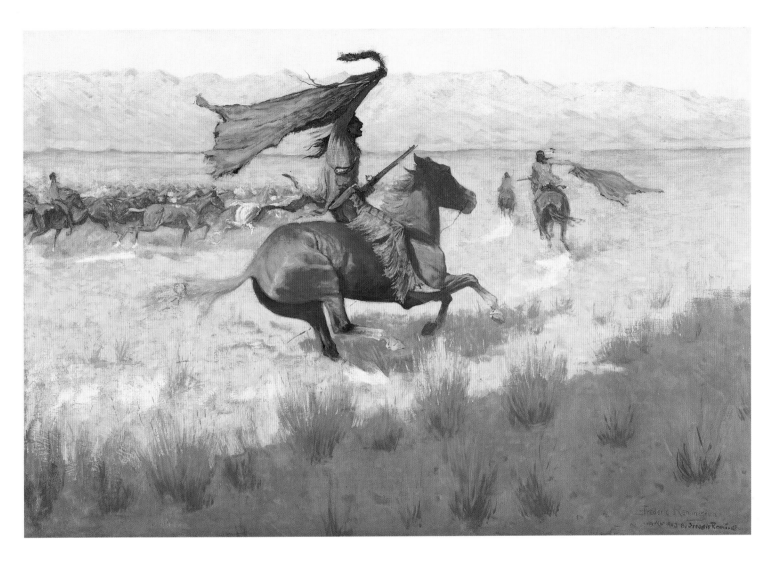

for painting the animal was well established in his lifetime, in part through his own efforts. He perpetuated (perhaps even initiated) the notion that he discovered the "correct" way of depicting horses in motion and that his work predated the photographic discoveries of Eadweard Muybridge. Because those photographs were already widely distributed when Remington studied at the Art Students League and, furthermore, were disseminated by Thomas Eakins, with whom Remington probably had contact, Remington's claim was mere bravado.[4] Nonetheless, the story indicates his investment in the horse as the ultimate form and equine anatomy as his area of personal expertise. From the beginning of his career, he painted in the tradition of the French military and animal painters whose work he would have been familiar with in the collection of the Metropolitan Museum of Art, New York: Alphonse-Marie de Neuville, Jean-Baptiste-Edouard Detaille, and, more importantly, the Metropolitan's celebrated and monumental display of horse movement in Rosa Bonheur's *The Horse Fair* (1853, see cat. no. 2, fig. 2). Remington's studio aids included a notebook titled "Book of Animals & c.," with numerous photos and illustrations of horses in various kinds of motion, and hundreds of photographs, most of

which he took himself, on similar themes. Countless anecdotes in the Remington literature indicate his desire to be identified with horse imagery. The most famous of these expressions is his friend Julian Ralph's remark that Remington "said he would be proud to have carved on his tombstone the simple sentence, 'He knew the horse.'"[5] His epitaph, in fact, does not include these words, an indication that Remington's remarks were not to be (and, indeed, were not) taken literally. The anecdote indicates, nonetheless, Remington's willingness to be known as an astute, convincing interpreter of animal movement. It may also suggest Remington's great admiration for the power, grace, and strength of the horse and his desire to be associated with that image, as well as, possibly, his recognition that the horse was becoming a relic of a preindustrialized past, much in the same way he conceived of the "vanishing Indian." In *Change of Ownership,* the horse, turning away from the viewer and cast partially in shadow, and the Native American, an iconic silhouette of "wild nature," metaphorically express a disappearing way of life that is underscored by the large "passing" shadow in the foreground.

The Louisiana Purchase Exposition, to which this image

is connected, had announced with fanfare that "The Automobile Everywhere [Is] in Evidence."[6] While only one automobile (still a fledgling invention) had graced the World's Columbian Exposition of Chicago in 1893, by 1904 it represented the "Spirit of the Twentieth Century."[7] In the context of the St. Louis World's Fair and the Louisiana Purchase of 1803 that it celebrated, the implications were clear. Just as the railroad had helped Western territory become "rich and powerful" so, too, would progress in transportation, symbolized by the automobile, enhance and transform modern life.[8] In contrast to the shiny modernity celebrated in St. Louis, Remington's image traded on a nostalgia for the Western past and all its vanishing elements: the Indian, the cowboy—and the horse. Thus, for Remington to say that "he knew the horse" meant more than merely knowing and translating it to an audience convincingly through paint or bronze; he thought of himself as someone who had lived in the age of the horse and who was anchored in a past that he believed to be superior to the future as it was evolving. The epitaph would have been not only an elegy to Remington and his way with the horse but also a reference to a passing era that had been his stock-in-trade.

1. Note on provenance: Will Hogg's diary entry for September 25, 1920, reads "Bought 2 Remingtons today at 1100 from Howard Young." According to an office inventory of October 1920 listing the newly arrived paintings, this painting and *The Parley* (cat. no. 17) were the two referred to in the diary.

2. The title Remington used in his ledger was "Horse Thieves. Stampede." *Change of Ownership* was exhibited three times during Remington's lifetime: in Remington's 1903 exhibition at Noé Art Galleries, New York, and in *Collier Collection: An Important Collection of Original Drawings and Paintings by Distinguished American Painters and Illustrators,* at the American Art Galleries, New York, November 4–11, 1905, an exhibition that later traveled to the Herron Institute, Indianapolis, in 1907.

3. The painting, however, appears to be the eighth in a series of eleven appearing in *Collier's,* which consists of *The Pioneers* (February 13, 1904, destroyed by Remington); *The Santa Fe Trade* (March 12, 1904, destroyed by Remington); *The Gathering of the Trappers* (April 16, 1904, destroyed by Remington); *The Emigrants* (May 14, 1904, MFA, Houston, see cat. no. 19); *A Night Attack on a Government Wagon Train* (June 11, 1904, destroyed by Remington); *Drifting before the Storm* (July 9, 1904, destroyed by Remington); *The Bell Mare* (August 13, 1904, the Gilcrease Museum, Tulsa, Oklahoma); the Houston painting discussed in this entry; *Pony Tracks in the Buffalo Trails* (October 8, 1904, Amon Carter Museum, Fort Worth, Texas); *Trailing Texas Cattle* (November 12, 1904, private collection, on loan to the Buffalo Bill Historical Center, Cody, Wyoming); *The End of the Day* (December 17, 1904, FRAM, Ogdensburg). The Houston museum thus owns two of the six surviving paintings in this series.

4. Michael Edward Shapiro, in Shapiro and Hassrick 1988, 96–101.

5. Julian Ralph, "Frederic Remington," *Harper's Weekly,* July 20, 1895, 688.

6. Everett 1904, 131.

7. Ibid., 134.

8. Ibid., 133.

17. The Parley

1903

Oil on canvas, 30 1/4 x 51 1/8 in. (76.8 x 129.9 cm)

Signed at lower right: Frederic Remington— / copyright 1903 by Frederic Remington

The Hogg Brothers Collection, gift of Miss Ima Hogg[1]

Acc. no. 43.21

In his more than twenty-year career, Remington rarely depicted peaceful negotiations among enemies, particularly white settlers and Native Americans. The West he painted was combative and confrontational whether it portrayed fighting between men of any race, between man and wild beast, or between man and the often unyielding nature of the region. At the heart of his work lay tension and conflict, characteristics of the strenuous life championed by Theodore Roosevelt and others, including Remington himself, as a means of reinvigorating American masculinity (see cat. no. 2). Remington was also partly drawn to these characteristics because of his training as a reporter and the value this occupation placed on recording discord and friction in the making and selling of a good story. In the last half of his career this feature of his art would mellow as Remington focused on more painterly concerns and yet,

except for his late landscapes, strain and strife remained at the core of his expression.

Exceptions to this emphasis in Remington's art would seem to include the promise of peace between Native Americans and whites in historical paintings such as *French Explorer's Council with the Indians* (c. 1901, see Checklist of Works, p. 136), any number of military paintings that show Native American scouts absorbed into the army (see, for example, cat. no. 4), or the rare painting of friendly relations, such as *White Man's Big Sunday—Indian Visitors on Thanksgiving Day* (c. 1896, private collection). But even the subjects of these paintings are predicated on confrontation—either the possibility or absence of it. In other paintings on similar subjects, such as Remington's illustrations of peaceful relations between the American occupation army and the Cubans in the wake of the Spanish-American War, he culti-

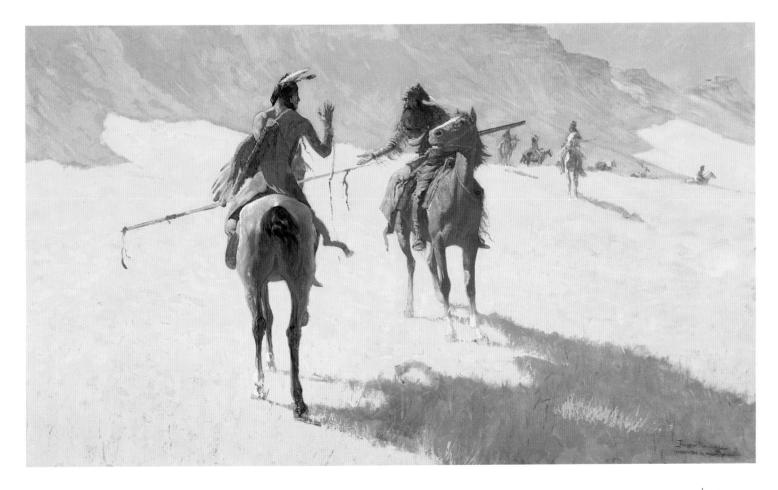

vates an atmosphere of edginess that renders any harmony between the cultures uncertain. Two of Remington's paintings, *The Parley* and *Questionable Companionship (The Parley)* (fig. 1), begin to suggest the possibility of peace, but even in these cases, Remington suspends action so that the viewer can only speculate at the outcome.[2]

In *The Parley,* a Native American raises his hand in peace while a frontiersman leans over in his saddle to extend his hand in friendship. The Native American holds on to his lance, the frontiersman, his rifle. Remington defines frontier law, then, as a combination of handshake agreements and weapons at the ready, a concept underscored by the frontiersman's hand hovering in the picture space just above the gleaming lance. Like the background figure facing the two negotiators, Remington places the viewer in a similar role of watching and waiting for an outcome that the painting's frozen moment in time can never make clear. The accompanying caption, as it appeared in a full-color single-page illustration in *Collier's Weekly* on October 20, 1906, heightens the tension and comes close to slanting the picture toward a single reading of the imminent descent of plainsmen into "wolf's law":

> *When the primitive red man and the white mountaineer were in parley, two dogs could not have bristled more nervously. They both feared treachery, and, remembering the incident of Anton Godin in 1832, whose companion, by prearrangement, shot the Gros-Ventre chief as they clasped hands, there was good reason for it. True, Godin's father had been murdered by these savages and there was always at hand a grievous fresh row. Between the wild plainsmen there was wolf's law—behind it stood no play, no solemn forms, no honor code, and the hand of peace was never far from the trigger of the loaded rifle.[3]*

While it is unclear who supplied the captions—Remington or his editors at *Collier's*—Remington, well versed in narrative traditions, liked to leave his audiences in suspense, and the tense atmosphere the caption creates conforms to his literary style. Pictorially, this quality of suggestiveness and suspension had always been a part of Remington's elaboration of subject matter, but it was a relatively new development technically. Both aspects are implied in a Remington quote of 1903: "Big art is a process of elimination. . . cut down and out—do your hardest work outside the picture, and let your audience take away something to imagine. . . . What you want to do is to just create the thought—materialize the spirit of a thing, and the small bronze—or the impressionist's picture—does that; then your audience discovers the thing you held back, and that's skill."[4] This passage focuses on Remington's

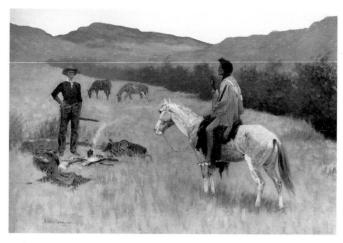

Fig. 1 Frederic Remington. *Questionable Companionship (The Parley),* 1899. Oil on canvas, 27 x 40 in. (68.8 x 101.6 cm). Thyssen-Bornemisza Collection, Lugano

thoughts about his recently developing techniques as they were informed by Impressionism, but it also suggests his interest in the narrative devices of history painting that encouraged viewers to "complete" the painting by imagining its outcome and pondering its moral message.

At this time in his career, Remington's art increasingly merged the suggestive, evocative, moody, and emblematic with his familiar brand of storytelling. Part of this change in his art can be attributed to the five-color photomechanical process of reproduction, which tended to reproduce color in broad, flat bands, creating abstract patterns of color that were inherent in the process but that also opened up new artistic opportunities. Remington had forged friendships with the American Impressionists Childe Hassam, Willard Metcalf, and J. Alden Weir and responded to their work as well as their constructive criticism of his own. Remington gained notoriety for having once expressed skepticism about the techniques of the French Impressionists, saying he had "two maiden aunts . . . that can knit better pictures than those [of the French Impressionists]."[5] His paintings of 1903, however, with their broad bands of yellow and lavender, place him firmly, if a bit tardily, with "the Monet gang back from Europe [who] want anything pale lilac and yellow," as the artist James Carroll Beckwith phrased it in 1890.[6] By 1909, the year of Remington's death, his earlier bravado had mellowed to outright praise of Impressionism, as he admitted, "The one influence . . . of value [to him] in these later years of work is Monet; not his subjects or his individual technique, but his theory of light in relation to his art."[7] He even called himself with wry humor a "plain air" man, a reference to the French expression for working out-of-doors, or "en plein air," and also a pun on the word "plain," as in simple and as in the topography of certain parts of the West with which he had become closely associated.[8]

Remington had grappled with color throughout his career, and his critics nearly always pointed out his use of it, either commenting that he was making progress or lamenting that his paintings, particularly his later works, were often "crudely colored" or "singularly dry, hard, and opaque."9 Other critics might condemn his choice of color but, nonetheless, found it an appropriate analogue for Western topography: "color is for the most part hot with violent contrasts of light and dark effects of burning sunlight," observed one critic, "and showing by the very abruptness and crudity of the color schemes a certain sympathetic response to that raw emphasis of the West which is to be noted in travelers tales."10 When Remington exhibited this painting at Noé Art Galleries, along with *Fight for the Water Hole* (cat. no. 15), *Change of Ownership* (cat. no. 16), and *A New Year on the Cimarron* (cat. no. 18), a critic praised his colors, noting that Remington had dispensed with painting glaring skies by focusing on mountain backdrops and late afternoon sunlight. Consequently, "colors are correspondingly subdued and the effect is decidedly fortunate."11

1. Note on provenance: Will Hogg's diary entry of September 25, 1920, indicates that he "Bought 2 Remingtons today at 1100 from Howard Young," referring to this painting and *Change of Ownership* (cat. no. 16).

2. *Questionable Companionship* is the title of several Remington images, including a pen-and-ink sketch at Buffalo Bill Historical Center, Cody, Wyoming, that was used to illustrate an article in the August 9, 1890, issue of *Harper's Weekly.* The article reported on the contact between cultures in Western territories, the use of sign language to communicate, and the ever-present danger that one's "companion" may not be trustworthy. All of these related images by Remington revisit this theme.

3. The caption for *Questionable Companionship (The Parley)* (fig. 1), when published in Remington's *Done in the Open* (Remington 1902), similarly included accompanying text possibly by Owen Wister, about strain and strife between cultures (and the impossibility of reconciliation): "Or does this night / Primeval shroud another mystery— / The gulf eternal twixt red man and white?"

4. Remington, quoted in Edwin Wildman, "Frederic Remington, the Man" in *Outing* 41 (March 1903): 715–16. See Samuels and Samuels 1990, 80, in which the authors interpret this quote in terms of Remington's development of narrative.

5. Remington, quoted in Doreen Bolger Burke, "In the Context of His Artistic Generation," in Shapiro and Hassrick 1988, 60.

6. James Carroll Beckwith, discussing the 1890 Society of American Artists show in New York, in Hiesinger 1991, 785.

7. Edgerton 1909, 669.

8. Remington to Al Brolley, December 8, 1909, in Splete and Splete 1988, 434.

9. *New York Times,* December 5, 1907, 8; "New Paintings by Mr. Remington and Mr. Dewey," *New-York Tribune,* December 6, 1908, 2.

10. "Gallery Notes," *New York Times,* December 8, 1909, 10. Another critic noted that Remington's color was harsh because "the color of the fluid lacking atmosphere of the plains is harsh" (*Evening Post,* December 3, 1908, 9).

11. Unpaginated clipping dated April 9, 1903, with handwritten notation "Mail" (FRAM, Ogdensburg). This same critic singled out *The Parley* and *Fight for the Water Hole,* finding them both to have "dignity, of a rough kind."

18. A New Year on the Cimarron (A Courier's Halt to Feed)

1903
Oil on canvas, 27 x 40 in. (68.6 x 101.6 cm)
Signed at lower right: Frederic Remington— / copyright By Frederic Remington [illegible]
The Hogg Brothers Collection, gift of Miss Ima Hogg
Acc. no. 43.10

In 1903, when Remington mounted only his second solo exhibition in New York since 1895, he included *Fight for the Water Hole* (cat. no. 15), *Change of Ownership* (cat. no. 16), and *The Parley* (cat. no. 17), as well as this painting.[1] The exhibition fueled the artist's momentum in his effort to win greater recognition as a painter rather than as merely an illustrator, and critics began to recognize the artist's freer brushwork, reduced and refined compositions, and enlivened palette, as well as the developing emotional qualities of his art. Depending on the context in which Remington's art was viewed at the time—either in the familiar popular magazine *Collier's Weekly* or in the fine-arts gallery Noé in New York City—Remington's paintings, translated into reproductions, could fulfill the narrative expectations of his readership while at the same time the original works could satisfy the well-honed artistic sensibilities of New York's art establishment. *A New Year on the Cimarron* and the three other Houston paintings exhibited at Noé demonstrate this dual purpose.

A surviving sketch (fig. 1) shows Remington's initial conception of the painting—three figures and three horses pausing along a riverbed for a meal—and includes his notes for a title, "The courier 'snake' on the," crossed out and replaced with "A halt to feed." Remington reduced the number of figures before laying in the canvas, as technical studies of the painting demonstrate (see p. 120). As in most of his paintings, Remington recycled themes, poses, motifs, and/or compositions from earlier works—in this instance, from an image used to illustrate his 1902 book of drawings *Done in the Open* (fig. 2).[2] Titled *Sheep Ranching,* it portrays a herdsman perched on a rock, protected by the shade of an outcropping. His dog and horse by his side and his gun at the ready, he surveys the plains for potential threats to his flock of sheep. The accompanying verse, supplied by Owen Wister or another author, describes the boredom of sheep ranching, as "nothin' for company or for fun / But a collie, a pony and a gun." The image and text take boredom as their theme, one that Remington undoubtedly experienced firsthand during his days as a sheep rancher in Kansas. In *A New Year on the*

Fig. 1 Frederic Remington, sketch for *A New Year on the Cimarron,* c. 1903. Pen and ink, 3 1/2 x 5 in. (8.9 x 12.7 cm). Frederic Remington Art Museum, Ogdensburg, New York (66.637)

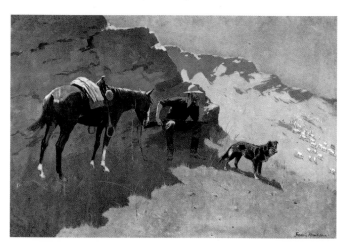

Fig. 2 Frederic Remington, *Sheep Ranching.* c. 1902. Oil on canvas, 27 x 40 in. (68.6 x 104.1 cm). Location unknown. Illustrated as halftone in Remington 1902. Hirsch Library, The Museum of Fine Arts, Houston, gift of Miss Ima Hogg

Cimarron, Remington borrows several elements from *Sheep Ranching*—the general pose of the perched figure with gun, the quiet horse at his side, and a topography that envelops and protects the figure. But the similarities end there. In *A New Year on the Cimarron,* Remington transforms the herdsman into a long-bearded frontiersman holding a cup and roasted meat in his hands (more cooks before him on a makeshift spit) and adds another frontiers-

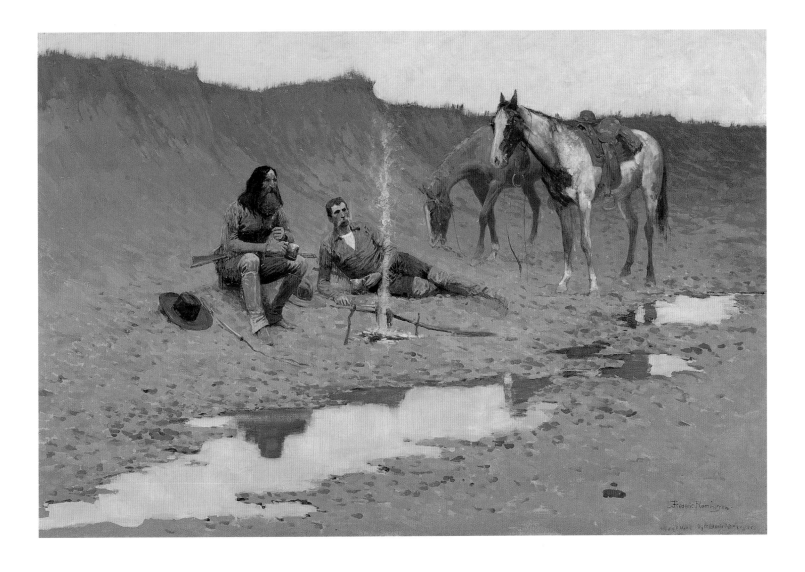

man and horse. The mountain plains have been replaced by a riverbed into which the figures and their mounts are nestled, and the scene is dramatically cropped to imply the long, snaking stretch of riverbed in both directions, features that appear in Remington's original sketch for the painting. The eerie light of a yellow and green sky contrasts with the lavender grays of the riverbed, the top of which is rimmed with spiky grass suggested by short swipes of a dry brush. Greenish puddles of water are marked by striations from Remington's brush to give a shimmering effect, and the water reflects the bearded figure and the alert horse, whose white markings lend it a ghostlike pallor. The scene appears as calm and quiet as the still water before them, but the figures' unified gaze toward the right (the beady eyes of the bearded figure are indicated by thin black lines) suggests that they may be attentive to some movement afoot across the riverbed, as if at any moment enemies alerted by the rising smoke could appear above and trap them. Whereas in *Fight for the Water Hole* (cat. no. 15), Remington provides a bird's-eye view of the trapped gunmen, in this painting, he places the figures deep into the riverbed, so that the viewer expe-riences the same uncertainty and tension as the frontiersmen themselves. They are both protected by the enveloping landscape and yet vulnerable to what lurks above them and beyond their view, a device he developed further in *The Shadows at the Water Hole* (1907).[3] This narrative device of suspension persisted in Remington's art, yet his technique had changed so dramatically in favor of creating mood rather than action that it is easy to miss the underlying story. Action, impending action, and certainly tension still continued to exist in his art, but the evolution of his methods of conveying them elevates his work from the illustrator's realm to that of the fine artist concerned with more complex stylistic and thematic issues.

Remington scholar and art historian Alexander Nemerov interprets this painting (and related ones) in the context of the artist and his culture's investment in social evolution—the belief that thoughtful, peaceful, rational humans emerged out of a primitive, bestial, and savage state.[4] Such a view implies that these primitive cowboy types were as evanescent as the disappearing smoke, that they were rungs in an evolutionary ladder that inevitably led to progressively higher stages in human development.

Fig. 3 A plaster cast of the river god from the west pediment of the Parthenon in the Yale School of Fine Arts drawing classroom. Illustrated in William Kingsley, *Yale College: A Sketch of Its History,* vol. 2 (New York: Henry Holt, 1879)

Nemerov's interpretation coincides loosely with that of *Collier's* editors. Remington copyrighted the painting in 1903 with the title *A Courier's Halt to Feed,* suggesting a narrative glimpse into the day of two traveling couriers whose quiet moments may or may not be dangerously interrupted. For unknown reasons, the painting was not reproduced in *Collier's* until 1913, four years after Remington died and ten years after he had painted it. In 1913, the title was changed to *A New Year on the Cimarron,* and the double-page full-color spread included a poem by C. L. Edson inspired by the painting that, with the title, reinforced the elegiac mood but not the narrative content of the scene. The fact that the image appeared in *Collier's* near New Year's Eve, a holiday centered in part on reflection, offered the viewer an opportunity to ruminate on a vanished era in the nation's history. In this context, the intense gaze of the two couriers may be interpreted to mean that they, too, are thinking deeply, pondering the prospects of the new year, which, if the virtually dry riverbed is any indication, look bleak indeed.

The melancholy quality of the painting was enhanced by the accompanying poem that describes a passenger on a train headed west: "A hallow roar / Told we were crossing the Cimarron, where my father crossed before. / I beckoned a hand to specter land, hailing the pioneer, / A scout looks up from his coffee cup the face of a dreaming seer." The poem sets up a series of relationships between father and son and between past and present. Where once the father traveled west by horse, the next generation "roared" through by train. In tracing the path of his dead father, the son "sees" the ghostly pioneers of Remington's painting. He imagines one of them (likely the bearded figure) as a "dreaming seer," as if this figure, looking eastward, could foresee the march of so-called progress westward and his role in achieving this end. The term "seer" connotes the prophetic figures of ancient Greece, an association that coincides with the pose and composition of one of Remington's figures. Remington restates an ancient theme with a more modern figure: by placing his mustachioed courier in a pose similar to that of the celebrated river god in the west pediment of the Parthenon (fig. 3),[5] he transforms his primitive Western types, wry river gods of the Cimarron, into heroic American exemplars of an ancient civilization that, too, would disappear in the inevitable cycle of human history.

1. This painting appeared in two other public exhibitions during the artist's lifetime: *Collier Collection: An Important Collection of Original Drawings and Paintings by Distinguished American Painters and Illustrators* at the American Art Galleries, New York, November 4–11, 1905; this same collection traveled to the Herron Institute, Indianapolis, in 1907.

2. Remington 1902, n.p. The poems illustrating the text were written by Owen Wister and others, although the author of each poem accompanying an image is not specified.

3. This painting was illustrated in the August 24, 1907, edition of *Collier's Weekly.* It is one of the many paintings that Remington himself destroyed in 1908.

4. Nemerov 1995, 36.

5. Remington would have known this particular figure as a cast of a part of the collection of Yale School of Fine Arts when he studied there under John Niemeyer.

19. The Emigrants

c. 1904
Oil on canvas
30 1/4 x 45 1/4 in. (76.8 x 114.9 cm)
Signed at lower right: Frederic Remington
The Hogg Brothers Collection, gift of Miss Ima Hogg[1]
Acc. no. 43.15

The Emigrants is the fourth in a series of paintings that Remington created for *Collier's* "illustrative of the Louisiana Purchase period" celebrated at the St. Louis World's Fair of 1904. The painting, then, may be viewed as one chapter in Remington's primer on the history of Anglo settlement in the West (see cat. no. 16).[2] As such, *The Emigrants* is a form of propaganda that makes westward expansion, from the white man's point of view, appear both heroic and inevitable. The series begins with scenes of pioneers arriving in riverboats (with peaceful Native Americans looking on), traders traveling by wagon train, and trappers en route to sell their animal skins and celebrate their success in a rendezvous. Next comes a group of illustrations (to which *The Emigrants* belongs) that show Native Americans confronting the massive tide of immigration by Anglo settlers arriving in the West and initiating the establishment of ranches and cattle drives. The series concludes with *The End of the Day* (1904, Frederic Remington Art Museum, Ogdensburg, New York) and the closing of the frontier. Overall, the series makes a powerful statement about manifest destiny, the country's self-appointed "divine right" to expand its territory westward to the Pacific Ocean, and "Indian removal" as a government policy for dealing with the indigenous civilizations that had prior claim to the land.

The Emigrants numbers among the relatively few works by Remington that take as their subject Anglo settlers heading west in a wagon train. Remington generally preferred to paint scenes of cavalry scouts, transient frontiersmen and trappers, heroic cowboys and gunmen. In this series, Remington felt compelled to add confrontation between settlers and Native Americans in his narrative of the "prairie schooners" and their long, arduous journey through contested territory. Here, Plains Indians assault a wagon train at the moment the lead wagon fords a stream, a motif similar to that used by the artist for an earlier image illustrating Poultney Bigelow's article "White Man's Africa," with a corresponding theme of the white colonization of lands inhabited by "savages" (fig. 1). In the fore-

ground of *The Emigrants,* a warrior, wearing a feather headdress and positioned atop his galloping horse, prepares to thrust his lance into a young boy who, futilely, uses a flimsy prod to ward off the attack. The boy, representative of the whole of white settlers, is cast as an unarmed, helpless victim in the face of "hostiles" who are elaborately dressed, painted, and armed in preparation for battle. The long line of wagons trailing off in the distance and beyond the picture plane appears to imply that even if this wagon train is derailed, there is an endless line of equally motivated settlers behind it, a concept underscored by the caption that accompanied the image in *Collier's Weekly,* where it appeared on May 14, 1904:

> *Indians attacking a wagon train of pioneers—one of the many and forgotten battles that were fought on the plains between red man and white, when the tide of emigration first set westward.*

Remington's series affirmed the Louisiana Purchase rhetoric surrounding the St. Louis World's Fair. As articulated by President Theodore Roosevelt, using the language of social Darwinism, "Our national expansion and evolution as a world power date from [the Louisiana Purchase]."[3] Further, "It [the Louisiana Purchase] stands out in marked relief even among the feats of a nation of pioneers, a nation whose people have from the beginning been picked out by a process of natural selection from among the most enterprising individuals of the nations of Western Europe. . . . From the moment she could, from her own shores, look over the broad expanse of the Pacific that was her manifest destiny. . . . It was a resistless tide of rich, rushing blood which made the United States what it is and which is thus fitly commemorated by the greatest of expositions."[4] Remington's young boy in the foreground of *The Emigrants* perfectly expresses the notion of "rich, rushing blood" making its way across the western territory.[5] Oddly, critics, commentators, and scholars at the time did not seem to make the connection between the domestic immigration westward that Remington and Roosevelt celebrated in

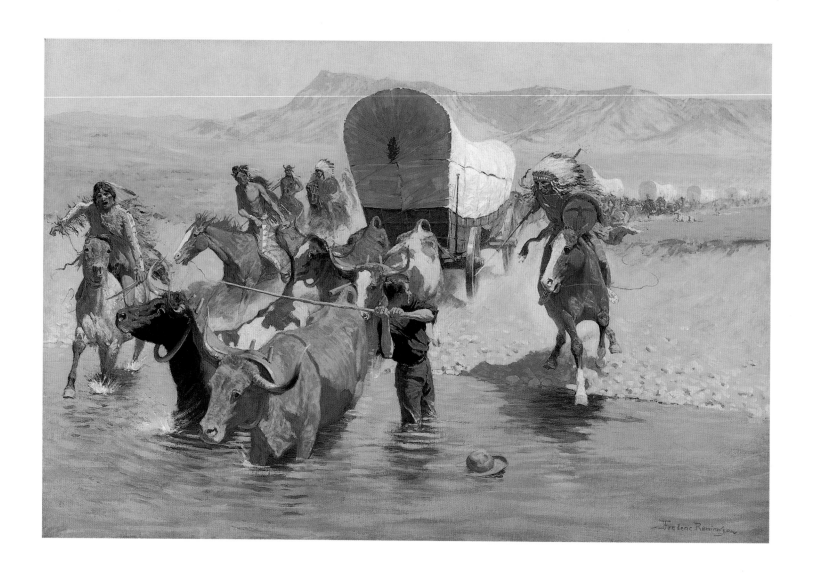

Fig. 1 Frederic Remington, *Crossing a Stream in the Orange Free State.* Illustrated as halftone in
Harper's Monthly, February 1897, 469. Hirsch Library, The Museum of Fine Arts, Houston,
gift of Dr. Mavis P. and Mary Wilson Kelsey

word and image in this kind of painting and the turn-of-the-century tide of foreign immigrants crossing the Atlantic Ocean, whose own "westward" settlement was seen by many to be a threat to national unity (see cat. no. 15). This very absence perhaps points to the overwhelming sense of righteousness and inevitability that accompanied most, but not all, discussions of westward expansion across the United States. Or perhaps the connection was indeed made, which would explain the consistent use of the term "emigrants" for this painting as opposed to "immigrants," which clearly referred to the rising number of Europeans entering the United States.

Remington's painting stereotyped the West as a perpetual site of "cowboy and Indian" skirmishes, an image that endured throughout the twentieth century in novels, movies, and popular television series. The Native Americans in the painting, once formidable foes, could be observed at the St. Louis fair as curious "relics" of the past. A book promoting the fair announced: "Indians! Yes, all kinds of them!"[6] Described as "crafty characters" and "whoop[ing]" with their friends, the fair presented them as historical artifacts of an American primeval past, in which, "like cave dwellers, they groped around in the half-light,

crawled on all fours through narrow passages, and lived very close to that warm-hearted old soul—dear Mother Earth."[7] The fair visitor could see these "relics of the past" and envision their "original" activities through the art of Remington, activities that had the mutually reinforcing effect of asserting the superiority of white culture and the righteousness of manifest destiny.

1. Note on provenance: This painting was acquired by Will Hogg at John Levy Galleries, New York, on September 28, 1920 (see cat. no. 1, n. 1).

2. See cat. no. 16, n. 3. See also Samuels and Samuels 1990, 80, 84–90.

3. Theodore Roosevelt, quoted in Everett 1904, 49.

4. Ibid., 57–58.

5. Remington scholar Harold McCracken has stated that *The Emigrants* possibly represents a true incident in which the boy in the foreground was scalped and left for dead but lived to tell the story (see Harold McCracken to James A. Chillman, February 14, 1947, MFA, Houston, object file). He wrote: "I cannot guarantee the truthfulness of the story although it was told to me by a personal friend of Remington's, who assured me that he got it first-hand from the artist."

6. Everett 1904, 337.

7. Ibid., 329, 334, 338.

20. The Herd Boy

c. 1905
Oil on canvas, 27 1/8 x 45 1/4 in. (68.9 x 114.9 cm)
Signed at lower right: Frederic Remington
The Hogg Brothers Collection, gift of Miss Ima Hogg[1]
Acc. no. 43.24

Like *The Mule Pack* (cat. no. 13), *The Herd Boy* was related to Remington's relationship with the promotional strategies of railroad companies, which at the beginning of the century, began employing artists and their art to lure potential passengers westward. This image of a Native American boy watching a herd on a cold winter evening appeared in the June 17, 1905, edition of *Collier's Weekly*. The illustration was used as an advertisement for Northern Pacific Railroad, which, at the time, invited passengers to travel the Yellowstone Park Line, the historic route first explored by Meriwether Lewis and William Clark. The railroad's promotional activity extended to the end of the journey itself; *The Herd Boy* went on display at the Lewis and Clark Exposition held in Portland, Oregon, in the summer and fall of 1905 so that those traveling on the Lewis and Clark trail could see the actual painting (they could not at this time, of course, have seen the "real" subject) reproduced in the advertisement. As Remington scholar Estelle Jussim has pointed out, "*Picturesque America* had issued [the] same travel invitation in 1872 by suppressing all information about the Indians; now, however, [with *The Herd Boy*] the Indian could be offered as a poignant tourist attraction."[2] In other words, Remington's sympathetic view of this figure paralleled developments in the common perception of the Native American during the last half of the nineteenth century: once Native Americans had been safely contained or eliminated and were no longer a threat to white settlers, artists including Remington could provide sensitive images of this "vanishing" race.

Remington's sympathetic images of Native Americans extended to his literary work as well. *The Way of an Indian* (1906), which described the rise and fall of a great Cheyenne warrior—a representative of the "rise and fall" of the Native American race in general—was even told from a Native American point of view, unusual for the time. From his early travels to the West and his experience observing Plains Indian cavalry scouts (he seems to have had a special affinity for the Cheyenne), Remington developed an understanding of Native American culture that was more than superficial. Nonetheless, Remington, like many other

artists of the American West, along with the United States government and the majority of its citizens, simply took for granted that the passing of the Native American was inevitable. Cast as survivors among a dwindling "primitive" race, many believed that Native Americans simply could not survive the progress of modern civilization, considered a greater force of good. So, at the same time that Remington offered *The Herd Boy* as a tourist attraction, he earned praise for his effort at "preservation," that is, recording an ethnic type that was, if not already extinct, certainly endangered.

Using a palette dominated by ethereal tones of light blue, green, gray, and lavender, Remington depicted a Native American youth wrapped in animal skin as he sits in profile astride his horse. In the distance, ghostlike tepees seem to dissolve into the frosty air. Wind sweeps across the plain, blowing the horse's tail between its legs (perhaps an apt metaphor for the plight of the boy's race), lifting the brave's hair and the horse's mane. The title alerts the viewer that the boy watches the herd, but Remington includes only two animals in the distance, as if to imply the diminishing number of animals under the boy's protection. As in most of Remington's paintings, the horse carries the emotional weight of the scene. Its emaciated haunches, drooping head, and gray-lined, half-closed lids suggest not only the immediate struggle of the Native American boy and his people, fighting to survive the harsh winter, but, combined with the disappearing herd, indicate the looming extinction of both. In the painting, the demise of the Native American is as certain as the evaporating hooves of the horse that vanish into the snow, their evanescence suggesting that in time the vulnerable figure will be obscured completely from view.

Remington recycled the motif of this late painting from one of his earliest images, a watercolor of 1885, completed the year he lost his saloon and traveled through Texas and the territories of Arizona and New Mexico making sketches he would use for the remainder of his career (fig. 1). The motif of a windswept figure in profile appeared again in *The American Tommy Atkins in a Montana Blizzard* in the

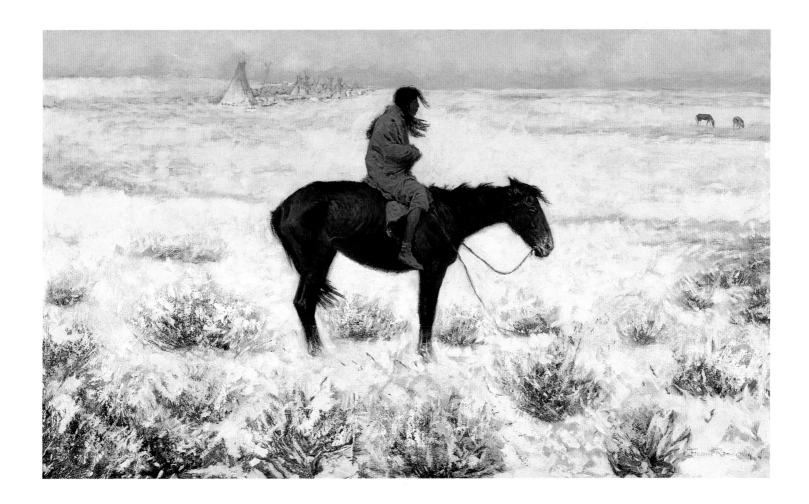

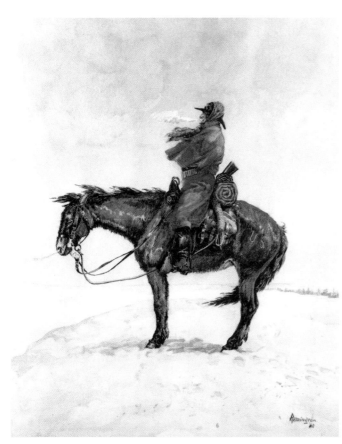

Fig. 1 Frederic Remington, *Cold Day on Picket,* 1885.
Watercolor, 14 3/4 x 12 5/8 in. (37.4 x 32 cm).
Collection of Dr. and Mrs. Herbert A. Durfee, Jr.

August 13, 1892, edition of *Harper's Weekly* and was interpreted loosely in an ink wash drawing titled *Riding Herd in the Rain* (c. 1897, Buffalo Bill Historical Center, Cody, Wyoming). Remington scholar Michael Shapiro notes that *The Herd Boy* is an example of Remington's translating a previous sculpture subject—in this case, his bronze *The Norther*—into painting.[3] In all of these earlier interpretations of a human figure confronting harsh climatic conditions, the figure represents a white settler, and the main themes, consequently, are hardship and loneliness. When Remington substituted a youthful Native American in these serial images, the meaning shifted to evoke pity for a vanishing race. Therefore, *The Herd Boy* relates more closely than the illustrations and sculpture just mentioned to Remington's illustrations in *Personal Recollections and Observations of General Nelson A. Miles* (1896) of Miles's campaign against the Sioux in the wake of Custer's defeat at the Little Bighorn (see cat. no. 12). These images similarly conveyed the brutal conditions of the devastating winter of 1876–77. *The Herd Boy,* then, exemplifies the manner in which Remington repurposed images for specific uses. He not only recycled and reimagined elements of earlier works, but he also used these features over time to produce different meanings depending on the context in which they appeared.

Magazine editors also availed themselves of the elasticity of Remington's imagery. The context of the painting changed again when *Collier's* used the image as a frontispiece for its February 12, 1910, issue titled *Outdoor America,* in which the majority of articles discussed outdoor winter themes. The painting's focus was changed from the poignant emblem of a disappearing race, used to promote the West to potential travelers, to an emphasis on the bleak winter cold, as an introduction to the issue's winter themes. When the painting was removed from its commercial context and placed in a gallery setting, it gained an entirely different emphasis as a work of art, as would be true for any artwork initially used for illustrative purposes. In a 1920 review of Remington's work at John Levy Galleries in New York (nine years after Remington's death), the *Evening Post Magazine* mentioned *The Herd Boy* in particular, calling it the "best of the group. . . . This picture nearly leaps out of the realm of illustration into the province of a more dynamic art. But no, it is fairer to leave him master in the realm of illustration which he chose. Remington was not a painter in the real sense of the word, and it was only in rare moments that he chose to transcend the 'tint' method, which he selected because of its reproductive qual-ities."[4] Nine years after Remington's death, the debate continued—as it does today—over Remington's status as an illustrator or painter. He was both, of course, and the lingering debate measures critics' discomfort—then and now—with associating popular culture with "high art."

1. Note on provenance: According to Hogg Brothers memoranda, Will Hogg acquired *The Herd Boy* and *The Call for Help* (cat. no. 21) from John Levy Galleries in New York no later than October 1920. These were two of the six paintings exhibited at the gallery during the winter of 1920. *The Herd Boy* may have hung at the Hogg Brothers offices for a time, but it, along with *The Mule Pack* (cat. no. 13), moved to Bayou Bend by at least 1933 (and probably in the late 1920s), where they stayed until the 1960s, when Miss Hogg began the conversion of her home into a house museum (see "Miss Ima Hogg, Inventory and Appraisement of Furniture and Furnishings at Bayou Bend, Houston, Texas, as of June 25, 1933" in the MFA, Houston, Archives). Bayou Bend Collection and Gardens, the Museum of Fine Arts, Houston, is the former home of Ima, Will, and Mike Hogg.

2. Jussim 1983, 96. For a discussion of the development of Native American imagery by white American artists, see Julie Shimmel, "Inventing the 'Indian,'" in Truettner 1991, 149–89.

3. Michael Edward Shapiro, in Shapiro and Hassrick 1988, 221.

4. *Evening Post Magazine,* January 17, 1920, 10.

21. The Call for Help (At Bay)

c. 1908
Oil on canvas, 27 1/4 x 40 1/8 in. (69.2 x 101.9 cm)
Signed at lower right: Frederic Remington— / 19[?]; and at lower center: copyright [illegible]
The Hogg Brothers Collection, gift of Miss Ima Hogg[1]
Acc. no. 43.9

In 1908, after Remington's third solo exhibition at the prestigious Knoedler and Company gallery in New York closed, Remington noted in his diary that the show was "a triumph. I have landed among the painters and well up too."[2] Over the course of the decade, Remington had been earning high praise for his work as an artist, particularly for the nocturnes he began painting at the turn of the century. In 1901, critics immediately and positively responded to these night scenes, calling them "decidedly artistic" and as welcome as "oases in the hot deserts."[3] Bolstered by this encouragement, Remington continued to experiment with capturing the varied effects of such nighttime light sources as the moon and fire, and these nocturnes, along with his

late paintings (see cat. no. 22), constitute his greatest artistic achievements.

The moody night scenes of the California tonalist painter Charles Rollo Peters initially piqued Remington's interest in his attempt to create night scenes of his own. Remington was also certainly acquainted with and responded more broadly to the poetical work of such stylistically disparate artists as George Inness, James McNeill Whistler, Thomas Wilmer Dewing, and Remington's friends Childe Hassam and Willard Metcalf. He was also intrigued by the methods of John Twachtman, a specialist in paintings of snow. For Twachtman, whose work Remington admired, "Never is nature more lovely than when it is snowing. Everything is

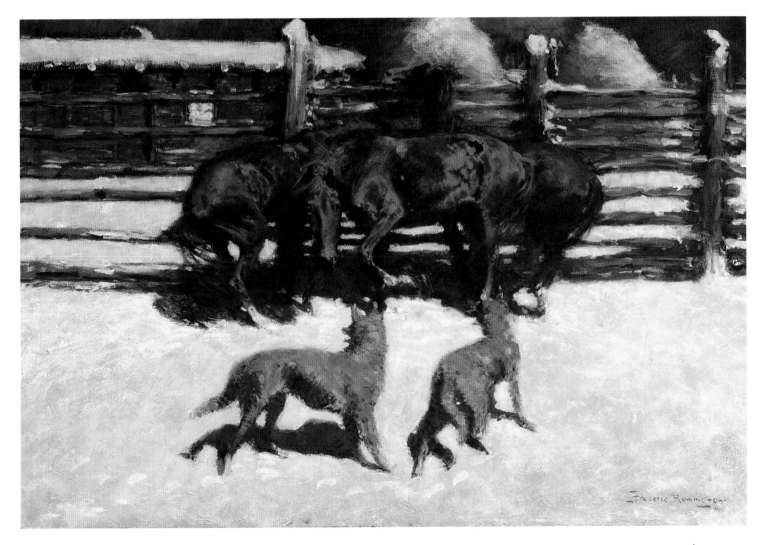

Fig. 1 Frederic Remington's property in Ridgefield, Connecticut, showing large haystacks, probably photographed by Remington c. 1908. Frederic Remington Art Museum, Ogdensburg, New York (1978.76.121.3)

so quiet and the whole earth seems wrapped in a mantle."[4] But while Twachtman used snow to convey a therapeutic and comforting stillness, Remington used it as a backdrop for scenes of violence in nature marked by eerie light effects. Augustus Thomas likewise seized on the supernatural quality of his friend Remington's nocturnes, noting that the artist "came to see and to master the nuances of the moon's witchery in all her moods."[5]

Remington's diaries record his painstaking efforts to capture moonlight in his art in general, and in *The Call for Help* in particular. On January 19, 1908, he remarked on the "Wonderful moonlight nights—tried to distinguish color in some sketches I took out of doors but it is too subtle a light and does not differentiate."[6] He made progress in the ensuing months but noted his frustration on March 17: "Those moonlights are elusive and require a world of monkeying." By mid-April, when he began work on *The Call for Help,* he noted with pride, "Wonderful moonlight night—studying—it has not yet been painted but I think I am getting nearer all the time."[7] *The Call for Help* was completed by mid-May, when he sent a crate of his paintings to New York,[8] but he was evidently unsatisfied with his work and continued to make changes to the painting. When he visited his framers Ashler and Stabb in New York on November 25, 1908, to view the frames made for the paintings in his December exhibition at Knoedler, he noted that "'Call for Help' is too green. I am looking to try and fix it up," which, his diary notes, he did on the twenty-seventh.

At first glance, *The Call for Help* is difficult to decipher

but, like the manner in which eyes adjust to darkness, forms and patterns begin to emerge out of the gloom. Against a broad expanse of moonlit snow—indicated in thick hatchmarks of green and gray paint—two wolves (or coyotes) approach three horses who, startled and frightened, huddle against a fence. The fence, an abstract pattern of broad bands of light and dark, marks the collision between the wildness of nature and the order of civilization, the latter represented by a log cabin and stacks of hay or grain. Using black, blue, and highlights of gray, Remington gives form to the three horses, much as he had skillfully suggested volume in his black-and-whites (see cat. no. 10, for example). As Remington scholar Melissa Webster has noted, the artist's career as an illustrator working in black and white, which required great control in suggesting a broad range of tonal values, "equipped him with the insight and ability to discriminate between and represent the fugitive tones and hues of night light."[9] Streaks of gray and blue suggest the musculature, sheen, and movement of the three horses; one cowers, another rears, while the third, partially obscured from view, presses close to the fence. The timber-constructed house, possibly inspired by one of Remington's own photographs of an Adirondack cabin, features a window whose light is suggested by bright splotches of orange and yellow. Rising above the fence loom two large haystacks, which, except for an early watercolor titled *My Ranch* (1883, Frederic Remington Art Museum, Ogdensburg, New York), are an anomaly in Remington's art. A photograph of the artist's

Fig. 2 Frederic Remington, *Broncos and Timber Wolves*, c. 1888. Oil on wood panel,
20 1/4 x 27 1/2 in. (51.6 x 70.1 cm). Los Angeles County Museum of Natural History,
William S. Hart Collection (museum collection no. 111)

Ridgefield, Connecticut, property, probably taken by
Remington himself, may have served as a source of inspi-
ration (fig. 1), but for an artist who constantly recycled
motifs and props, the haystack form is a curious addition.
Besides their role as balancing features in the composition,
one wonders if during these years in which Remington
associated himself more closely with the American Impres-
sionists, he could not help but insert a wry reference to the
notorious haystacks painted by the French Impressionist
Claude Monet, which had appeared in various exhibitions
in Boston and New York.[10] Remington masterfully depicted
these lumpen forms at night, an exercise that even Monet
never attempted.

The Call for Help recalls subjects Remington had painted
before, notably *Broncos and Timber Wolves* (fig. 2), which
illustrated Theodore Roosevelt's *Ranch Life and the Hunting-
Trail* (1888). Substituting animals for the usual "cowboys
and Indians," Remington arranged a group of horses in a
circle and confronted them with a ring of wolves, a com-
positional device he favored (see cat. no. 15 and Checklist
of Works, p. 134). A cursory comparison between the two
paintings demonstrates just how much Remington had
developed in his effort to transcend the limits of illustra-
tion. Here, Remington reduced and simplified the compo-
sition by setting the figures against the contrasting bands
of light and dark that indicate the fence and distilling the
painting's emotional value into a combination of contorted
horses and eerie moonlight effects.

Remington's 1908 exhibition received superb reviews,

and at least five critics singled out *The Call for Help* for
special praise. The *New York Times* critic, who categorized
Remington as primarily a storyteller and preserver of the
romance of Western life, suggested that *The Call for Help*
"tells, perhaps, the most impressive story" among the
paintings in the show.[11] Other critics praised Remington
as both a great storyteller and a great painter, as someone
who moved beyond depicting the "beer and skittles" side
of Western life to convey its elemental, primal side, as the
critic of the *Evening Post* phrased it.[12] The *Post* also men-
tioned that *The Call for Help* "graphically recalls to any one
who has known Western life the horse's cry of fright, but
outside of the story it tells it is a fine bit of painting and
drawing. The horse who is facing the dreaded coyote shiv-
ers." The critic of the *Globe and Commercial Advertiser*
concentrated on Remington's technical improvement,
noting, "He handles his pigment with surer brush, in
a bigger way and a more logical manner, with greater sim-
plicity than hitherto. His color is purer, more vibrant,
more telling, and his figures are more in atmosphere."
This critic particularly admired the "suggestive" quality
of Remington's night scenes and named *The Call for Help*
a "stirring composition and well rendered."[13] The *Evening
Mail* mentioned that two of the paintings, including
The Call for Help, "[rose] to as high a level of power as
anything that Remington has ever done." For this critic,
the painting suggested the "despairing shriek" of the horses,
whose "expression of movement in the winding and wrig-
gling ponies is intense and terrible." In fact, this critic

found Remington's images of man and animal to be "strange, angular, raw, and impossibly ugly to the point of caricature. . . . But caricature is in Remington's blood—caricature, and power. Though no Indian, no cowboys, no cayuses [native range horses] ever lived that were equal in fierce ugliness to these, his pictures are nevertheless great."[14] Critics normally construed the "fierce ugliness" in Remington's work as an appropriate measure of Western life. Further, they embraced this "ugliness" as an example of the masculine virility of his art, an adjective similarly applied to the work of the Eight, a group of artists including Robert Henri who, earlier in 1908 and inviting widespread controversy, exhibited bold, raw paintings of the seamy underside of city life. Appearing after the recognition that "ugliness" had become an appropriate measure of contemporary life, Remington's *The Call for Help* would be construed by contemporary critics as "modern" and hard-edged, new ways of perceiving his art. For the critic of the *New-York Tribune,* the "strangeness" of his painting evoked an emotional resonance that was new to Remington's work and that would be described best as "feeling." The *New-York Tribune* praised the "leaps and bounds" Remington was making as a painter, noting, "Each time that his work has appeared in public of late it has denoted an advance, and on the present occasion the gain is greater than ever." Further, the same critic noted, "As for the night scenes, it would be difficult to congratulate Mr. Remington too warmly on the spirit and the skill with which he has painted them. Suffused with a strange gray-green light, they expose some characteristic incident of the plains. . . . horses attacked by wolves and crying in their terror for help from their owner's cabin. . . . There is life in them all, the realism of things clearly seen and apprehended with sympathetic feeling."[15]

The word "feeling" was not one critics normally, if ever, used in discussions of Remington's art. Here, however, the critic insists on the discovery of a new elemental and primal connection between Remington and his subject (it was already implicit in the subject itself) that converged in the painting: its evocative mood and supernatural quality made the West look like a timeless dreamworld. For an artist who, when writing a youthful description about him-self at the age of fifteen, asserted "There is nothing poetical about me,"[16] Remington's early protests were proven wrong by his critics who recognized and admired the artist's ability to paint a state of mind.

1. Note on provenance: Remington's diary entry for December 8, 1908, indicates that *The Call for Help* was among several paintings sold at the exhibition at Knoedler in 1908, although he did not include the name of the purchaser. The painting came through John Levy Galleries in New York, from whom Will Hogg bought the picture as well as *The Herd Boy* (see cat. no. 20) by October 1920. The painting was published posthumously in a full-color single-page illustration in *Collier's Weekly,* on December 17, 1910, and included a caption that underscores the narrative aspect of the painting: "Wolves have run the ponies in a pasture to the cabin of their natural protector—man—and hesitate whether to bring on a general engagement so near a house."

2. Remington diary entry for December 12, 1908 (FRAM, Ogdensburg). All of Remington's diaries are located at FRAM.

3. Review of Remington's exhibition at Clausen's Gallery, New York, 1901, in the *Evening Post,* December 14, 1901, 19.

4. Twachtman to J. Alden Weir, December 16, 1891, in Kathleen A. Pyne, "John Twachtman and the Therapeutic Landscape," in Chotner et al. 1989, 53.

5. Thomas 1913, 361.

6. Remington, diary entry for January 18, 1908 (FRAM, Ogdensburg).

7. Remington, diary entry for April 12, 1908. On April 13, 1908, he noted that he was painting *The Call for Help* and, to escape "the enemy in my face" (a reference to the difficulty in capturing moonlight effects in this painting), he visited with friends.

8. *The Call for Help* appears on Remington's crate list in his diary entry for May 14, 1908.

9. Webster 1986, 57.

10. Remington would have been familiar with the serial imagery of his Impressionist colleagues, and he would have known Claude Monet's serial images of haystacks from exhibitions of those works in New York at the American Art Galleries, Durand-Ruel, the National Academy of Design, or any number of exhibitions in Boston, including the Monet-Rodin exhibition at Copley Hall in 1905. See cat. no. 17 for a discussion of Remington's estimation of Monet.

11. *New York Times,* December 2, 1908, 8.

12. *Evening Post,* December 3, 1908, 9.

13. *Globe and Commercial Advertiser,* December 3, 1908, 10.

14. *Evening Mail,* December 2, 1908, n.p.

15. *New-York Tribune,* December 6, 1908, 2.

16. Remington, quoted in Dippie 1975, 8

22. *Episode of the Buffalo Gun (The Visitation of the Buffalo Gun; The Mystery of the Buffalo Gun; A Buffalo Episode)*

1909
Oil on canvas
27 x 40 in. (68.6 x 101.6 cm)
Signed at lower left: Frederic Remington / 1909
The Hogg Brothers Collection, gift of Miss Ima Hogg[1]
Acc. no. 43.22

On August 24, 1909, Remington noted in his diary that he had "worked on my dashing 'Buffalo Gun.'" At that time, Remington was producing new paintings for his annual December exhibition at Knoedler and Company gallery in New York, and he mused in his diary a few days later, "I wonder if this bunch [of paintings] will make artistic New York sit up?"[2] The 1909 exhibition at Knoedler assured Remington's reputation among the important American painters, and he was able to acknowledge with pride in his diary on December 9, "I have belated but splendid notices from all the papers. . . .The 'illustrator' phase [of my career] has become background."[3] At the pinnacle of his career, he died just over two weeks later, after an operation for a ruptured appendix failed.

Episode of the Buffalo Gun numbers among the seventeen major paintings and six small landscape sketches exhibited at Knoedler in December, and several New York critics mentioned the painting in their columns. For example, the *New York Evening Post* commented on the painting's "great spirit" but, like many critics of Remington's color sensibilities, still found his colors "glaring."[4] Gustav Kobbe, a critic of the *New York Herald,* also found the

Houston painting "Another spirited picture. . . . Indians under fire and on the run."[5] The critic of *American Art News* was less kind and refused to concede that Remington had become more of a painter than illustrator, one of the abiding issues in the Remington criticism. In "*Mystery* [sic] *of a Buffalo Gun*," the critic found the drawing "careless," especially of the forward horse, and added sarcastically, "By the way—what is the mystery?"[6] But the majority of reviews of the 1909 exhibition were the most celebratory of Remington's career. As one critic wrote, "It must be extremely trying for those commentators on pictorial art who always insisted this distinguished artist was 'only an illustrator,' and decried his ability to paint, to visit such an exhibition as the present one. For by this time they must be impressed with the facts that Remington's work is at once splendid in its technique, epic in its imaginative qualities, and historically important."[7] Another critic singled out the painterly surfaces of Remington's late work: "All of them [the paintings in the exhibition]. . . are impressive, and in many of them the picturesqueness inherent in the familiar episodes is cleverly subdued to a more aesthetically rewarding, if less piquant, beauty of surface and color."[8] Still others dwelled on the evocative power of his work: "Indeed, in all of Remington's pictures the shadow of death seems not far away. . . . The presence . . . of a great central motive like this, derived from the actual conditions of that vast, hungry region whose jewel and symbol is the dry skull reposing on the desert's breast, is an indication of power, and the ability to express the motive in a hundred vivid forms is a proof of genius."[9]

With large masses of densely jumbled lines and squiggles giving way to smooth, flattened areas, *Episode of the Buffalo Gun* reveals the full-blown painterly effects of Remington's late style. Six Southern Plains Indians dressed for war and astride their horses turn away quickly from their vantage at the top of a mesa, stunned by the long-range shot of a buffalo gun whose bullets leave a trail of dust at left. A gentle tree-lined river disappears in the background at right, while mesas mark the distant geography. A riot of Impressionist brushwork using pure, unmixed pigments—greens, yellows, and reds—to suggest the sun-baked plain dotted with brush, and placed over lavender to indicate deep shadow contrasts with the smooth, glassy passages of river at right. The tail of the forward horse is a rainbow of vivid color, while other areas, such as its leg in shadow, are described in a thin purple wash. Through dots and dabs of paint that shimmer and vibrate, Remington expresses both the scintillating atmosphere of this hot, dry Western landscape and the pell-mell quality of the action that takes place in it. He positioned the two figures in the

foreground as rhyming opposites, indicating their recoiling poses not through linear, dark outlines but in umber shades that, placed near yellows and greens, help to make the paint surface shimmer. Remington clearly achieved the effects he intended: "I have always wanted to be able to paint running horses so you would feel the details and not *see* them. I am getting so I can stagger at it."[10] This quality of suggestiveness also extends to the figures, whose lean, taut, sinewy muscles express an economy of force and movement reinforced by the constant left angles: the lances, the mane of the forward horse, and the directional brushwork of the scrappy scrub brush. When these densely textured passages give way to the thinly brushed landscape at right, Remington's study in contrasts—between thick and thin, and between violence and peace—become powerful symbols of something beyond skirmishes on the plains, and perhaps evoke what the critic above called "the shadow of death."

The subject matter pictured here—Native Americans surprised by the effects of a buffalo gun—may derive from a well-known event that took place in the Texas Panhandle near Adobe Walls in 1874. In June of that year, a group of buffalo hunters (including Billy Dixon, the same man who figured in the Buffalo Wallow Fight; see cat. no. 15), while staying in a ruined adobe fort, were confronted by a group of Comanches, Apaches, and Kiowas under the leadership of Quanah Parker.[11] As Dixon described the event, "On the third day a party of about fifteen Indians appeared on the edge of the bluff, east of Adobe Walls Creek, and some of the boys suggested that I try the big '50' [a buffalo gun] on them. The distance was not far from seven-eighths of a mile. A number of exaggerated accounts have been written about this incident. I took careful aim and pulled the trigger. We saw an Indian fall from his horse. The others dashed out of sight behind a clump of timber. . . . I was admittedly a good marksman, yet this was what might be called a 'scratch' shot."[12]

The only documentation to suggest that Remington based his story on this event dates to 1945, when Billy Dixon's wife, after seeing this painting reproduced in a calendar, wrote a letter claiming that it was her husband who had made the miraculous shot pictured in the painting.[13] While bizarre marksmanship may have formed the pretext for the painting, it is important to point out that Remington ignores the subject of who made the shot and concentrates instead on presenting the event exclusively from a Native American point of view. Remington had asserted this position in his book *The Way of an Indian* (completed in 1900, published in 1906), in which he generally took a sympathetic and dignified look at the demise of

the Native American as a result of the nineteenth-century westward expansion (see cat. no. 20). Because viewers do not see the enemy of the figures in the painting, they may sense what it was like for these figures as they react and reel from the event, the tumult of color and brushwork conveying the emotional intensity of the scene. The event may be specific—the reaction to a long-range rifle—but it resonates on another level, illustrating the fleeing figures as, metaphorically, doomed to vacate forever the land that once was theirs (see cat. no. 16).

On another level, *Episode of the Buffalo Gun* hints at a relatively recent development in Remington's art; the gentle landscape at right is reminiscent of his sketches of the scenery of the north woods in upstate New York on the border of Canada, not far from Ogdensburg.[14] Just weeks before Remington began work on this painting, he had vacationed with his wife at the Pontiac Club on the Canadian border, where he had painted a number of these plein-air Impressionist sketches, also exhibiting them publicly at Knoedler in 1909. In this work, the artist found a way to merge his preoccupation with the calming comfort of his north woods adventures in the East with the confrontation and violence of the desert Southwest that had characterized his art for decades.

1. Note on provenance: The painting was unsold after the exhibition at Knoedler in 1909, and Remington offered it to his friend Al Brolley (see Splete and Splete 1988, 435). This painting may have been acquired by Will Hogg at Howard Young Galleries, New York, on June 23, 1922 (see cat. no. 2, n. 1).

2. Remington, diary entry for August 27, 1909 (FRAM, Ogdensburg).

3. Remington, diary entry for December 9, 1909 (FRAM, Ogdensburg).

4. *New York Evening Post,* December 9, 1909, 9.

5. Gustav Kobbe, "Painters of Indian Life," *New York Herald,* December 26, 1909, 11.

6. *American Art News,* December 11, 1909, 6.

7. Undated, unidentified clipping, folded in with Remington's diary entry for December 7, 1909 (FRAM, Ogdensburg).

8. Undated, unidentified clipping, folded in with Remington's diary entry for December 8, 1909 (FRAM, Ogdensburg).

9. Undated, unidentified clipping, folded in with Remington's diary entry for December 11, 1909 (FRAM, Ogdensburg).

10. Remington, diary entry for October 3, 1908 (FRAM, Ogdensburg).

11. This event took place just a few months before the Buffalo Wallow Fight. The event led to the Red River War of 1874–75, which brought about the relocation of the Southern Plains Indians to reservations in Oklahoma.

12. Dixon 1935b, 14. See also "Second Battle of Adobe Walls," in Texas State Historical Association 1996, 1:34–35.

13. Olive Dixon to Hughes Tool Company, February 28, 1945, forwarded to James Chillman, director of the MFA, Houston, March 5, 1945 (MFA, Houston, object file).

14. I thank Peter H. Hassrick for sharing this observation with me. See, for example, *Pontiac Club, Canada* (1909, FRAM, Ogdensburg) and *Canada* (1909, FRAM, Ogdensburg).

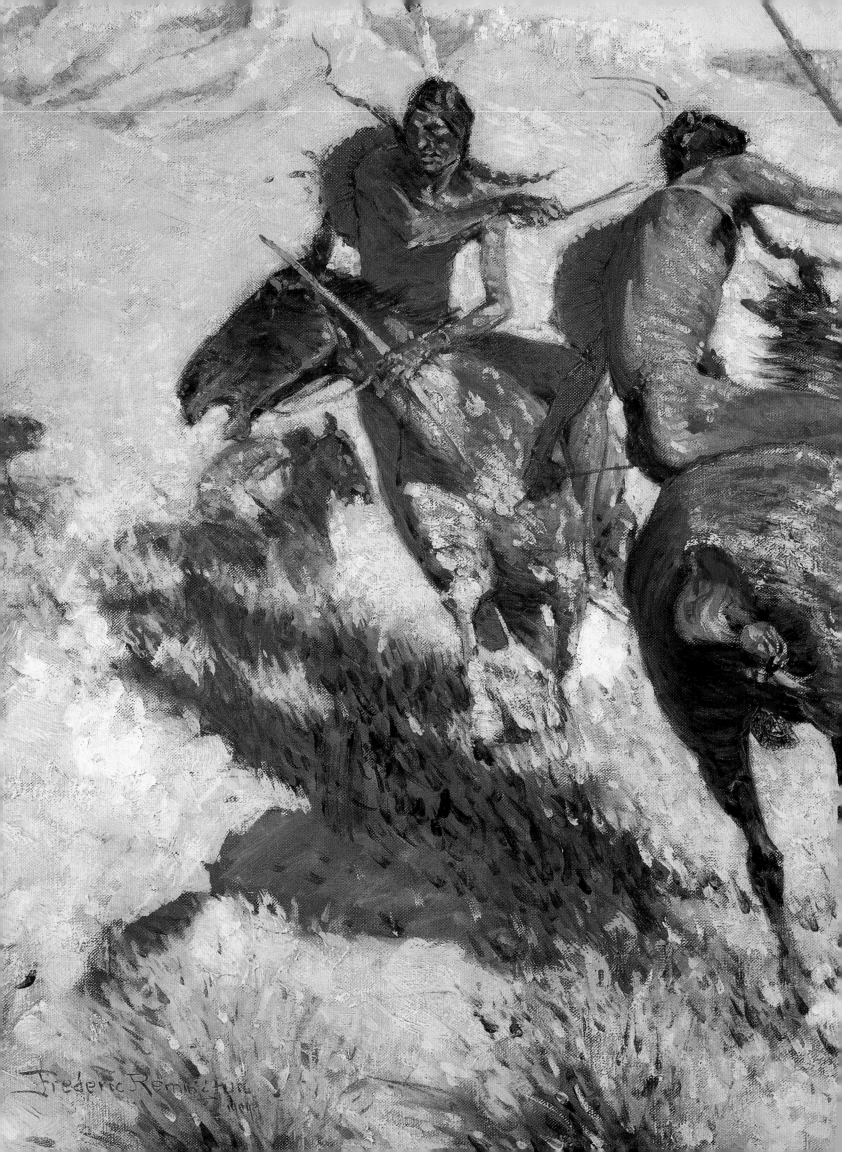

OBSERVATIONS ON REMINGTON'S TECHNIQUE

Observations on Remington's Technique

WYNNE H. PHELAN

THIS ESSAY ADDRESSES observations made on six of the Remington paintings in the Hogg Brothers Collection during their recent conservation. The selected paintings span the career of the artist, beginning with *The Lookout,* painted in 1887, and ending with *Episode of the Buffalo Gun,* painted in 1909. The observations are informed by the technical investigation of each painting using infrared reflectography and x-radiography. A detailed examination of the artist's methods and materials necessarily preceded the conservation process. Conservation treatment of the Remington paintings revealed the variety in his brushwork and palette that had been previously masked by thick, discolored varnish and disfiguring restorations.

Accomplished draftsmanship and composition served as mainstays of Remington's style throughout his career. The six paintings examined here illustrate the scope of Remington's exploration of canvas textures, preliminary toning methods, techniques of drawing on canvas, paint consistencies, brushwork, and color theory. Investigation of the paintings affords insight into the constant experimentation with painterly methods and materials that characterized Remington's development as a painter.

The Lookout, executed in 1887, is the earliest Remington painting in the Hogg Brothers Collection (fig. 1). In the spring of 1886, Remington had stated his ambition to become an artist, and his technique reflects the early stages of working with oil paint. He selected a small, medium-weight canvas (much smaller than those of his later works). It seems that he did not prepare his canvas with a traditional ground layer; the pronounced weave pattern of the linen canvas is readily apparent in the skips, or "paint holidays," between the brushstrokes of the foreground landscape (fig. 2), whereas a traditional ground layer would be thick enough to mask the weave pattern.

Using a pencil, Remington lightly sketched the landscape divisions. He then toned in the landscape boundaries with thin washes of oil paint. Once the landscape elements were roughed in, he sketched the horse and rider in pencil. It is clear that Remington continued to use drawing to make

changes in his figures even after he had started painting; pencil lines drawn into the wet paint are visible in and around the contour of the lookout and his mount and are most discernible in the horse's tail.

Fig. 2 Detail of fig. 1 showing exposed canvas illustrating the paint holidays

Fig. 3 Infrared reflectogram detail of fig. 1 illustrating how Remington lengthened the nose of the horse

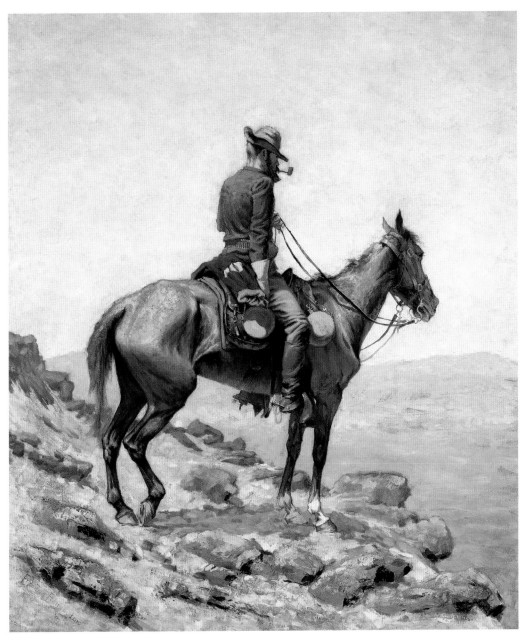

Fig. 1 *The Lookout*, 1887 (cat. no. 1)

Using infrared reflectography and x-radiography, we can follow the creative process of the artist as his drawing developed and as he adjusted the figures in his compositions. The modifications illustrate Remington's pursuit of drama and accuracy in his paintings. In this work the most striking alteration from his original drawing is the horse's head, and in the infrared reflectogram we can see that he lengthened the nose (fig. 3). By enlarging the head, Remington makes the horse appear undernourished, an implied consequence of the hard life on the range. The multiple modifications to the spur on the lookout's left foot suggest Remington's painstaking interest in the accurate depiction of Western costume (fig. 4). As he had a large collection of Western paraphernalia, Remington no doubt often referred to it while he painted. In the infrared reflectogram the shadowy area around the hind legs of the horse reveals that

Fig. 4 Infrared reflectogram detail of fig. 1 illustrating the redrawing of the spur on the lookout's left foot

Fig. 5 Infrared reflectogram detail of fig. 1 illustrating the shadow still visible from the previously drawn straight leg and the anatomical detail of the horse's leg, particularly the fetlocks

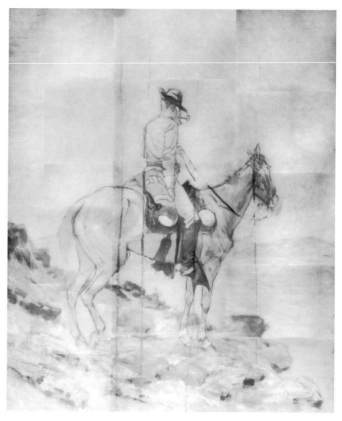

Fig. 6 Infrared reflectogram of fig. 1 indicating that Remington used carbon black for shading

Fig. 7 X-ray detail of fig. 1 illustrating that Remington used lead white to create highlights and areas of impasto

Remington adjusted the position of the right hind leg. He changed a straight leg with its hoof flat on the ground into a bent leg, typical of a resting horse, where the weight is shifted to the left haunch and the released right leg allows the hoof to rest on its toe. The drawing of the fetlocks in particular demonstrates his close observation of horse anatomy (fig. 5). A photograph cited above shows Remington studying the bent leg and fetlock of a tethered horse at his farm in New Rochelle (see cat. no. 2, fig. 3). A comparison of the underlying drawing and the finished painting discloses how the drawing features the anatomical structure of the fetlock. The modeling and texture of the surface details were rendered in paint.

In modeling his forms Remington worked from dark to light. To darken a color he mixed it with black. In infrared reflectography the darkest areas indicate the presence of carbon black, and the black areas in the reflectogram indicate the areas where Remington used carbon black for shading (fig. 6). The light areas on the X ray reveal where he mixed his colors with lead white to create highlights. Other white pigments do not have the density to make this pattern on an X ray. The heavy pigment particles lend body to the paint. Remington repeatedly took advantage of this property of lead white to build areas of impasto, as in the foreground rocks (fig. 7). The dappling of pink and blue on the rump of the horse, simulating the play of light on form, is a departure from his usual modeling technique and is possibly the result of his familiarity with Impressionist paintings.

Remington used a broad brush and long, sweeping strokes to paint the generalized landscape, leaving it unde-

fined to create a sense of distance and atmosphere. In the sky, he applied paint in short strokes with a smaller, flat brush, perhaps to achieve the shimmering effect of light as was done in Impressionist painting. The paint appears to have the dry, pasty consistency that may be the result of the unprimed canvas absorbing the oil medium too quickly. Paint that lacks adequate medium does not flow

into the crevices of the canvas but instead remains on the top of the threads, resulting in the paint holidays noted above. Rem-ington used a fine brush and thin strokes to define the contours and modeling of the horse and rider. He rendered the costume, harness, and trappings in great detail, more evidence of his knowledge of Western paraphernalia and his concern for historical accuracy.

In *The Lookout,* Remington effectively announced that he was willing to experiment with his brushwork and palette. He concentrated on refining the definition and form of the horse and rider, making adjustments by redrawing

even after he had started painting. The single rider in profile is a dramatic compositional formula he continued to employ throughout his career, as seen in *The Herd Boy* (fig. 8). The infrared reflectogram reveals that in that painting also, Remington lengthened the nose of the horse to give the appearance of an undernourished animal (fig. 9). As in *The Lookout,* the horse becomes the dramatic vehicle for illustrating the harshness of life endured in the early West. Remington's gift for heightening the effect of a scene through his deft manipulation of form is central to his development as an artist.

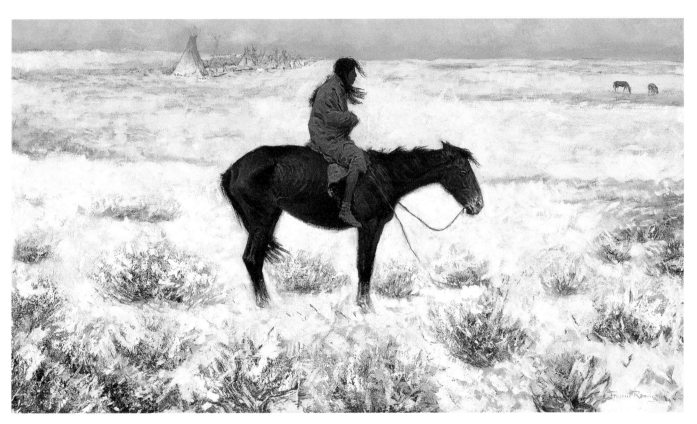

Fig. 8 *The Herd Boy,* c. 1905 (cat. no. 20)

Fig. 9 Infrared reflectogram detail of the horse's head in fig. 8 illustrating how Remington lengthened the nose of the horse

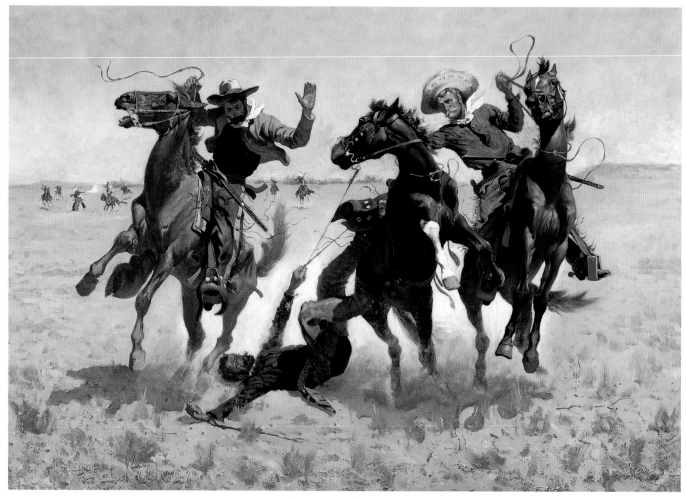

Fig. 10 *Aiding a Comrade,* c. 1890 (cat. no. 2)

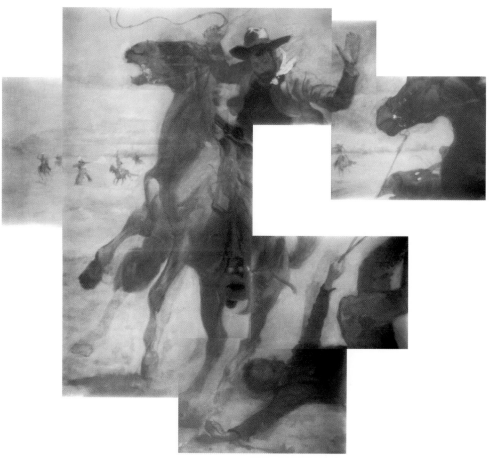

Fig. 11 Infrared reflectogram detail of fig. 10 illustrating changes that Remington made
in the positions of the horses and riders

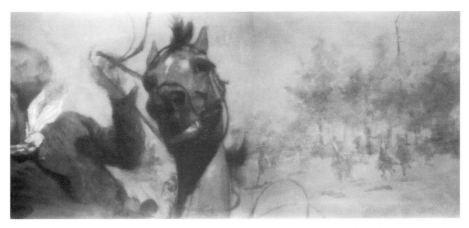

Fig. 12 Infrared reflectogram detail of fig. 10 illustrating how Remington shifted the positions of the Indians and replaced the trees at right

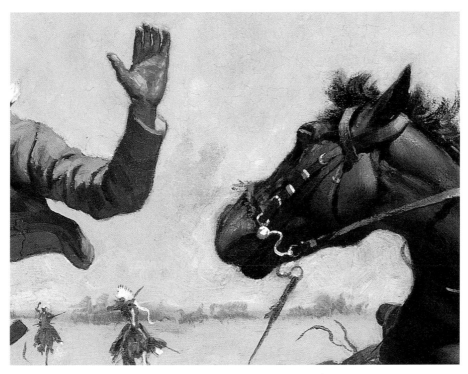

Fig. 13 Detail of fig. 10 showing the pentimento and the crackle pattern

In *Aiding a Comrade,* c. 1890 (fig. 10), Remington used a medium-size canvas with a commercially prepared white ground. He used two colors for preliminary toning: gray in the sky and creamy pink in the landscape. In the infrared reflectogram we see how he labored over his drawing to refine the tension and drama in the composition. The infrared reflectogram of the foreground figures also reveals multiple adjustments. He manipulated the positions of the horses and riders to ensure the depiction of the most dramatic moment, the instant before the hoof strikes the fallen cowboy (fig. 11). Remington also altered the background significantly. He moved the horizon line down about an inch. Previously it had been the same height as the mesa on the horizon at the right. He moved the pursuing Indians from the viewer's right to the left and took out a small stand of trees at the right, substituting

more distant, undefined vegetation in the center background (fig. 12).

A pentimento, or change in the painting that the artist painted over, is revealed when an artist uses paints rich in medium that become transparent with time. The pentimento around the head of the black horse illustrates that Remington made changes not only in the drawing, but as he was painting as well (fig. 13). In this case, the change made to the horse's nose indicates that Remington decided to reposition the head to turn farther away from his fallen rider.

Remington worked quickly, using a wet-on-wet technique. The crackle pattern that looks similar to alligator hide attests to the fact that the paint was not dry when he painted over his initial design (fig. 13). The paint application in this composition is generally quite thin and lean. The impasto in the foreground landscape is the exception;

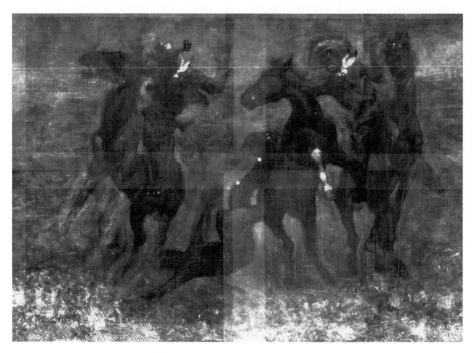

Fig. 14 X ray of fig. 10 showing white lead impasto in the foreground

bolstered with lead white pigment, it adds relief rather than definition to the pattern of the terrain (fig. 14). The Native American figures and landscape are painted in thin washes with a few bold brushstrokes, suggesting Remington's intention to leave the background atmospherically hazy in contrast to the almost photographic detail of the large figures in the foreground. This dramatic shift in definition focuses the viewer's attention on the main event.

In this composition Remington used multiple devices to promote the action and drama of his story. Although his palette was based on local colors, the perceived intensity of the hue is heightened by the selection of colors that are nearly complementary—for example, the warm sienna browns juxtaposed against the cool ultramarine sky. Value contrast serves to emphasize the centerpiece of the drama; the dark values of the fallen cowboy and his rearing black horse are set against the light pink of the landscape and brilliant blue of the sky. Equally important is his manipulation of the figures that he continued to change as he painted. In the final manifestation the cowboys seem ready to burst through the picture plane as they ride toward us, the momentum of the horses sealing the fate of the fallen cowboy. The whiplash line of the reins and the patterning of the shadows echo the forms and heighten the sense of movement. The pronounced shift in scale and definition of form between the foreground and the background enhance the immediacy of the drama. In *Aiding a Comrade* Remington added significantly to his painterly vocabulary but remained consistent in his objective to create a dramatic narrative that would increase public interest in the Old West.

In *The Mier Expedition: The Drawing of the Black Bean,*

1896 (fig. 15), Remington applied a smooth, pink-beige primer to tone down the white ground. He then rendered a detailed drawing, elements of which remain important visual components in the finished painting. The drawing appears to have been executed with a fine-pointed brush in black oil paint. Infrared reflectography discloses the detail of the underdrawing, including guidelines for the perspective (fig. 16); of particular note is the strong diagonal line at center. The underdrawing reveals three major changes Remington made between the preliminary sketch and the finished composition. In his preliminary sketch he planned to have a figure in front of the table, facing the viewer. In the reflectogram, faint sketch lines of the legs are visible with the feet facing forward; this figure was omitted completely in the finished painting. Likewise, in the middle distance, behind the pottery at the right, a sketch of a figure striding is visible in the infrared reflectogram (fig. 17); this figure appears to be similar to the striding figure in the background of the painting (fig. 18). The third major change is the placement of the guard in the foreground, dressed in white, with his back to the viewer. There are lines suggesting that this figure was originally farther back and more in the center of the composition (fig. 19).

The X ray (see fig. 23) reveals only a minor adjustment to the position of the right foot of the figure in the foreground with his back to the viewer. The artist changed a profile view of the foot to one where the foot is concealed by the pant ruffle. He made a minor change, which is not concealed in the finished painting, in the position of the right foot of the prisoner drawing the bean. The left hand of the large guard in white appears initially to have been

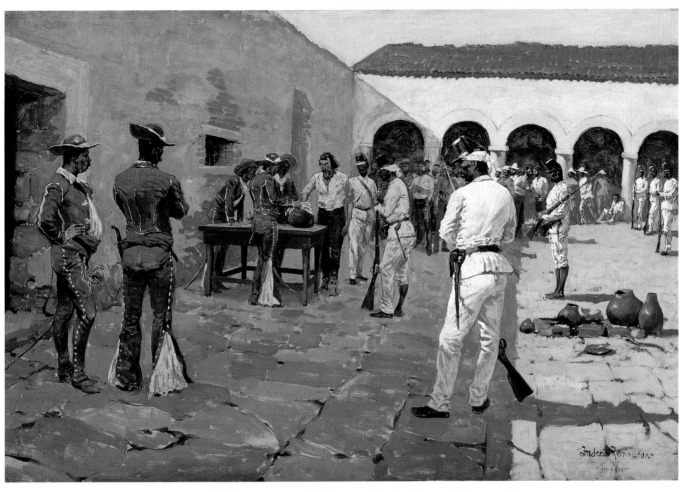

Fig. 15 *The Mier Expedition: The Drawing of the Black Bean*, 1896 (cat. no. 8)

Fig. 16 Infrared reflectogram of fig. 15 illustrating the underdrawing and the diagonal guidelines for the perspective

Fig. 17 Infrared reflectogram detail of fig. 15 illustrating sketch of a figure striding

Fig. 19 Infrared reflectogram detail of fig. 15 illustrating sketch lines that suggest the original position of the guard in the foreground

Fig. 18 Detail of fig. 15 illustrating the striding figure in the background

Fig. 20 Infrared reflectogram detail of fig. 15 illustrating the underdrawing of the left hand of the large guard in white

drawn hovering near his holster (fig. 20). Major alterations in the composition, such as the placement of the guard in white, may have been rubbed back (scrubbed off) with solvent or scraped off with a palette knife, instead of being overpainted. The area around the prisoner in the center of the background exhibits quite a bit of abrasion (fig. 21). This is the area where the guard in white was originally placed. The scraping may be evidence of Remington's method of eliminating an unwanted element in the composition once he changed his mind.

Viewing the painting as a whole, it is clear that keeping the paint layer thin and fluid permitted Remington to make use of his drawing and the preliminary toning in the finished painting. When he made small adjustments, remaining traces of the initial sketch were often incorporated into the finished work. In the area around the left back leg of the table we can see a horizontal line suggesting that Remington originally planned to place the table farther to the left, or perhaps it is a remnant of a previous architectural boundary (fig. 22). The thin washes and isolated dabs of impasto complement rather than conceal the initial sketch. By allowing us to read the pattern of lead white pigment that is used throughout the composition, the X ray (fig. 23) aids our view of Remington's fluid painting tech-

Fig. 21 Detail of fig. 15 illustrating scraping around the center figure

nique. The rapid brushwork conveys an air of immediacy, lending the impression that the artist is on the spot, painting the drama as it unfolds in the same way a photographer records a news event today.

The technique of *The Mier Expedition: The Drawing of the Black Bean* is reminiscent of the journalistic style of Remington's grisaille watercolors and oil paintings. As with *The Lookout,* Remington mixed his colors with carbon black to make shadows and with lead white to make highlights as he continued to model his forms from dark to light. His palette is restricted to gray-scale hues and earth tones. The most brilliant color is the red-orange of the sashes worn by the Mexican cavalrymen.

Remington selected a stage-set composition, relying on contrasting values of light and dark to form the sight lines that lead the eye to the focal point of the drama in the middle distance. The bold contrast of light and dark, combined with the activity of the brushwork, intensifies the dramatic moment. Remington cleverly conceived of a scene without any physical, dramatic motion so that all eyes are riveted on the small gesture of the man drawing the bean.

Fig. 22 Detail of fig. 15 of line either suggesting the original placement of the table or indicating a previous architectural boundary

Fig. 23 X ray of fig. 15 showing Remington's brushwork

In *A New Year on the Cimarron*, 1903 (fig. 24), Reming-
ton started with the familiar medium-size, medium-weight,
plain-weave, commercially primed canvas. He then applied
a thin, beige-colored wash to tone down the white ground.
The horizon line is barely suggested by a single graphite
line (fig. 25). Red contour lines are visible in the figures,
and blue and red contour lines are visible in the horses
(fig. 26). Once the figures were placed, Remington reserved
these areas in the landscape. The background brushstrokes
stop or go around the figures, and areas of the beige prim-
ing are visible around the men and the horses. Peter Hassrick
has referred to Remington using a transfer process for his
drawings on canvas (Shapiro and Hassrick 1988, 139). The
contour lines visible in the painting could be confused
with the crayon lines of a transfer. Testing indicates that
these lines in *A New Year on the Cimarron,* however, are
paint, not crayon. Moreover, the painted lines cover a pencil
underdrawing, visible only with the infrared (fig. 27).
The underdrawing exhibits variation in value and line den-
sity, a sketchlike quality associated with drawing. Emily
Neff has located a preliminary study for the painting in the
Frederic Remington Art Museum (see cat. no. 18, fig. 1).
Comparing the underdrawing with the finished painting
reveals that Remington omitted the figure at the lower
right corner and changed the placement and number of

horses. No traces of additional figures are found in the
infrared image. Remington must have changed his mind
as he composed on the canvas.

It can be determined that Remington modified his
drawing as he painted. The head of the grazing horse was
redrawn (fig. 28) and minor adjustments were made in the
positions of the legs of both horses and the saddle holster.
The only change visible in the paint layer is seen in the
pentimento around the outstretched foot of the reclining
figure (fig. 29), indicating a change in positioning.

In this painting the landscape is beautifully constructed
with patterned brushstrokes of yellow and lavender, a palette
selection that suggests that Remington had been looking
at the paintings of the Impressionists. He used a variety
of painterly techniques—contrasting colors, textures, and
patterned, directional brushwork—to make the landscape
setting the compelling feature of the composition. The
X ray shows the fluidity of the rapidly applied brushstrokes
(fig. 30). Small areas of gatoring (the crackle pattern in the
paint) at the bottom of the picture are testimony to a wet-
on-wet working method. Remington worked so rapidly the
paint did not have a chance to dry before he added another
layer. With a loaded, large, flat brush, he laid down a cross-
hatch-patterned impasto of lemon yellow and pale green
in the sky. With a smaller, flat brush he painted the more

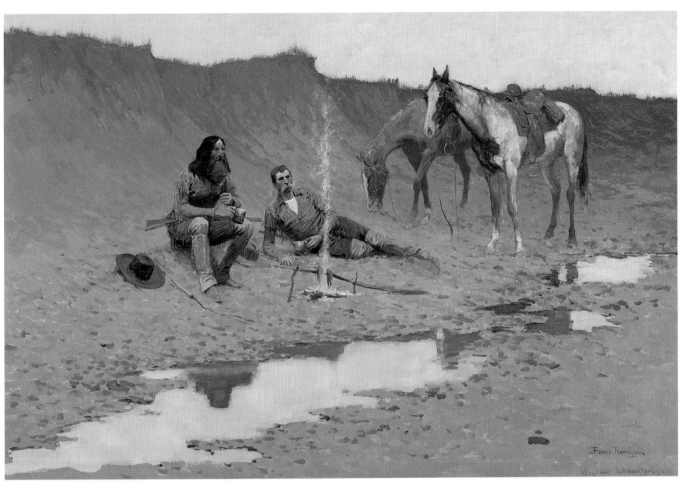

Fig. 24 *A New Year on the Cimarron,* 1903 (cat. no. 18)

Fig. 25 Infrared reflectogram detail of fig. 24 showing pencil sketch lines of the horizon

fluid diagonal strokes of the lavender bank. The directional brushwork guides our eyes to the focal point of the composition: the yellow pool of the river. Using a dry, stiff brush Remington dragged the deep lavender along the top of the bluff vertically into the lemon yellow sky, producing a blurred, shimmering horizon. This passage, which plays off the complementary colors of yellow and lavender in the painting, recalls the September 13, 1909, diary entry in which Remington wrote about making paintings vibrate (all of Remington's diaries are in the collection of the Frederic Remington Art Museum, Ogdensburg, New York). Correspondingly, he dragged his brush through the rich, semiliquid paint of the river to form the vertical lines that suggest quivering reflections in the water. The dry-brushed, scumbled smoke adds another vertical element. The lovely brushwork in the landscape creates a tension between the diagonal perspective and the vertical of the picture plane, infusing movement into the landscape, which contrasts with the static figures.

The scale of the figures is subdued when compared to that of *Aiding a Comrade* or *The Mier Expedition: The Drawing of the Black Bean;* they fit into the landscape rather than dominate it. The meticulous technique used in rendering the couriers recalls the depiction of the scout in *The Lookout.* Remington painted the men with the same narrow, linear brushstrokes, delineating in detail their costumes and

Fig. 26 Detail of fig. 24 showing red and blue contour lines visible in the horses

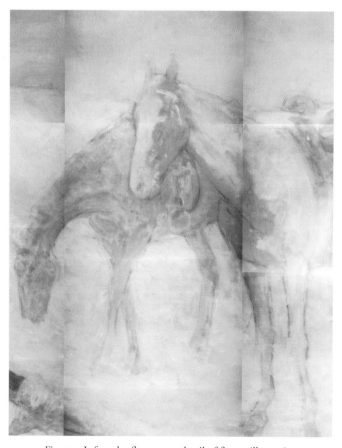

Fig. 27 Infrared reflectogram detail of fig. 24 illustrating
the pencil underdrawing

Fig. 28 Infrared reflectogram detail of fig. 24 illustrating modifications
made to the head of the grazing horse

Fig. 29 Detail of fig. 24 showing pentimento of the reclining figure's foot

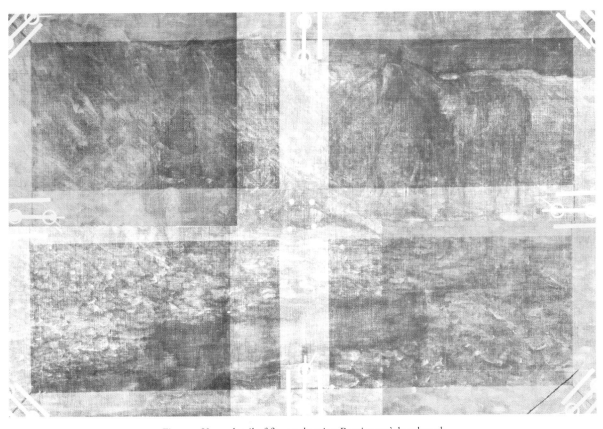

Fig. 30 X-ray detail of fig. 24 showing Remington's brushwork

frontier accoutrements, and even the tan lines on their foreheads. In contrast to the men, the horses are casually roughed in with broad color washes, leaving the neutral beige priming exposed in areas. Perhaps the tight, contrived brushwork of the frontiersmen, so at odds with the loose, painterly qualities in the landscape, serves as evidence of a lingering tension between Remington the artist and Remington the journalist.

A New Year on the Cimarron is a painting of a seemingly peaceful scene. The landscape, the dominant feature in the painting, is the compressed space of a riverbed. The pool at the center is the focal point for the viewer and the frontiersmen. The drama is produced by the orchestrated brushwork and vibrant patterns of color. *A New Year on the Cimarron* fulfills the artist's stated aim to make paintings that created a mood. The mood appears to be the serenity of the "golden hour" at the end of the day, but it may also be the lull before the storm.

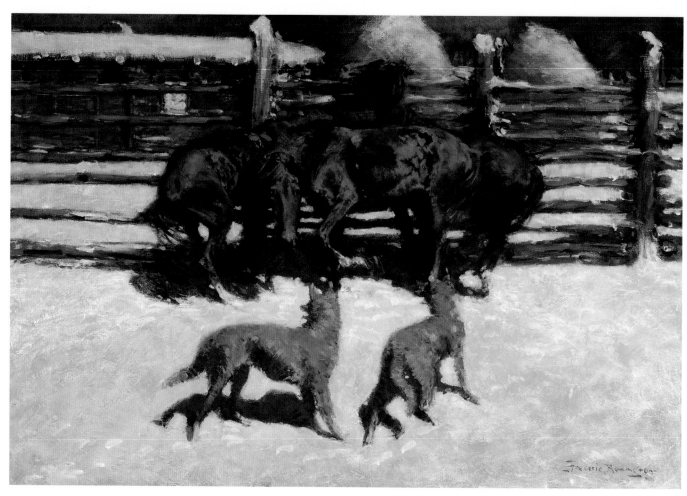

Fig. 31 *The Call for Help,* c. 1908 (cat. no. 21)

Fig. 32 Infrared reflectogram detail of fig. 31 illustrating the drawing of the
head of the rearing horse

Concerning *The Call for Help,* c. 1908 (fig. 31), Remington wrote in his diary on February 18, 1908, "—laid in a couple of canvases." Presumably they came from his regular supplier, DeVoe in New York. The gray preparation layer is visible at the very edge of the canvas, in the paint holidays around the fence rails, and in the shadows around the wolves (or coyotes). The only distinct drawing visible with infrared reflectography is in the head of the rearing horse, done with a fine brush and dilute black paint (fig. 32). Remington probably roughed out a brush sketch of the entire composition, which was then masked by its integration with the finished work.

Fig. 33 X ray of fig. 31 illustrating the swirling brushstrokes and the artist's technique of painting wet-on-wet

Fig. 34 Detail of fig. 31 illustrating the technique of scumbling

We know Remington was working on this painting by April 13, 1908. His diary entry for that day includes, "Painted on the 'Call for Help.'" Remington used dense washes to tone or "lay in" the animals: brown in the area of the wolves, and black followed by green for the horses. He toned the background with washes of Prussian blue and black mixed with viridian green. Using a large, flat brush he laid in the thick lead white impasto representing the windblown snow on the ground. In the X ray the swirling strokes are clearly visible, as are deep, drying cracks indicating that the artist was painting wet-on-wet (fig. 33). Remington used thinner applications of lead white to

Fig. 35 Detail of fig. 31 demonstrating that Remington modified the tail of the wolf by painting it over the impasto background

represent snow on the fence rails and haystacks. Subsequently, he applied a viridian green scumble over all the white areas (fig. 34). He modified the contour of the wolves with the white paint of the background and by scratching through the paint with the tip of his brush handle. He appears to have modified the position of the tail of the wolf at the left, because it is painted over the impasto background (fig. 35). For the final modeling of the horses he applied dabs of pure color: viridian green, Prussian blue, brown, and ocher. In his November 15, 1909, diary entry Remington comments that *The Call for Help* is too green. Two days later he records retouching the painting. When examining the painting it is difficult to find a passage where he painted over the green. The X ray indicates that the light in the window has an underlayer of lead white (fig. 36). Changing the light in the window from white to orange was possibly a modification Remington made to balance the green.

In the finished painting we no longer see references to the preliminary drawing. The contour lines that were so visible in his earlier works have disappeared. In his diary he admires the canvases of his colleague Robert Reid, stating they are "all plein air and outlines lost—hard outlines are the vane of old painters."

Fig. 36 X-ray detail of fig. 31 illustrating an underlayer of lead white

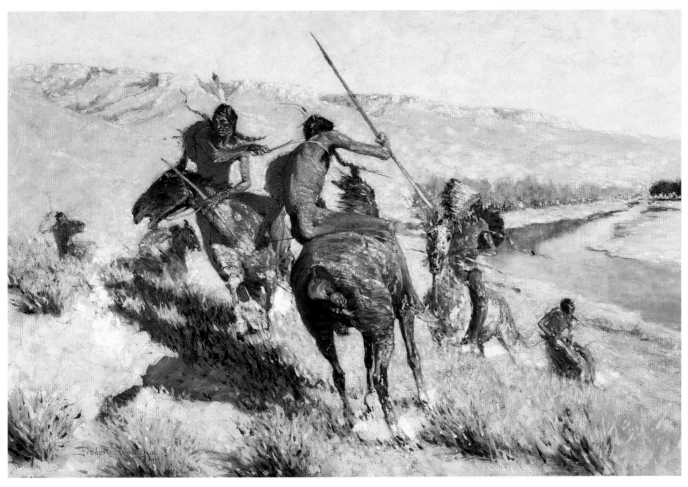

Fig. 37 *Episode of the Buffalo Gun*, 1909 (cat. no. 22)

The third dimension in the composition is compressed by the combination of fluid brushwork and patterned color. The animals and the landscape merge into one another and play equal roles in developing the drama in the scene. The eye rests on the lone spot of bright orange: the window that serves as a beacon of hope for the beleaguered horses.

Episode of the Buffalo Gun (fig. 37) was painted in 1909, Remington's last year. Remington started with a coarse-weave canvas, a new preference that he recorded in his diary as early as January 1908. Careful to retain the texture of the canvas, he brushed on a thin wash of blue-gray to tint the fabric. There is no commercial ground layer. The blue-gray wash serves as a shadow tone for his figures and their shields. The contour line of the torso of the central figure is a strip of the same blue-gray priming. Remington sketched his figures with a fine brush and red pigment, possibly alizarin. Since the fine, nervous line of the drawing complemented the linear brushwork employed to develop the figures, the artist retained passages of drawing in the finished work, as seen in the back of the central figure (fig. 38). In the three main Native American figures, Remington alternated three systems to define contour boundaries: the thread-thin, red sketch line, the line of reserved blue-

gray priming, and the edge of painted background. These techniques have the effect of visually muting the contour lines so that they seem to dissolve.

Remington established the spatial areas of the landscape by gradating his brushstrokes from thick to thin. He also varied the texture of the brushwork from the thin, low-relief, dry-brush impasto in the foreground to the broad-brush, high-relief, liquid impasto in the background. In the sky he applied a continuous layer of impasto, completely concealing the texture of the canvas. With each loaded broad brushstroke he varied the hue in alternating sweeps of cerulean blue and yellow green, creating an atmosphere in motion (fig. 39). He painted the background slopes with long, arched, horizontal brushstrokes, using a slightly smaller, flat brush. The pasty consistency of the paint caused skips in the moderate impasto, intermittently revealing the coarse texture of the canvas. The mesas are rendered in the only vertical brushstrokes in the painting. Remington modeled the shadows of the gorges in the distant golden plateaus by reserving areas of the blue-gray priming that he then enhanced with touches of blue and green. The river and trees are likewise thinly painted. In the foreground he continued the brushy yellow impasto of the

Fig. 38 Detail of fig. 37 showing the fine red sketch line that Remington used to help define contour

background as an underlayer. He again reserved areas of the blue-gray priming on the coarse canvas for the shadows. Then, using a pointed brush, he articulated the grass with rhythmic brushstrokes of blue, green, and touches of red. The nearly horizontal brushstrokes of the foreground flow on a diagonal from the lower left to the upper right.

Remington used the same fine-line brushwork to paint the figures, causing them to merge with the pattern of the landscape. He maintained the diagonal direction of the brushstroke of the landscape in the figures, with the exception of the center figure, where the direction becomes completely horizontal. Together, the linear rhythms of the brushwork and the texture of the canvas create a surface pattern.

There is no black in this painting. Remington modeled his forms with color instead of value, working from cool to warm instead of dark to light. He used a relentlessly hot palette, dominated by red and yellow. Red is the predominant hue of the horses and riders, making them the central focus of the composition. In spite of his surprisingly extensive mixing with lead white, visible in the X ray, even the lighter hues retain their brilliance (fig. 40). Remington separated the brushstrokes of contrasting color to such a degree that optical mixing is a strain and the eye quivers with the resonance between the warm reds and yellows and the counterpoint greens and blues.

Remington first mentions painting *Episode of the*

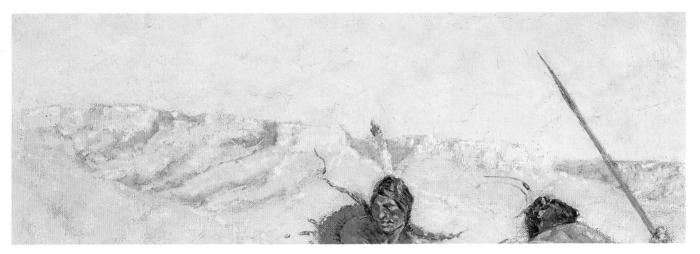

Fig. 39 Detail of fig. 37 showing the brushwork employed to paint the varying hues of the sky

Fig. 40 X ray of fig. 37 demonstrating that despite Remington's extensive mixing with lead white, even the lighter hues retain their brilliance in this painting

Buffalo Gun in his diary after returning from the Adirondacks in 1909. On August 23 he wrote, "Fine day—worked all morning *Visitation of a Buffalo Gun*" (alternative title for the painting). The next day he mentioned it again: "Hot—worked on my dashing *Buffalo Gun.*" He must have worked very quickly and been pleased with the results, for on August 27 he wrote, "Been doctoring paintings—the final bath of air. I wonder if this bunch will make artistic New York sit up?" An exhibition of his paintings at Knoedler and Company was planned to open later

that fall. Finally, on September 13, he wrote, "I am putting the final vibration on my pictures." Vibration is the key sensation on viewing *Episode of the Buffalo Gun*. We assume that this painting was included with the October 26 shipment to Knoedler. Remington recorded it on his exhibition list.

The exhibition garnered rave reviews, and certainly the critics noticed the final stages of Remington's metamorphosis from illustrator to painter. The artist's December 9, 1909, diary entry reads, "The art critics have all come

down—I have belated but splendid notices from all the papers. They ungrudgingly give me a high place as a *mere painte* [*sic*]. I have been on their trail a long while and they never surrendered while they had a leg to stand on. The *illustrator* has become background."

Remington evolved from being dependent solely on his able draftsmanship to having the confidence to compose directly on the canvas with his brush. As his composition process became more fluid and direct, elements of the process (priming, drawing, and toning) were incorporated into the finished painting. Remington's palette developed from a reliance on predominantly local color to a dynamic, expressive instrument that could convey action, atmos-phere, and drama. Varying his brushwork and juxtaposing paint consistencies added texture to his painting surfaces. He composed with a variety of application techniques, such as drawing through the paint, scumbling, and rubbing back to achieve his vision. While his early paintings were dominated by figures, with only minor attention paid to the landscape, his later paintings achieved a synthesis between figure and landscape. Remington seemingly had an instinctive talent for composition and acquired an early competence in draftsmanship. His developed sense of color and patterned brushwork enhanced his natural ability to enthrall the viewer with his romantic vision of the Old West.

Checklist of Works

Titles of Remington's paintings often vary among those listed for copyright, published illustrations, or exhibition.
Alternative titles are included in parentheses. Works are listed in chronological order.

Battle of Beecher's Island, 1868 (Custer's Last Stand)
c. 1885
Watercolor on paper, image 12 x 21 in. (30.5 x 53.3 cm)
Signed at lower left: Remington
43.62

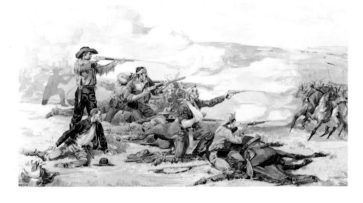

The Lookout
1887
Oil on canvas, 26 x 22 in. (66 x 55.9 cm)
Signed and dated at lower left: Frederic Remington / '87
43.19
Related image published: Lt. Col. E. V. Sumner, "Besieged by the Utes, the Massacre of 1879," *Century Magazine,* October 1891, 838, wood engraving.
Cat. no. 1

Looking through the Telescope (Hostin Kar Uses a Telescope)
c. 1888
Oil on board in black and white, 10 1/2 x 13 3/8 in. (26.7 x 34 cm)
Inscribed on verso: Looking through the Telescope. 9pp.
Signed on verso: Frederic Remington
43.68a
Published: John Willis Hays, "Hostin Kar," *Youth's Companion,* May 24, 1888, 255, wood engraving.

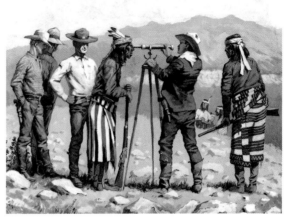

Spurs
1888
Pen and ink on paper, 13 3/8 x 5 3/4 in. (34.9 x 14.6 cm)
Signed at center left: F. R.; at lower center: Spurs
43.69

A Pronghorn Antelope
c. 1889
Pen and ink on paper, 13 1/2 x 6 3/8 in. (34.3 x 16.2 cm)
Inscribed at lower center: A prong-horn antelope—
for a hunting article—
Signed at center: Remington
43.69a

*Pueblo Indian Village (Distribution of Beef at San
Carlos Agency)*
c. 1889
Oil on canvas in black and white, 17 x 27 in. (43.2 x 68.6 cm)
Signed at lower right: FREDERIC REMINGTON / SAN CARLOS
43.54
Published: Frederic Remington, "On the Indian Reservations,"
Century Magazine, July 1889, 397, wood engraving.

The Gendarme (A Gendarme)
1889
Watercolor and gouache on paper, image 17 x 12 7/8 in.
(43.2 x 32.7 cm)
Signed at lower right: Frederic Remington. / City of Mexico.

'89—
Inscribed at lower left, in margin: —Gendarme.—
43.63
Published: Thomas A. Janvier, "The Mexican Army," *Harper's
Monthly,* November 1889, 822, wood engraving.

Aiding a Comrade (Past All Surgery)
1889–90
Oil on canvas, 34 x 48 1/8 in. (86.4 x 122.2 cm)
Signed at lower left: FREDERIC REMINGTON
43.23
Cat. no. 2

*The Transgressor (The Apache Trail; Tio Juan Hanging There
Dead!; The Way of the Transgressor)*
1891
Oil on canvas, 33 1/8 x 23 1/8 in. (84.1 x 58.7 cm)
Signed at lower right: FREDERIC REMINGTON
43.12
Published: Maurice Kingsley, "Tio Juan," *Harper's Monthly,*
February 1893, 390, wood engraving.
Cat. no. 3

Scouts Climbing a Mountain
1891
Oil on canvas, 43 x 20 in. (109.2 x 50.8 cm)
Signed at lower right: FREDERIC REMINGTON / 1891
43.11
Cat. no. 4

*U.S. Cavalry Hunting Garza Men on the Rio Grande
(United States Cavalry Hunting for Garza on the Río
Grande)*
c. 1892
Watercolor, pen and ink, and white heightening on paper in
black and white, 20 1/4 x 30 3/4 in. (51.4 x 78.1 cm)
Signed at lower right: Frederic Remington.
43.61
Published: Richard Harding Davis, "The West from a Car
Window," *Harper's Weekly,* March 5, 1892, 220, halftone.

A Call to Arms ("Dragoons, Mount!")
1892–93
Watercolor, gouache, pen and ink, graphite, and white
heightening on paper, 22 x 31 in. (55.9 x 78.7 cm)
Signed at lower right: Frederic Remington.
43.60
Published: Poultney Bigelow, "In the Barracks of the Czar,"
Harper's Monthly, April 1893, 775, halftone.

*A Haircut in a Cavalry Stable (A Hair-Cut in a Cavalry
Stable; Barber Shop in Cavalry Stable)*
1892–93
Watercolor, pen and ink, graphite, and white heightening on
paper in black and white, 18 3/4 x 21 7/8 in. (47.6 x 55.6 cm)
Signed at lower right: Frederic Remington / Krasnoi Séló

Inscribed at lower left: [illegible]
43.68
Published: Poultney Bigelow, "In the Barracks of the Czar,"
Harper's Monthly, April 1893, 782, halftone.

An Amoor Cossack (Cossacks of the Amoor)
1892–94
Watercolor and pen and ink on paper, image 21 3/4 x 27 1/16 in.
(55.3 x 68.73 cm)
Signed at lower left: Frederic Remington / An Amoor Cossack.—
43.71
Published: Poultney Bigelow, "The Cossack as Cowboy, Soldier,
and Citizen," *Harper's Monthly,* November 1894, 929, halftone.

The Hussar (Private of Hussars; A German Hussar)
1892–93
Oil on canvas, 28 x 23 in. (71.1 x 58.4 cm)
Signed at lower right: FREDERIC REMINGTON—
43.13
Published: First Lt. Powhatan H. Clarke, "Characteristic
Sketches of the German Army," *Harper's Weekly,* May 20, 1893,
480, halftone.
Cat. no. 5

The Infantry Square

c. 1893

Oil on canvas in black and white, 24 x 34 in. (61 x 86.4 cm)

Signed at lower left: REMINGTON—

43.49

Published: Maurice Kingsley, "Gabriel, and the Lost Millions of Perote," *Harper's Monthly*, September 1893, 549, wood engraving.

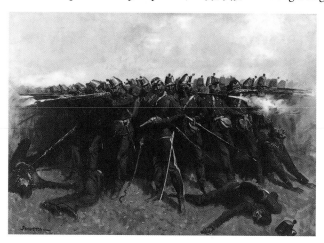

The Flight (A Sage-Brush Pioneer)

1895

Oil on canvas, 23 x 33 in. (58.4 x 83.8 cm)

Signed at lower right: Frederic Remington / copyright 1895 Harper Bros.

43.8

Published: Owen Wister, "The Evolution of the Cow-Puncher," *Harper's Monthly*, September 1895, 607, halftone.

Cat. no. 6

Bronco Buster

1895, this version cast July 30, 1906

Bronze, green over brown patina, lost-wax cast,

22 5/8 x 22 3/4 x 15 1/4 in. (57.5 x 57.8 x 38.7 cm)

Signed at front, top of base at right: Copyright by / Frederic Remington

Inscribed at rear, top of base along right curve: ROMAN BRONZE WORKS N.Y.

Inscribed on underside of base: 49

43.73

Cat. no. 7

The Last Stand (Twenty-Five to One)

c. 1896

Oil on canvas in black and white, 24 x 35 in. (61 x 88.9 cm)

Signed at lower right: Frederic Remington—

43.57

Published: Miles 1896, 177, halftone.

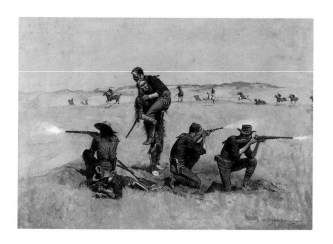

The Mier Expedition: The Drawing of the Black Bean (Prisoners Drawing Their Beans)

1896

Oil on canvas, 27 x 40 in. (68.6 x 101.6 cm)

Signed at lower right: Frederic Remington— / copyright 1896 / Harper Bros.

43.14

Published: Frederic Remington, "How the Law Got into the Chaparral," *Harper's Monthly*, December 1896, 67, halftone.

Cat. no. 8

The Blanket Signal

c. 1896

Oil on canvas, 27 x 22 in. (68.6 x 55.9 cm)

Signed at lower left: Frederic Remington

43.16

Cat. no. 9

Untitled (Portrait Head; Self-Portrait [?])

1896–98

Graphite on paper, 8 x 5 in. (20.3 x 12.7 cm)

Signed at lower right: Frederic Remington.

43.70

The Going of the Medicine-Horse (Indian Fire God)
1897
Oil on canvas in black and white, 40 x 27 in. (101.6 x 68.6 cm)
Signed at lower right: Frederic Remington— / copyright 1897 /
Harper Bros.—
43.53
Published: Frederic Remington, "The Great Medicine-Horse: An
Indian Myth of the Thunder," *Harper's Monthly,* September 1897,
516, halftone; Charles de Kay, "A Painter of the West: Frederic
Remington and His Work," *Harper's Weekly,* January 8, 1910, 14,
halftone.
Cat. no. 10

The Cowboy (Untitled)
c. 1897
Watercolor, pen and ink, and white heightening on paper,
17 3/4 x 16 1/4 in. (45.1 x 41.3 cm)
Signed at lower right: Frederic Remington—
43.64
Published: Remington 1897, cover, halftone.

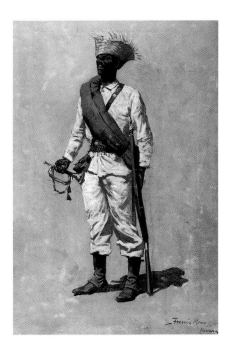

One of Gomez' Men (Spanish Soldier, Spanish-American War)
1899
Oil on canvas in black and white, 36 x 24 in. (91.4 x 61 cm)
Signed at lower right: Frederic Remington / Havana / Cuba
43.42
Published: Frederic Remington, "Havana under Our Regulars,"
Collier's Weekly, April 1, 1899, cover, halftone.

U.S. Soldier, Spanish-American War
(A First-Class Fighting Man)
1899
Oil on canvas in black and white, 36 x 24 in. (91.4 x 61 cm)
Signed at lower right: Frederic Remington / Havana / Cuba
43.41
Published: Frederic Remington, "The American Regular,"
Collier's Weekly, March 25, 1899, 12–13, halftone.

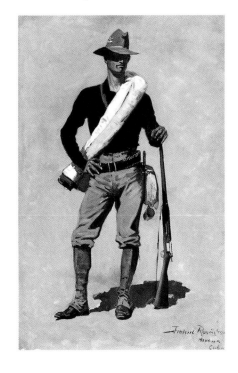

The Return of Gomez to Havana
1899
Oil on canvas in black and white, 27 x 40 in. (68.6 x 101.6 cm)
Signed at lower right: Frederic Remington / Havana
43.38
Published: *Collier's Weekly,* March 18, 1899, 12–13, halftone.

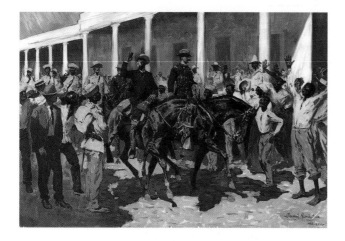

Disbanding Gomez's Army
1899
Oil on canvas in black and white, 27 x 40 in. (68.6 x 101.6 cm)
Signed at lower right: Frederic Remington
43.44
Published: *Collier's Weekly,* April 15, 1899, 12–13, halftone.
Cat. no. 11

The Dry Leaves Had Lasted Longer than She
c. 1899
Oil on canvas in black and white, 17 5/8 x 24 in. (44.6 x 61 cm)
Signed at lower right: Frederic Remington
43.32
Published: Frederic Remington, "The Story of the Dry Leaves,"
Harper's Monthly, June 1899, 101, halftone.

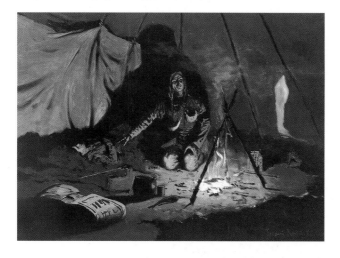

The Defeat of Crazy Horse
(The Defeat of Crazy Horse by Colonel Miles, January, 1877;
Winter Attack on an Indian Village)
c. 1901, possibly c. 1896
Oil on canvas in black and white, 27 x 40 in. (68.6 x 101.6 cm)
Signed at lower right: Frederic Remington

43.35
Published: Francis V. Greene, "The United States Army,"
Scribner's Magazine, November 1901, 595, halftone.
Cat. no. 12

French Explorer's Council with the Indians
(At the Iroquois Council Fire)
c. 1901
Oil on canvas in black and white, 19 x 29 in. (48.3 x 73.7 cm)
Signed at lower left: Frederic Remington—
43.40
Published: Woodrow Wilson, "Colonies and Nation: A Short
History of the People of the United States," part 1, *Harper's
Monthly,* April 1901, 723, halftone.

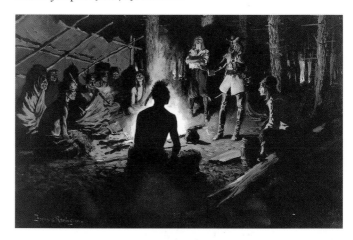

The Mule Pack (An Ore-Train Going into the Silver Mines,
Colorado; Colorado Ore Train)
1901
Oil on canvas in black and white, 27 x 40 in. (68.6 x 101.6 cm)
Signed at lower right: Frederic Remington / Colorado / copyright
by *Harper's Weekly* 1901
43.56
Published: *Harper's Weekly,* March 2, 1901, 226–27, halftone.
Cat. no. 13

Days on the Range ("Hands Up!")
c. 1902
Oil on canvas in black and white, 40 x 27 in. (101.6 x 68.6 cm)
Signed at lower right: Frederic Remington—
43.48
Published: Alfred Henry Lewis, *Wolfville Days* (New York:
Frederick A. Stokes, 1902), frontispiece, halftone.
Cat. no. 14

Fight for the Water Hole (An Arizona Water Hole;
A Water-Hole in the Arizona Desert)
1903
Oil on canvas, 27 1/8 x 40 1/8 in. (68.9 x 101.9 cm)
Signed at lower right: Frederic Remington— / copyright 190[?]
By Frederic Remington
43.25
Published: *Collier's Weekly,* December 5, 1903, 24–25, color
halftone.
Cat. no. 15

Change of Ownership (The Stampede; Horse Thieves)
1903
Oil on canvas, 27 x 40 in. (68.6 x 101.6 cm)
Signed at lower right: Frederic Remington— / copyright 1903
By Frederic Remington
43.17
Published: *Collier's Weekly,* September 10, 1904, 14–15, color
halftone.
Cat. no. 16

The Parley
1903
Oil on canvas, 30 1/4 x 51 1/8 in. (76.8 x 129.9 cm)
Signed at lower right: Frederic Remington— / copyright 1903
By Frederic Remington
43.21
Published: *Collier's Weekly,* October 20, 1906, 8, color halftone.
Cat. no. 17

A New Year on the Cimarron (A Courier's Halt to Feed)
1903
Oil on canvas, 27 x 40 in. (68.6 x 101.6 cm)
Signed at lower right: Frederic Remington— / copyright
By Frederic Remington [illegible]
43.10
Published: *Collier's Weekly,* December 27, 1913, 16–17, halftone.
Cat. no. 18

The Emigrants
c. 1904
Oil on canvas, 30 1/4 x 45 1/4 in. (76.8 x 114.9 cm)
Signed at lower right: Frederic Remington
43.15
Published: *Collier's Weekly,* May 14, 1904, 16–17, color halftone.
Cat. no. 19

The Herd Boy
c. 1905
Oil on canvas, 27 1/8 x 45 1/4 in. (68.9 x 114.9 cm)
Signed at lower right: Frederic Remington
43.24
Published: *Collier's Weekly,* June 17, 1905, advertisement, halftone;
Collier's Weekly, February 12, 1910, cover.
Cat. no. 20

The Call for Help (At Bay)
c. 1908
Oil on canvas, 27 1/4 x 40 1/8 in. (69.2 x 101.9 cm)
Signed at lower right: Frederic Remington— / 19[?]; and at lower
center: copyright [illegible]
43.9
Published: *Collier's Weekly,* December 17, 1910, 6, color halftone.
Cat. no. 21

Episode of the Buffalo Gun (The Visitation of the Buffalo
Gun; The Mystery of the Buffalo Gun; A Buffalo Episode)
1909
Oil on canvas, 27 x 40 in. (68.6 x 101.6 cm)
Signed at lower left: Frederic Remington— / 1909
43.22
Cat. no. 22

Selected Bibliography

The following abbreviations are used throughout the notes:

FRAM, Ogdensburg Frederic Remington Art Museum, Ogdensburg, New York

IH Papers Ima Hogg Papers, the Center for American History, the University of Texas at Austin

MFA, Houston Museum of Fine Arts, Houston

WCH Papers William Clifford Hogg Papers, the Center for American History, the University of Texas at Austin

Axelrod 1985. Axelrod, Alan, ed. *The Colonial Revival in America.* New York and London: W. W. Norton, 1985, published for the Henry Francis du Pont Winterthur Museum.

Ballinger 1989. Ballinger, James K. *Frederic Remington.* New York: Harry N. Abrams, in association with the National Museum of American Art, Smithsonian Institution, 1989.

Barnstone 1979. Barnstone, Howard. *The Architecture of John F. Staub: Houston and the South.* Austin and London: University of Texas Press, in cooperation with the Museum of Fine Arts, Houston, 1979.

Bernhard [1984] 1996. Bernhard, Virginia. *Ima Hogg: The Governor's Daughter.* Austin: Texas Monthly Press, 1984. Reprint, St. James, N.Y.: Brandywine Press, 1996.

Billings 1994. Billings, Theo M. "The Museum of Fine Arts, Houston: A Social History." Ph.D. diss., University of Houston, 1994.

Bonjean and Moore 1982. Bonjean, Charles M., and Bernice Milburn Moore. *Miss Ima: 1882–1982 Centennial Celebration.* Austin: Hogg Foundation for Mental Health, 1982.

Brod 1987. Brod, Harry, ed. *The Making of Masculinities.* Boston: Allen and Unwin, 1987.

Burns 1995. Burns, Sarah. "Revitalizing the 'Painted Out' North: Winslow Homer, Manly Health, and New England Regionalism in Turn-of-the-Century America." *American Art* 9 (Summer 1995): 20–37.

Bywaters 1978. Bywaters, Jerry. *Seventy-five Years of Art in Dallas: The History of the Dallas Art Association and the Dallas Museum of Fine Arts.* Dallas: Dallas Museum of Fine Arts, 1978.

Campbell 1989. Campbell, Randolph B. *An Empire for Slavery: The Peculiar Institution in Texas 1821–1865.* Baton Rouge and London: Louisiana State University Press, 1989.

Chotner et al. 1989. Chotner, Deborah, Lisa N. Peters, and Kathleen A. Pyne. *John Twachtman: Connecticut Landscapes.* Exh. cat. Washington, D.C.: National Gallery of Art, distributed by Harry N. Abrams, 1989.

Clark 1986. Clark, Clifford Edward, Jr. *The American Family Home, 1800–1960.* Chapel Hill and London: University of North Carolina Press, 1986.

Cook and Kaplan 1977. Cook, Charles Orson, and Barry J. Kaplan. "Civic Elites and Urban Planning: Houston's River Oaks." *East Texas Historical Journal* 15, no. 2 (1977): 29–37.

Cortissoz [1913] 1923. Cortissoz, Royal. *American Artists.* New York and London: Charles Scribner's Sons, 1923. Originally published by the *New-York Tribune,* 1913.

Cotner 1959. Cotner, Robert C. *James Stephen Hogg: A Biography.* Austin: University of Texas Press, 1959.

Dippie 1975. Dippie, Brian W. "Frederic Remington's Wild West." *American Heritage* 26, no. 3 (April 1975): 7–79.

Dixon 1935a. Dixon, Olive K. "The Buffalo Wallow Fight." Extract from *"Life of 'Billy' Dixon."* Dallas: P. L. Turner, 1935, 3–11. Excerpted from Billy Dixon, *Life and Adventures of "Billy" Dixon, of Adobe Walls, Texas Panhandle* [Guthrie, Okla.: Cooperative, 1914].

Dixon 1935b. Dixon, Olive K. "The Fight at Adobe Walls." Extract from *"Life of 'Billy' Dixon."* Dallas: P. L. Turner, 1935, 3–15.

Dodge 1883. Dodge, Colonel Richard Irving. *Our Wild Indians.* Hartford, Conn.: A. D. Worthington, 1883.

Edgerton 1909. Edgerton, Giles. *Craftsman* 15 (March 1909): 658–70.

Erdman and Papademetriou 1972. Erdman, Donnelley, and Peter C. Papademetriou. *The Museum of Fine Arts, Houston: Fifty Years of Growth, 1922–1972. Architecture at Rice,* no. 28. Houston: Rice University, 1972.

Everett 1904. Everett, Marshall. *The Book of the Fair.* Chicago: Henry Neil, 1904.

Ferenbach 1968. Ferenbach, T. R. *Lone Star: A History of Texas and the Texans.* New York: MacMillan, 1968.

Fox 1980. Fox, Stephen. "Public Art and Private Places: Shadyside." *Houston Review: History and Culture of the Gulf Coast* 2 (Winter 1980): 37–55.

Fox 1990. Fox, Stephen. *Houston Architectural Guide.* Houston: American Institute of Architects/Houston Chapter and Herring Press, 1990.

Gebhard 1987. Gebhard, David. "The American Colonial Revival in the 1930s." *Winterthur Portfolio* 22 (Summer–Autumn 1987): 109–48.

Goetzmann 1992. Goetzmann, William H. "The West as America: Reinterpreting Images of the Frontier, 1820–1920." Review of the exhibition at the National Museum of American Art, Washington, D.C. *Southwestern Historical Quarterly* 96, no. 1 (July 1992): 129–31.

Green [1845] 1935. Green, General Thomas J. *Journal of the Texian Expedition against Mier.* New York: Harper and Brothers, 1845. Facsimile reprint, Austin: Steck, 1935.

Harris 1997. Harris, Neil. "Midwestern Medievalism: Three Chicago Collectors." In *Cultural Leadership in America: Art Matronage and Patronage,* vol. 27 of *Fenway Court.* Boston: Isabella Stewart Gardner Museum, 1997.

Hassrick and Webster 1996. Hassrick, Peter H., and Melissa J. Webster. *Frederic Remington: A Catalogue Raisonné of Paintings, Watercolors and Drawings.* 2 vols. Seattle and London: Buffalo Bill Historical Center, Cody, Wyoming, in association with University of Washington Press, 1996.

Haynes 1990. Haynes, Sam W. *Soldiers of Misfortune: The Somervell and Mier Expeditions.* Austin: University of Texas Press, 1990.

Hendrickson 1995. Hendrickson, Kenneth E., Jr. *The Chief Executives of Texas from Stephen F. Austin to John B. Connally, Jr.* College Station: Texas A & M University Press, 1995.

Hewitt 1990. Hewitt, Mark Alan. *The Architect and the American Country House, 1890–1940.* New Haven and London: Yale University Press, 1990.

Hiesinger 1991. Hiesinger, Ulrich W. "Impressionism and Politics: The Founding of The Ten," *Magazine Antiques* 140, no. 5 (November 1991): 780–93.

Higham 1955. Higham, John. *Strangers in the Land: Patterns of American Nativism, 1860–1925.* New Brunswick, N.J.: Rutgers University Press, 1955.

Hofstadter 1955. Hofstadter, Richard. *The Age of Reform.* New York: Vintage Books, 1955.

Hosmer 1965. Hosmer, Charles B., Jr. *Presence of the Past: A History of the Preservation Movement in the United States before Williamsburg.* New York: G. P. Putnam's Sons, 1965.

Hughes 1997. Hughes, Robert. *American Visions: The Epic History of Art in America.* New York: Alfred A. Knopf, 1997.

Hunt 1967. Hunt, David C. "The Old West Revisited: The Private World of Doctor Philip Cole." *American Scene* 8, no. 4 (1967).

Iscoe 1976. Iscoe, Louise Kosches. *Ima Hogg: First Lady of Texas: Reminiscences and Recollections of Family and Friends.* Austin: Hogg Foundation for Mental Health, 1976.

Isham [1905] 1942. Isham, Samuel. *The History of American Painting.* 1905. Reprint. New York: MacMillan, 1942.

Johns 1991. Johns, Elizabeth. *American Genre Painting: The Politics of Everyday Life.* New Haven and London: Yale University Press, 1991.

Johnston 1991. Johnston, Marguerite. *Houston: The Unknown City, 1836–1946.* College Station: Texas A & M University Press, 1991.

Jussim 1983. Jussim, Estelle. *Frederic Remington, the Camera, and the Old West. The Anne Burnett Tandy Lectures in American Civilization,* no. 3. Fort Worth: Amon Carter Museum, 1983.

Kaplan 1983. Kaplan, Wendy. "R. T. H. Halsey: An Ideology of Collecting American Decorative Arts." *Winterthur Portfolio* 17 (Spring 1983): 43–53.

Kennedy 1971. Kennedy, David M., ed. *Progressivism: The Critical Issues, Critical Issues in American History,* no. 6. Boston: Little, Brown, 1971.

King 1970. King, John O. *Joseph Stephen Cullinan: A Study of Leadership in the Texas Petroleum Industry, 1897–1937.* Nashville: Vanderbilt University for the Texas Gulf Coast Historical Association, 1970.

Lomax [1940] 1956. Lomax, John A. "Will Hogg, Texan." *Atlantic Monthly* 165 (May 1940): 662–73. Reprint, Austin: University of Texas Press for the Hogg Foundation of Mental Health, 1968.

Marzio et al. 1989. Marzio, Peter C., et al. *A Permanent Legacy: 150 Works from the Collection of the Museum of Fine Arts, Houston.* New York: Hudson Hills Press, in association with the Museum of Fine Arts, Houston, 1989.

May, B. 1991. May, Bridget. "Progressivism and the Colonial Revival: The Modern Colonial House, 1900–1920." *Winterthur Portfolio* 26, nos. 2–3 (Autumn 1991): 107–22.

May, S. 1991. May, Stephen. "The West as America." Review of the exhibition at the National Museum of American Art, Washington, D.C. *Southwest Art* (October 1991): 100–109.

McCracken 1947. McCracken, Harold. *Frederic Remington: Artist of the Old West.* Philadelphia: J. B. Lippincott, 1947.

Meyer 1976a. Meyer, Wendy Haskell. "River Oaks, Still the 'Satin

Slipper' Suburb." *Houston Home and Gardens* 2, no. 11 (August 1976): 41–48, 134–35.

Meyer 1976b. Meyer, Wendy Haskell. "An Interview with John Staub." *Houston Home and Gardens* 2, no. 11 (August 1976): 135–36.

Miles 1896. Miles, Nelson A. *Personal Recollections and Observations of General Nelson A. Miles.* Chicago: Werner, 1896.

Murray 1986. Murray, Ken. *The Body Merchant: The Story of Earl Carroll.* Pasadena, Calif.: Ward Ritchie Press, 1986.

Museum of Fine Arts, Houston, Bulletin 1992. *The Museum of Fine Arts, Houston: An Architectural History, 1924–1986; A Special Bulletin* 15, nos. 1–2 (April 1992).

Nance 1998. Nance, J. M., ed. *Archie P. McDonald, Dare-Devils All: Texas Mier Expedition, 1842–44.* Austin: Eakin Press, 1998.

Nemerov 1995. Nemerov, Alexander. *Frederic Remington and Turn-of-the-Century America.* New Haven and London: Yale University Press, 1995.

Oglesby 1950. Oglesby, Resa C. "History of the Fort Worth Art Association." Master's thesis, Texas State College for Women, 1950.

Porterfield 1996. Porterfield, Nolan. *Last Cavalier: The Life and Times of John A. Lomax.* Urbana and Chicago: University of Illinois Press, 1996.

Ratcliffe 1992. Ratcliffe, Sam DeShong. *Painting Texas History to 1900.* Austin: University of Texas Press, 1992.

Remington 1897. Remington, Frederic. *Drawings by Frederic Remington.* New York: Robert Howard Russell, 1897.

Remington 1902. Remington, Frederic. *Done in the Open: Drawings by Frederick [sic] Remington.* New York: P. F. Collier and Son, 1902.

Remington 1961. Remington, Frederic. *Pony Tracks.* New ed., with a preface by J. Frank Dobie. Norman: University of Oklahoma Press, 1961. Original edition, New York: Harper and Brothers, 1895.

Rhoads 1976. Rhoads, William B. "The Colonial Revival and American Nationalism." *Journal of the Society of Architectural Historians* 35, no. 4 (December 1976): 239–54.

Rhoads 1977. Rhoads, William B. *The Colonial Revival.* New York: Garland, 1977.

Rose and Kalil 1985. Rose, Barbara, and Susie Kalil. *Fresh Paint: The Houston School.* Exh. cat. The Museum of Fine Arts, Houston. Austin: Texas Monthly Press, 1985.

Roth 1964. Roth, Rodris. "The Colonial Revival and 'Centennial Furniture.'" *Art Quarterly* 27, no. 1 (1964): 57–81.

Rotundo 1982. Rotundo, E. Anthony. "Manhood in America: The Northern Middle Class, 1770–1920." Ph.D. diss., Brandeis University, 1982.

Ruckstull 1925. Ruckstull, F. W. *Great Works of Art and What Makes Them Great.* Garden City, N.Y.: Garden City Publishing Company, 1925.

Samuels and Samuels 1982. Samuels, Peggy, and Harold Samuels. *Frederic Remington: A Biography.* Garden City, N.Y.: Doubleday, 1982.

Samuels and Samuels 1990. Samuels, Peggy, and Harold Samuels. Remington: *The Complete Prints.* New York: Crown, 1990.

Saunders 1988. Saunders, Richard H. *Collecting the West: The C. R. Smith Collection of Western American Art.* Austin: University of Texas Press, 1988.

Schneider et al. 1995. Schneider, Beth B., et al. *Education in the Arts: The Museum of Fine Arts, Houston; A Special Bulletin* 16, nos. 1–2 (February 1995).

Shapiro 1981. Shapiro, Michael Edward. *Cast and Recast: The Sculpture of Frederic Remington.* Washington, D.C.: Smithsonian Institution Press for the National Museum of American Art, 1981.

Shapiro and Hassrick 1988. Shapiro, Michael Edward, and Peter H. Hassrick. *Frederic Remington: The Masterworks.* Exh. cat. New York: Harry N. Abrams, 1988.

Splete and Splete 1988. Splete, Allen P., and Marilyn D. Splete. *Frederic Remington: Selected Letters.* New York: Abbeville Press, 1988.

Stern 1986. Stern, William F. "The Lure of the Bungalow." *Cite: The Architecture and Design Review of Houston* (Winter 1986): 8–11.

Stillinger 1980. Stillinger, Elizabeth. *The Antiquers.* New York: Alfred A. Knopf, 1980.

Texas Parks and Wildlife Department 1983. Texas Parks and Wildlife Department, Historic Sites and Restoration Branch. "Varner-Hogg Plantation State Historical Park, Brazoria County, Texas." *Texas Parks and Wildlife* 2 (1983).

Texas State Historical Association 1996. *The New Handbook of Texas in Six Volumes.* Austin: Texas State Historical Association, 1996.

Thomas 1913. Thomas, Augustus. "Recollections of Frederic Remington." *Century Magazine,* July 1913, 354–61.

Thompson 1973. Thompson, Marjorie S. *Frederic Remington: Selections from the Hogg Brothers Collection, the Museum of Fine Arts, Houston.* Houston: Museum of Fine Arts, Houston, 1973.

Trachtenberg 1991. Trachtenberg, Alan. "Contesting the West." Review of the exhibition *The West as America,* National Museum of American Art, Washington, D.C. *Art in America* 79, no. 9 (September 1991): 118–23, 152.

Truettner 1991. Truettner, William H., ed. *The West as America: Reinterpreting Images of the Frontier, 1820–1920.* Exh. cat. Washington and London: Smithsonian Institution Press for the National Museum of American Art, 1991.

Truettner and Nemerov 1992. Truettner, William H., and Alexander Nemerov. "More Bark than Bite: Thoughts on the Traditional—and Not Very Historical—Approach to Western Art." *Journal of Arizona History* 33, no. 3 (Autumn 1992): 311–24.

Tyler 1992a. Tyler, Ron. "Western Art and the Historian: The West as America, a Review Essay." *Journal of Arizona History* 33, no. 2 (Summer 1992): 207–24.

Tyler 1992b. Tyler, Ron. "The Intent of the Artist or the Scholar: A Reply." *Journal of Arizona History* 33, no. 3 (Autumn 1992): 325–27.

Varner-Hogg 1958. James Stephen Hogg. West Columbia, Tex.: Varner-Hogg Plantation State Historical Park, 1958.

Vorpahl 1972. Vorpahl, Ben Merchant. *My Dear Wister! The Frederic Remington–Owen Wister Letters.* Palo Alto, Calif.: American West Publishing Company, 1972.

Vorpahl 1978. Vorpahl, Ben Merchant. *Frederic Remington and the West: With the Eye of the Mind.* Austin and London: University of Texas Press, 1978.

Wallach 1994. Wallach, Alan. "The Battle over 'The West as America,' 1991." In *Art Apart: Art Institutions and Ideology across England and North America,* ed. Marcia Pointon. Manchester and New York: Manchester University Press, 1994, 89–101.

Warren 1966. Warren, David B. "American Decorative Arts in Texas: The Bayou Bend Collection of the Museum of Fine Arts, Houston." *Antiques* 90 (December 1966): 796–815.

Warren 1975. Warren, David B. *Bayou Bend: American Furniture, Paintings and Silver from the Bayou Bend Collection.* Houston: Museum of Fine Arts, Houston; Boston: New York Graphic Society, 1975.

Warren 1982. Warren, David B. "Ima Hogg, Collector." *Antiques* 121 (January 1982): 228–43.

Warren 1988. Warren, David B. *Bayou Bend: The Interiors and the Gardens.* Houston: Museum of Fine Arts, Houston, 1988.

Warren et al. 1998. Warren, David B., Michael K. Brown, Elizabeth Ann Coleman, and Emily Ballew Neff. *American Decorative Arts and Paintings in the Bayou Bend Collection.* Princeton: Museum of Fine Arts, Houston, in association with Princeton University Press, 1998.

Weber 1979. Weber, Bruce J. *Will Hogg and the Business of Reform.* Ann Arbor, Mich.: UMI Press, 1979.

Weber and Cook 1980. Weber, Bruce J., and Charles Orson Cook. "Will Hogg and Civic Consciousness: Houston Style." *Houston Review: History and Culture of the Gulf Coast* 2 (Winter 1980): 21–36.

Webster 1986. Webster, Melissa J. "Frederic Remington: His Art and His Nocturnes." Master's thesis, University of California, Davis, 1986.

Wildman 1903. Wildman, Edwin. "Frederic Remington, the Man." *Outing* 41 (March 1903): 712–16.

Wilson, A. 1978. Wilson, Ann Q. *Nomination Form for the Hogg Building/Pappas Building.* Report prepared for the Department of the Interior, National Park Service, National Register of Historic Places Inventory, Washington D.C.: Department of the Interior, 1978.

Wilson, R. 1971. Wilson, Robert L. *Theodore Roosevelt, Outdoorsman.* New York: Winchester Press, 1971.

Winchester 1961. Winchester, Alice, ed. *Collectors and Collections: The Antiques Anniversary Book.* New York: Antiques, 1961.

Woods 1994. Woods, Marianne Berger. "Viewing Colonial America through the Lens of Wallace Nutting." *American Art* 8 (Spring 1994): 66–86.

Wright 1930a. Wright, Roscoe E. "Tender Tempest—A Tardy Tribute to Will C. Hogg." *Houston Gargoyle* 3, no. 38 (September 21, 1930): 6, 22–23.

Wright 1930b. Wright, Roscoe E. "Millions for Learning: Will Hogg's Will Materializes His Dream." *Houston Gargoyle* 3, no. 40 (October 5, 1930): 14.

Index

105; Remington's third solo exhibition at, 101
Kobbe, Gustav, 105–6

Landscape (Inness), 37n.148
Landslide Oil Company, 33n.39
"Latin Colonial" architecture, 32n.8
Lefevre, Arthur, 8
Levy, John, 30
Lewis, Alfred Henry, 78, 136
Lewis and Clark Exposition, 98
Lomax, John: and story about Will Hogg, 7, 8; on Will Hogg, 31, 32n.10, 36n.127, 37n.153; as Will Hogg's friend, 30
Lost Generation, 7
Louisiana Purchase Exposition, 87–88
Lovett, Edgar Odell, 14

MacBeth's Gallery, 30
Mackay, Malcolm, 26, *27*
Mackay, William Andrew, 37n.143
MacMonnies, Frederick William, 61
Mallory, Sir Thomas, 57
Martin, Homer Dodge, 31
Martin Varner and Josiah H. Bell Leagues, 12
McCracken, Harold, 3, 97n.5
McIntyre, Odd, 7–8
McLaughlin, Charles, *62*, 64
McLaughlin, Guy, 26
Meissonnier, Jean-Louis-Ernest, 44
Menil, Dominique Schlumberger de, 33n.29
Menil, John de, 33n.29
Metcalf, Willard Leroy: as anomaly in Hogg's collection, 49n.1; Hogg's collection of works by, 37n.148; Remington's response to works by, 90, 101
Metropolitan Museum of Art: Remington bronzes purchased by, 61n.6; role of, in Remington's development, 44, 87
"The Mexican Army" (Janvier), 64n.2, 132
Mies van der Rohe, Ludwig, 32
Miles, Nelson A.: association with Hogg family, 27–28; and Buffalo Wallow Fight, 82; *Personal Recollections and Observations of General Nelson A. Miles*, 26, 74, 99; and trip with Remington, 50
Monet, Claude, 37n.154, 103
Moody, Dan, 32n.15
Moran, Thomas, 30, 52
Mount Vernon, 17
Mullen, Mrs. Joseph, 14
Murphy, Francis, 37n.148
Museum of Fine Arts, Houston: history of, 13–16; memorial to Will Hogg in, 7; Montrose Wing of, *4;* original building of, *13;* presentation of Hogg Brothers Collection to, 3; and Shadyside, 19
"The Mush-Ice Heroes" (Spears), 76
Muybridge, Eadweard, 87

National Academy of Design, 43
nationalism, 16
National Museum of American Art: purchase of *Fired On* for, 26, 61n.6; *The West as America* (exhibition), 85n.18
nativism, 16, 34n.72
Nemerov, Alexander: on *Fight for the Water*

Hole, 83, 84n.5; on *A New Year on the Cimarron*, 93–94
Neuville, Alphonse-Marie de, 44, 87
newspaper industry, 33n.21
New York Journal, 71
New York Sun: review of American Art Association exhibit in, 53–55; review of Remington's first solo exhibition in, 70n.1; review of *The Transgressor* in, 49n.3
New York Times: obituary of Will Hogg in, 3–4; on Remington's technique, 91nn.9, 10; review of *The Hussar* in, 55n.6; review of Remington's 1908 exhibition in, 103
New-York Tribune: on Remington's place in art world, 45; on Remington's technique, 91n.9; review of Remington's 1908 exhibition in, 104
Nicholson, Alice. *See* Hanszen, Alice Nicholson Hogg
Niemeyer, John Henry, 40, 94n.5
Noé Art Galleries, 88n.2, 91
Northern Pacific Railroad, 98
Norton, R. W., 3, 26
Nutting, Wallace, 16

On the Great Highway (Creelman), 73n.2
Organization Looking to Enlargement and Extension by the State of the University Plan of Higher Education in Texas (later Hogg Organization), 13
Our Wild Indians (Dodge), 83
Outing magazine, 40, 91n.4

"A Painter of the West: Frederic Remington and His Work" (de Kay), 70, 84, 135
Parker, Quanah, 106
Patton Place, 12
Penn's Treaty with the Indians (Hicks), 31, 37n.154
Personal Recollections and Observations of General Nelson A. Miles (Miles), 26, 74, 99
Peters, Charles Rollo, 101
Potter, Hugh, 19, 20–21
Progressives: definition of, 33n.25; movement of, 9–10; politics of, 5; values of, 7; and Will Hogg, 8–9
Progressivism, 16

Quitman News, 33n.21

R. W. Norton Gallery, 26
Ralph, Julian, 87, 88n.5
Ranch Life and the Hunting-Trail (Roosevelt), 103
Ranney, William Tyler, 42
Raymond, Sarah, 36n.122
Reconstruction, 9
Red River War, 107n.11
Reid, Robert, 126
Remington, Clara Sackrider (mother), 40
Remington, Eva Caten (wife), 40
Remington, Frederic, *45;* and American West, 7, 45, 46; "Book of Animals" (photo album), *61,* 87; memorial exhibition for, 32n.3; painting technique of, 110–30; property of, *102; A Snow-Shoe Trip to California* (photo album), *81;* visit to Cuba of, 71, *73;* visit to Europe of, 53, 55, 71

Remington, Frederic, works: *Aiding a Comrade, 43, 43–46, 114, 132; —,* Hogg's purchase of, 37n.144; —, technique in, 115–16; *The American Tommy Atkins in a Montana Blizzard,* 98–99; *An Amoor Cossack,* 55n.1, *133,* 133; *The Apache Trail* (see *The Transgressor*); *An Arizona Water Hole* (see *Fight for the Water Hole*); *Barber Shop in Cavalry Stable* (see *A Haircut in a Cavalry Stable*); *Battle of Beecher's Island, 131,* 131; *At Bay* (see *The Call for Help*); *The Bell Mare,* 88n.3; *The Blanket Signal,* 65–66, *67,* 134; —, and relation to *The Hussar,* 53; *Bronco Buster* (bronze), *28,* 59–61, *60,* 134; —, Hogg's purchase of, 29; *Broncos and Timber Wolves,* 103; *A Buffalo Episode* (see *Episode of the Buffalo Gun*); *The Buffalo Signal,* 65; *The Buffalo Signal* (bronze), 65; *The Call for Help,* 101, *101*–4, *124,* 137; —, in *Collier's Weekly,* 104n.1; —, Hogg's purchase of, 100n.1; —, technique in, 124–27; *A Call to Arms,* 55n.1, *133,* 133; *A Cavalry Scrap, 27, 28;* —, Hogg's purchase of, 30; *Change of Ownership,* 86–88, *87,* 137; —, Hogg's purchase of, 29, 91n.1; —, in Noé Art Galleries, 91; —, in second solo exhibition, 92; *The Charge and Killing of Padre Jarante,* 62; *The Cheyenne* (bronze), 61n.6; *Cold Day on Picket,* 99; *Colorado Ore Train* (see *The Mule Pack*); *Coming through the Rye* (bronze), 61n.6; *Cossacks of the Amoor* (see *An Amoor Cossack*); *A Courier's Halt to Feed* (see *A New Year on the Cimarron*); *The Cowboy, 30, 135,* 135; *Crossing a Stream in the Orange Free State,* 97; *Custer's Last Stand* (see *Battle of Beecher's Island*); *A Daring Plunge,* 59; *Dash for the Timber,* 43, 44; *Days on the Range,* 78, *79,* 136; *The Defeat of Crazy Horse,* 74–75, *75,* 136; *The Defeat of Crazy Horse by Colonel Miles, January, 1877* (see *The Defeat of Crazy Horse*); *Disbanding Gomez's Army,* 71–73, *72,* 136; *Dismounted—The Fourth Troopers Moving the Led Horses,* 43; *Distribution of Beef at San Carlos Agency* (see *Pueblo Indian Village*); *Dragging a Bull's Hide over a Prairie Fire in Northern Texas,* 46n.2; "*Dragoons, Mount!*" (see *A Call to Arms*); *Dragoons* (bronze), 61n.6; *Drawings by Frederic Remington* (book), *30; Drifting before the Storm,* 88n.3; *The Dry Leaves Had Lasted Longer than She, 136,* 136; *The Emigrants,* 95–97, *96,* 137; —, in *Collier's Weekly* series, 88n.3; —, Hogg's purchase of, 29, 42n.1; *The End of the Day,* 88n.3, 95; *Episode of the Buffalo Gun,* 105, *105*–7, *127,* 137; —, technique in, 127–30; *The Fall of the Cowboy,* 56, *58; Fight for the Water Hole,* 80–85, *80,* 137; —, and comparison with *A New Year on the Cimarron,* 93; —, as favorite of Ima Hogg and Alice Nicholson Hogg Hanszen, 3; —, in Noé Art Galleries, 91; —, in second solo exhibition, 92; *Fired On,* 26, 61n.6; *A First-Class Fighting Man* (see *U.S. Soldier, Spanish-American War*); *The Flight,* 56–58, *57,* 134; *French Explorer's Council with the Indians,*